ALADDIN SANE 50

ALADDIN SANE 50

CHRIS DUFFY

The definitive celebration of Bowie's iconic album and
music's most famous photograph — with unseen images.

WELBECK

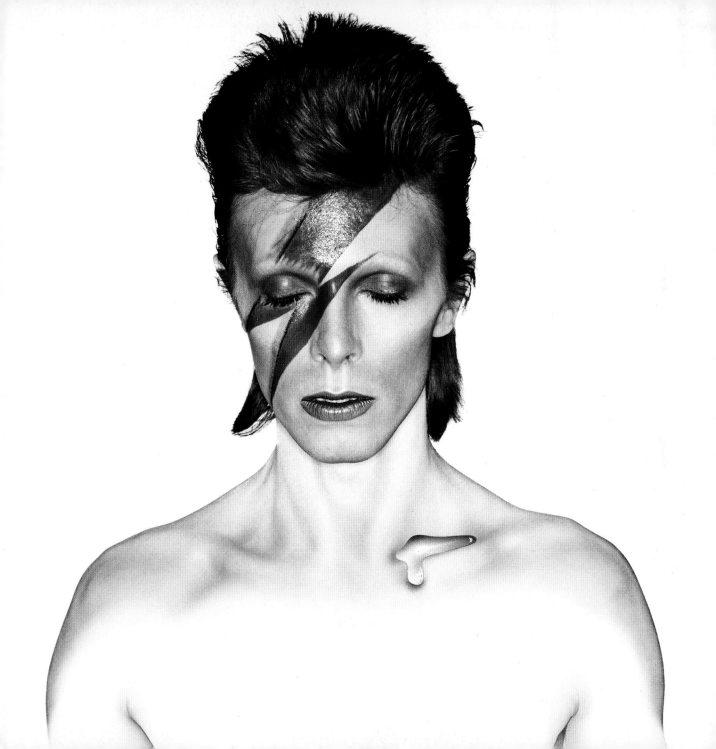

INTRODUCTION
CHRIS DUFFY

SUNDAY 7 January started like any other Sunday morning at home. My father, Duffy, had a ritual of playing records at full volume through his Rogers Valve amp and a pair of 12-inch Wharfedale speakers with tweeters, which had been built into the white melamine cabinets that dominated two corners of the living room.

The usual suspects were jazz heroes, Cannonball Adderley, Colman Hawkins, Charlie Mingus, Bix Beiderbecke — the list was endless, but occasionally he threw a curveball into the mix. It's always a bit disconcerting for a teenager when their music is listened to and enjoyed by their parent. As a rule every generation rebels against the status quo and parental boundaries — and I was no exception. However, record companies regularly sent Duffy records of bands or artists they wanted him to shoot, so it wasn't unusual to hear a catholic mix of tonic scales.

As I came down the stairs and the music became louder, I became transfixed by what I was hearing. The spontaneity and immediacy of the music was intoxicating; I stood on the landing for a while to absorb the energy of the sounds. As the track finished, I entered the living room and asked my dad: "Who was that you were playing?"

He replied: "It's a guy called David Bowie, do you like it?" "Yes, definitely. What's the album called?" "*Ziggy Stardust and the Spiders from Mars.*" "Can I borrow it?" "Yes, but don't scratch it. In fact, I'm shooting his next album cover. Do you want to meet him?"

My interest in music started around 1965 when I was 10 years old. At the time, I would travel back to see my grandparents in the East End of London, where I was raised until the age of five. My parents couldn't afford to live together, so I lived with my mum in East Ham, at my grandparents' house. On one of my weekend visits, my Uncle David introduced me to the Beatles, specifically the *Rubber Soul* album, which I played endlessly on his prized Garrard SP25 record deck.

Amazingly, just a year later, I met the Beatles at my dad's studio. Duffy had become good friends with Lennon and the group had dropped by to see him.

I became a lifelong Beatles fan, but as the mood of the 1960s evolved so did my taste in music. Prog and heavy rock became my new interest and I threw myself into listening to the likes of Deep Purple, Yes, Led Zeppelin and Jimi Hendrix. The 1960s were evolving into the 1970s. I grew my hair long and all we talked about at school was bands and music. *Sounds*, *Melody Maker* and *New Musical Express* were our bibles. There were a couple of bands formed in our year and I was desperate to join one of them. My Uncle Pete had given

PREVIOUS PAGE — The studio where the *Aladdin Sane* session took place. On the right is the mobile dressing room, where the lightning bolt "flash" was applied to David's face.

me his old Watkins Rapier electric guitar, but I soon abandoned it because I had no amplification and instead settled for a 12-string Eko guitar which I managed to save up for. I studiously learnt Bob Dylan and Woody Guthrie songs from songbooks I had purchased from Macari's in the Charing Cross Road, which had simple chord structures and the additional benefit of being able to sing along to even if you weren't vocally gifted.

But the sounds emanating from the Wharfedale speakers on that Sunday morning in January 1973 were different, very different. I needed to know more. So did I want to meet him ...?

On the evening of Tuesday, 9 January, I rocked up to Trident Studios in St Anne's Court, Soho, London. The studio was situated in a pedestrian walkway that connected Dean Street to Wardour Street, only a minute away from the legendary Marquee music venue where David would play in October that year. I would also play there two years later in the band I ended up in, called Bazooka Joe.

The front facade of Trident was glass so you could see in, but all that was visible was essentially a reception desk. I rang the bell and a studio runner behind the desk let me in. "I've come to see Duffy," I said, 'They're in there," he said, pointing to the door on the right of the desk. I knocked on the door and almost immediately it opened. There he was, David Bowie, the man who had magnetically drawn me to this special moment in time. He looked me up and down and said: "Who are you?" "I'm Chris, Duffy's son," I replied. "Duffy's son?" he said in a kind of questioning manner as if he had never considered that Duffy had any children. He paused a second while evaluating me then said: "Your father is a lunatic. Come in, come in."

The Trident control room was relatively compact and as I entered the room I clocked Ken Scott to my left, who was focused on pulling and pushing sliders up and down on the recording console. He was oblivious to my presence and focused on communicating with a guitarist behind the glass window wearing a large set of headphones and sporting a 1968 Les Paul Custom stripped-down Gold Top guitar. It was Mick Ronson, David's musical director and guitarist extraordinaire.

Duffy hadn't arrived and I felt like a fish out of water, but David was gracious and beckoned me to make myself comfortable on the brown leather sofa to the side of the recording desk. David refocused with Ken onto Mick and it became apparent that they were in the middle of recording the Rolling Stones track 'Let's Spend the Night Together'. Ken rewound the tape — the analogue howl of the Ampex tape being played in reverse is something now assigned to a past era. He had the studio speakers up at full volume. The song started and Mick Ronson began to layer the track with jagged guitar overdubs.

What an extraordinarily privilege that moment was, to be in Trident Studios with David Bowie, Mick Ronson and Ken Scott recording 'Let's Spend the Night Together' on the *Aladdin Sane* album that was to become David Bowie's launch to megastardom.

Duffy finally turned up, Ken and Mick took a break, and David began discussing ideas with Duffy about the upcoming photo shoot for the album. Duffy asked what the album was going to be called, and David replied: "A Lad Insane." Duffy instantly processed that and came back with "Aladdin Sane."

That moment perfectly reflected the creative process that David and Duffy had evolved, and so *Aladdin Sane* was born.

I was 17 when I first met David and he was only 26, but it dawned on me much later that he had already produced four impressive albums and was on a trajectory that would change the popular music industry. I realized that my talent and ability in music could never come close to what I had just experienced, and although I did pursue playing in bands for a while, I recognized that I would only ever be a mediocre musician and my best bet was to be behind a lens.

The *Aladdin Sane* photo shoot was hastily arranged, to be held at Duffy's studio on the weekend of 14 January. From conversations with David, Duffy knew that in one way or another make-up would play a central role in the final image, and he wanted the best make-up artist in town. Barbara Daly stood out as the obvious candidate. She had carved her way to prominence working with *Vogue* photographer Barry Lategan and was constantly breaking new ground. Barbara, however, was not available and Duffy was in a bind. On Wednesday, 10 January, just four days before the *Aladdin Sane* session, Duffy was shooting an advertorial commission for Elizabeth Arden, where the make-up artist was Pierre Laroche.

Duffy asked Pierre if he was available on the weekend. He was, and another piece of the jigsaw fell into place. Timing in life is everything, even more so because Duffy had recently formed a company called Duffy Design Concepts, a vehicle whereby he could have complete control on projects from the ground up, to include concept, design and photography. This commission from Tony Defries, David's manager, was a perfect fit.

Duffy had brought in a young designer called Celia Philo, who had worked with him a year earlier when shooting the Pirelli Calendar. Although Duffy was a brilliant draughtsman, having graduated from Saint Martin's School of Art in London, he tasked Celia with designing the double-sided song sheet that was to be part of the album. Duffy also brought in Philip Castle, the highly talented airbrush artist who had collaborated with him on the 1973 Pirelli Calendar. Defries had been extremely impressed by these images and the techniques they employed and the calendar became the blueprint that would drive the *Aladdin Sane* visuals.

A flash was the core element that David presented to Duffy. He had initially lifted the flash symbol from Elvis Presley and used it in an elongated, one-colour form as part of the live show background, as well as on Woody Woodmansey's drum kit skin. But how to develop that into a concept for a record sleeve?

In the kitchen of Duffy's studio lay a rice cooker his mother had given him. It was seldom used but it was the key that ignited the *Aladdin Sane* Lightning Bolt. A National Panasonic cooker, it sported a red and blue flash symbol, and when Duffy presented this to David both agreed that the colourway was perfect. A blue and red flash would be applied to David's face.

David had previously used a small tattoo-style anchor on his face at performances and Pierre initially tried to emulate a small flash in the same place — but Duffy took one look and told him to remove it. Grabbing a bright red lipstick from Pierre's make-up box, he began to draw the outline of a large

flash across David's face and then said: "Now fill that in." Interestingly, the *Aladdin Sane* make-up applied on that day was the one and only time David ever wore it. However, as difficult as it is to apply, fans worldwide are still seen adorning themselves with this make-up at Bowie gatherings and events. The blue and red flash has become the ubiquitous Bowie brand symbol, much like the Nike tick, instantly recognizable.

On Thursday, 6 July 1972, David Bowie shocked a UK audience with his appearance on the BBC programme *Top of the Pops* singing 'Starman'. He was dressed in a Freddie Buretti-designed jumpsuit, confidently owning the stage and draping his arm around his guitarist Mick Ronson, while looking down the camera lens, enticing the viewer to believe that he was singing directly and personally to them. It opened the door to an audience of young people who felt an immediate affinity with his bold and brazen attitude, blurring the lines of convention and sexuality. And now with *Aladdin Sane*, the visual impact of the album was immediate and again challenged the viewer in many ways. What was the message behind this surreal, kabuki-style death mask? It was brave and daring and asked more questions than it answered. Duffy unwittingly had created an image that would ultimately come to define both men's careers and legacy.

Much has been discussed and analyzed about the *Aladdin Sane* cover, not least the teardrop symbol on David's clavicle bone. This was solely of Duffy's fashioning and had, in fact, initially been inspired by a small brooch worn by our former au pair Sally Arnold when she came back to visit us (she was now working for Mick Jagger). The brooch was the Rolling Stones' tongue and lips logo designed by John Pache. Duffy was intrigued by it and realized that it was not only a brilliant design for an album cover but also a merchandising goldmine.

Duffy's initial idea was for the teardrop to become a piece of jewellery, but it eventually took on a different slant, directing Philip Castle's airbrushing in creating a Dalí-inspired, dreamlike water element — arguably representing emotion, with a phallic outline symbolizing sexuality. None of this was discussed with David and was Duffy's final artistic stamp on the work. In an interview years later, however, David commented on the teardrop, saying that he didn't quite understand Duffy's idea, but that it was "quite sweet".

I had started working in a photo processing lab in early 1973 and didn't start assisting Duffy until later that year, so I missed out on the *Aladdin Sane* photo shoot, but during that period before David went to America he would be a regular dinner guest. David had a polite and gentle manner, always a great sense of humour and a mickey-taking satirical edge that only the British understood — borrowed from the Goons, Peter Cook and Dudley Moore, and Monty Python's Flying Circus. It was obvious that he felt relaxed in Duffy's company. Neither man would accept mediocrity, and the time they spent together was a high-octane discourse in art, music, books, culture and the creative process. That's what made them work so well together; they had similar intellects, passions and interests and they fed off each other's creative energy.

Duffy said many times that to move forward you had to burn your bridges, and so it was on 3 July 1973 that David did exactly that. I was at the

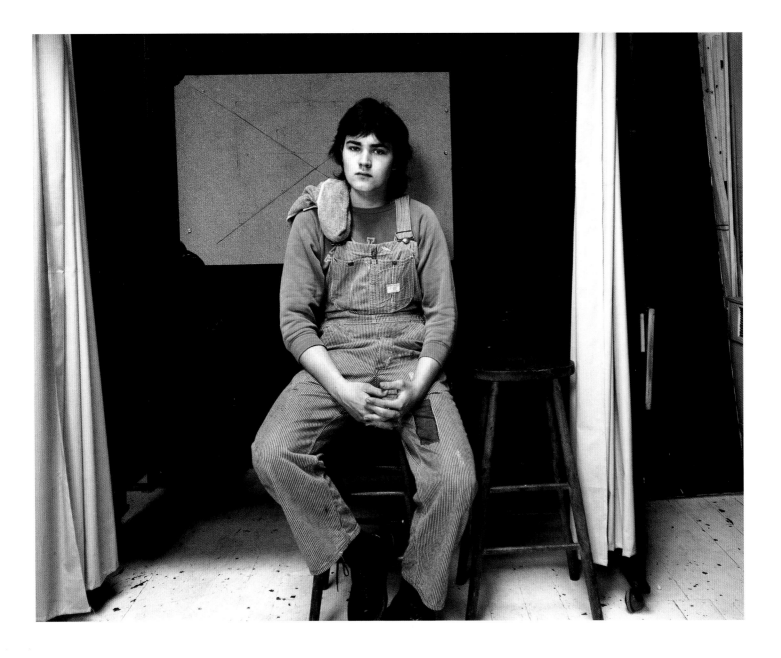

final Ziggy performance at London's Hammersmith Odeon when David abruptly killed off his Ziggy persona on stage — and like so many other David Bowie fans, I felt that the bright flame that had burnt so brightly was now being snuffed out prematurely. I had been personally connected to this journey, a bit player observing from the sidelines, and like so many others brought into the fold was now wondering where would it go.

Of course, Duffy's theory was right: killing off Ziggy allowed David to develop in new and exciting ways. The theory was to come full circle in 1980 when Duffy photographed David for the fifth and last time for the *Scary Monsters* album cover. Duffy himself burnt his own bridge by throwing his negatives on a bonfire and setting light to it all. I'm grateful that a neighbour complained to the council about the thick black acrid smoke produced from burning plastic film and Duffy was forced to put the fire out, saving his images from complete obliteration.

ABOVE — A young Chris Duffy, sat in front of the portable dressing room where David's make-up was applied.

In one way or another, David Bowie has always been in the background of my adult life, constantly creating and attempting to push the boundaries of what is possible. Like all great artists sometimes producing works of brilliance and other times not, it's the risk any artist takes to pursue a new frontier. We all have our favourite Bowie periods and albums, but as we moved into the twenty-first century David's career had, to some degree, taken a back seat and it wasn't until the 2013 Victoria and Albert Museum's David Bowie Is exhibition that Bowie exploded back onto the scene.

The image that was chosen to spearhead the exhibition was an outtake from the *Aladdin Sane* session, an "Eyes Open" image first released in 2010 in Kevin Cann's book *Any Day Now*. The exhibition toured the world and was seen by over 2 million visitors. The Duffy Archive loaned the V&A the original dye transfer print that's considered to be the mothership: every reproduction of the image — be that on clothing merchandise, badges, bags, etc. — traces its lineage directly back to this single print, which I once described as the *Mona Lisa* of Pop.

The *Aladdin Sane* image has become internationally ubiquitous, inspiring artists across the globe. It is considered by many as a cultural icon and 50 years on it looks as fresh and contemporary as the day it was released. Today, it is in the permanent collection of both the Victoria & Albert Museum and the National Portrait Gallery in London.

I have lived with this image in a very special way for many years, and I recognize what an unparalleled privilege it is to be a gatekeeper to such an influential and important work of art. I can imagine that the image will continue to bring pleasure and inspire future generations to push the boundaries of their artistic endeavours.

No artist lives in a vacuum: all are influenced by other creatives, but producing work that sets one apart from the pack is a rare and unique gift. David was a master at identifying other people's talent and harnessing it to bring his own ideas to fruition, creating something new and unique. In compiling this book for the 50th anniversary of *Aladdin Sane*, I have borrowed from David's method in harnessing the talents and insights of a group of extremely talented contributors, to whom I am extremely grateful, to give a broader insight into what is surely one of the most influential rock/pop albums of all time, and also into producing an image considered a cultural icon.

Duffy passed away in 2010 and David sent me a heartfelt email with his condolences. Then, sadly, David passed in 2016. I would like to think that this book would win the approval of both Duffy and David.

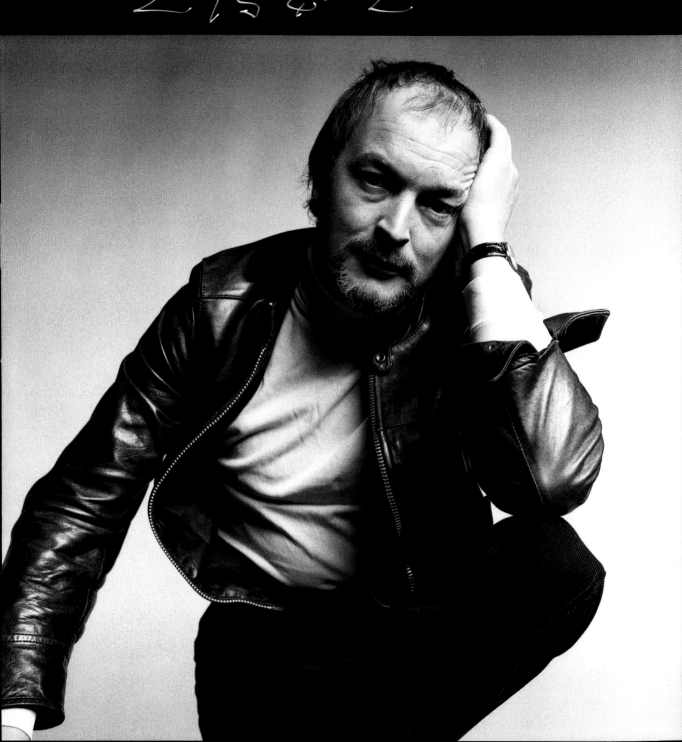

DUFFY:
THE GREAT
ESCAPER

GEOFFREY MARSH

(A) SUPREMELY TALENTED AND ESOTERIC MAN ... A MAN WHO THRIVED ON RISKS AND CHALLENGES, WHO LIVED TO CREATE.

LORD DAVID PUTTNAM,
DUFFY'S ONE-TIME AGENT

IF you have an hour spare and want to discover Brian Duffy's life in detail, go to YouTube and watch *The Man Who Shot the 60s* (2010). This TV biography, directed by Linda Brusasco, was released just before his death aged 76. But if you have some more time spare, take the new Elizabeth Line to Tottenham Court Road station, stroll south past Denmark Street, once London's "Tin Pan Alley", to 107 Charing Cross Road and walk into Foyles bookshop. Ignore the piles of new bestsellers, shut your eyes and imagine a warren of utilitarian 1930s corridors and classrooms full of students. This was Saint Martin's School of Art until 2011, one of the engine rooms of British art and design training. Fast backward to 6 November 1975, and the Sex Pistols are playing their first gig supporting Bazooka Joe. Playing guitar with the latter band will soon be one Chris Duffy, Brian's oldest son. Then turn the clock back further to the dynamic late 1960s when Gilbert and George, Richard Long and Bill Woodrow were all students — and finally stop at 1950. There is a truculent lanky teenager standing there, it's a 17-year-old Brian Duffy just about to start on the art course.

Like so many Londoners with an erratic and troubled wartime education, Duffy might have left school at 15 and gone straight into manufacturing work. Given his temperament, one can imagine him as a frustrated shop steward goading a succession of reactionary managements. Fortunately, in the era when the welfare state was being established, with some prodding from teachers keen to encourage ordinary kids to take an interest in the arts, Duffy was able to escape a dead-end job. Instead, he discovered a career which allowed him to explore and exploit his varied creative abilities. Fired up by visits to London galleries, and enjoying painting, Duffy applied to Saint Martin's. He won a scholarship, but he soon abandoned the highly competitive art course, where Frank Auerbach was a contemporary, and moved to the fashion design department, whose concentration of female students was an added attraction. For an evocation of Saint Martin's and the surrounding Soho a few years later, watch the exploitation movie *Beat Girl* (1960), with Gillian Hills as the Saint Martin's student.

In the 1950s, after working for a variety of fashion designers, Duffy moved into photography, eventually working at *Vogue* from late 1958 until striking out on his own in 1963. With his working-class credentials burnished by ability, ambition and a degree of arrogance, he was part of the generation, along with David Bailey, who changed photography. Duffy later explained: "Before 1960, a fashion photographer was tall, thin and camp. But we three [Bailey and Donovan] are different: short, fat and heterosexual. We were great mates but also great competitors. We were fairly chippy and if you wanted it you could have it. We would not be told what to do."

Inner London was changing too. Among the Modernist council estates rising on all sides were the first signs of inner city "gentrification", a term coined in 1964, with campaigns to preserve Victorian landmark buildings. Landlords started selling up their decaying blocks of bedsits for restoration as "period" properties. As these changes began, Duffy secured the lease on a former stained-glass workshop for his studio at 151a King Henry Road, NW3. It was No. 3 because there were two smaller photo studios at the back.

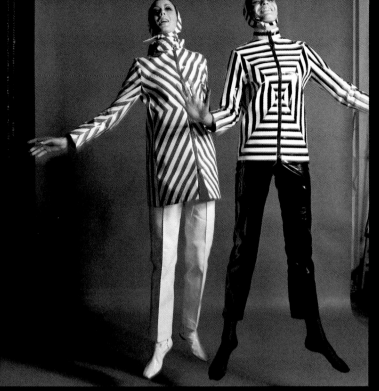

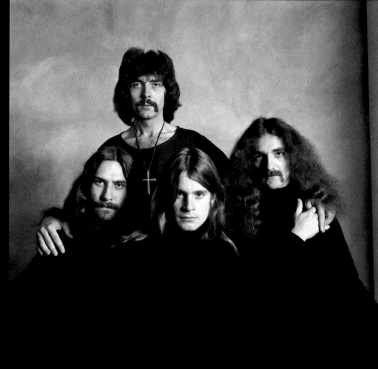

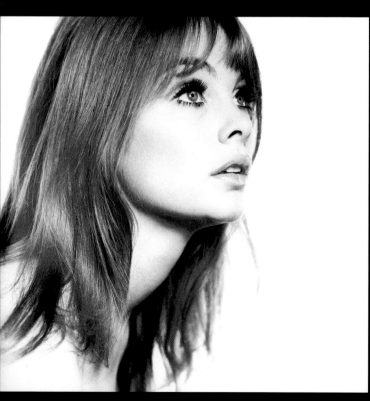

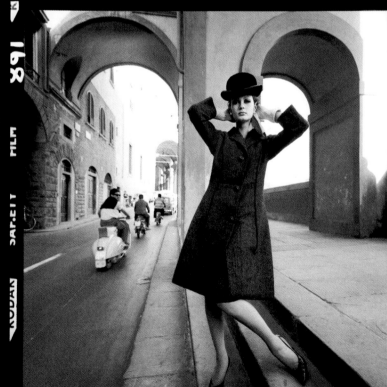

ABOVE, CLOCKWISE FROM
TOP LEFT — Moyra Swan and
Verushka von Lehndorff, *Queen*,
1965; Black Sabbath, London, 1973;
Ponte Vecchio, Florence, *Vogue*,
1961; Jean Shrimpton, London, 1963.

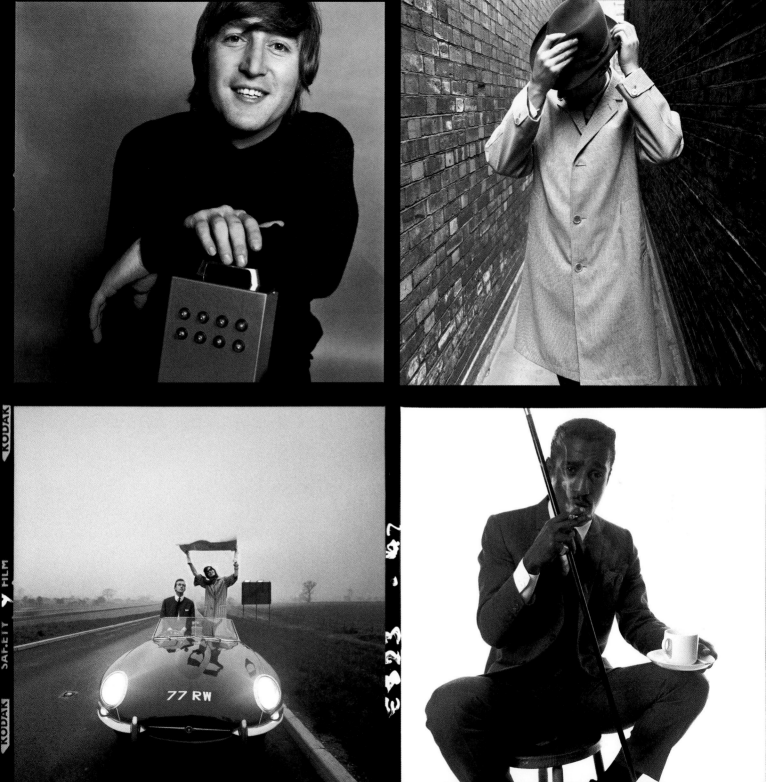

ABOVE, CLOCKWISE FROM
TOP LEFT — John Lennon with
UFO detector, London, 1965; Man in
Alley, Aquascutum, London, 1960;
Sammy Davis Jr, London, 1960;
E-Type Jaguar on newly opened M1
motorway, 1961.

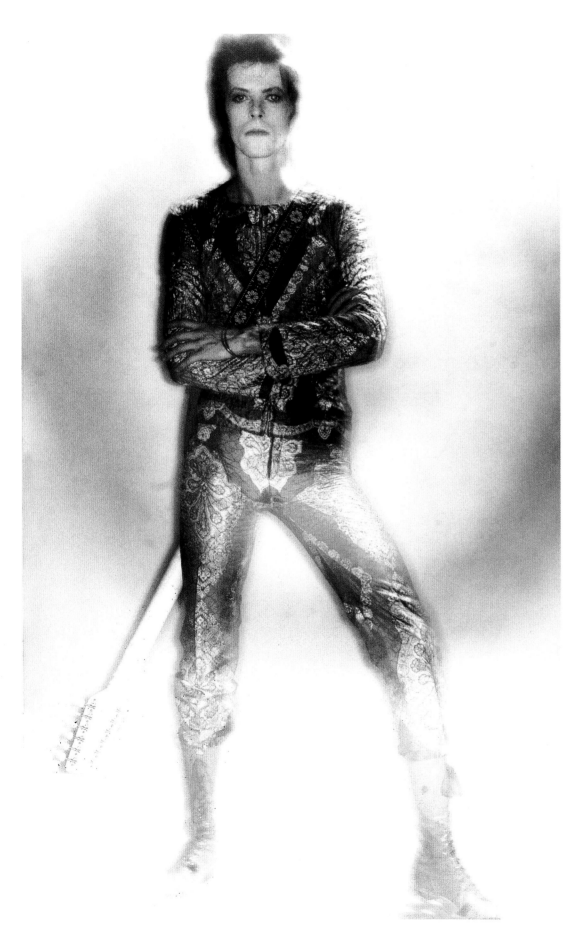

PREVIOUS PAGE — French *Elle*, Pret à Porter, Paris, 1977.

LEFT AND OPPOSITE — Duffy's first photographs of David, 1972. These images have never been published before.

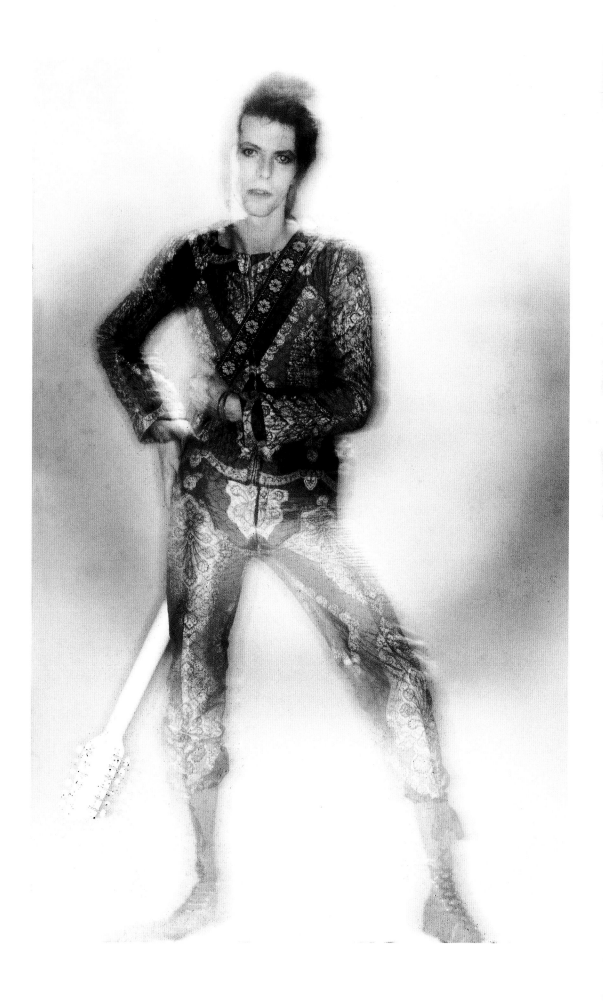

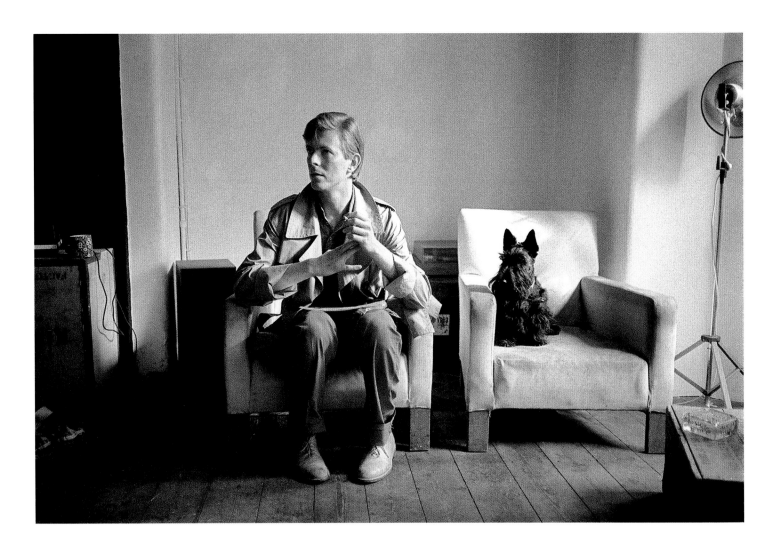

ABOVE — David attends a meeting in an unknown office in Soho, 1979.

OPPOSITE — Richard Sharah applies David's make-up for the Scary Monsters session, with costume designer Natasha Kornilof, in Chris Duffy's studio, 1980. A copy of *Lodger* can be seen on the shelf.

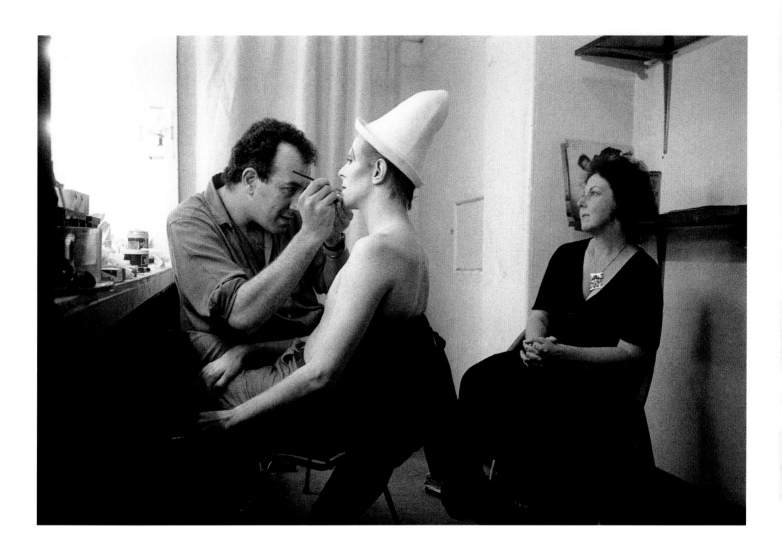

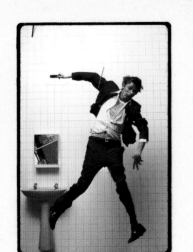

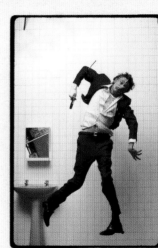

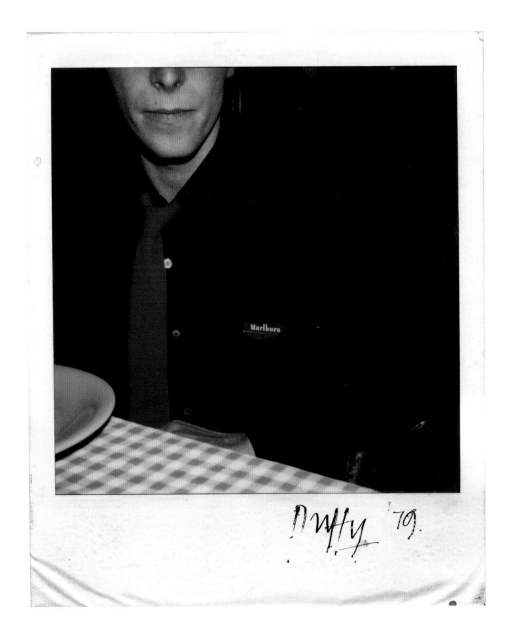

David Bailey was a couple of streets away at 177 Gloucester Avenue. Terence Donovan, the third of the trio Norman Parkinson termed affectionately "The Black Trinity", was a regular visitor. Arnold Newman took a revealing shot of the three in February 1976, with "Top 3" scrawled on a board in the background. Soon inner London would begin rapidly to change as middle-class professionals realized they could make a financial killing paying maybe five or ten thousand pounds for properties that are now sold for millions. However, for the moment, cultural wars lay in the future as the 1960s saw a successful social revolution — gay sex partially decriminalized in 1967, equal pay promised in 1970, the race relations acts of 1965, 1968 and 1976.

Meanwhile, Brian Duffy built up his successful photographic practice mixing advertising work at £300 a day with fashion shoots, more interesting but less remunerative, at £150 a day. He also photographed famous personalities, including Harold Wilson, Reggie Kray, Sammy Davis Jr,

PREVIOUS PAGE — Original Kodachrome transparencies showing outtakes from the *Lodger* session.

ABOVE — A Polaroid of David at lunch with Duffy.

Michael Caine, Tom Courtenay, Nina Simone, John Lennon, Sidney Poitier, Charlton Heston and Brigitte Bardot. It was photography liberated by the rapid evolution of 35 mm SLR cameras, at a time when digital lay far in the future. The cameras used physical rolls of film, which usually meant a wait of at least a couple hours for developing before it was possible to see the first results of a session. During 1967/68 Duffy took a detour into the British film business, and among his credits are serving as producer with the novelist Len Deighton of *Oh! What A Lovely War* (1969), directed by Richard Attenborough. Bowie was auditioned for the film but did not make the cast. However, if you watch carefully, you can see his then girlfriend, Hermione Farthingale, in the Edwardian music hall chorus. Early in 1973, Duffy photographed the hugely successful Black Sabbath with a demure-looking Ozzy Osborne. He could handle everyone from the prime minister to rock bands, but what about David Bowie?

Duffy was a creative force of many and wide-ranging interests. He always enjoyed woodworking and in 1979 made another escape. He suddenly gave up photography completely to retrain and work as a furniture restorer, in the process destroying part of his archive. By then Chris Duffy, his son, was a successful photographer in his own right. Perhaps Duffy felt having another photographer in the family meant he could move full time into another of his interests. Despite the "Black Trinity's" huge impact and success, they had their problems. Seventeen years later, Donovan committed suicide in 1996 aged just 60. David Puttnam, for a while Duffy's agent, summarized his broader significance as part of the progressive, free-thinking wave of rebels that helped create a more liberal, inclusive and accepting Britain:

> Brian was far more than a gifted photographer; he was a uniquely constructive "social anarchist" who, through sheer force of personality, helped push the stultifying conservatism of the 1950s into permanent retreat. They may not know it, but every participant in what today would be referred to as the "creative industries" will be forever in his debt. Being around Duffy could be explosive and even alarming; but it was never, ever, dull. He questioned the validity of everything and was courageous enough to challenge just about every received convention he ran up against. In some, that can be an insufferable trait, but in Duffy it was nothing short of inspirational; it allowed those he influenced to develop the type of informed self-belief that can move mountains.

In January 1973, he looked through his Hasselblad lens at another escapee, this time from British suburban mediocrity, who was also to reshape the country's cultural and social values. They might have scrapped, they might have fought, but working together, as the shutter clicked, something remarkable was created.

But for the moment, let's end with David Puttnam's summary of a remarkable Londoner, Brian Duffy: "Irreverent, loving and irresistible".

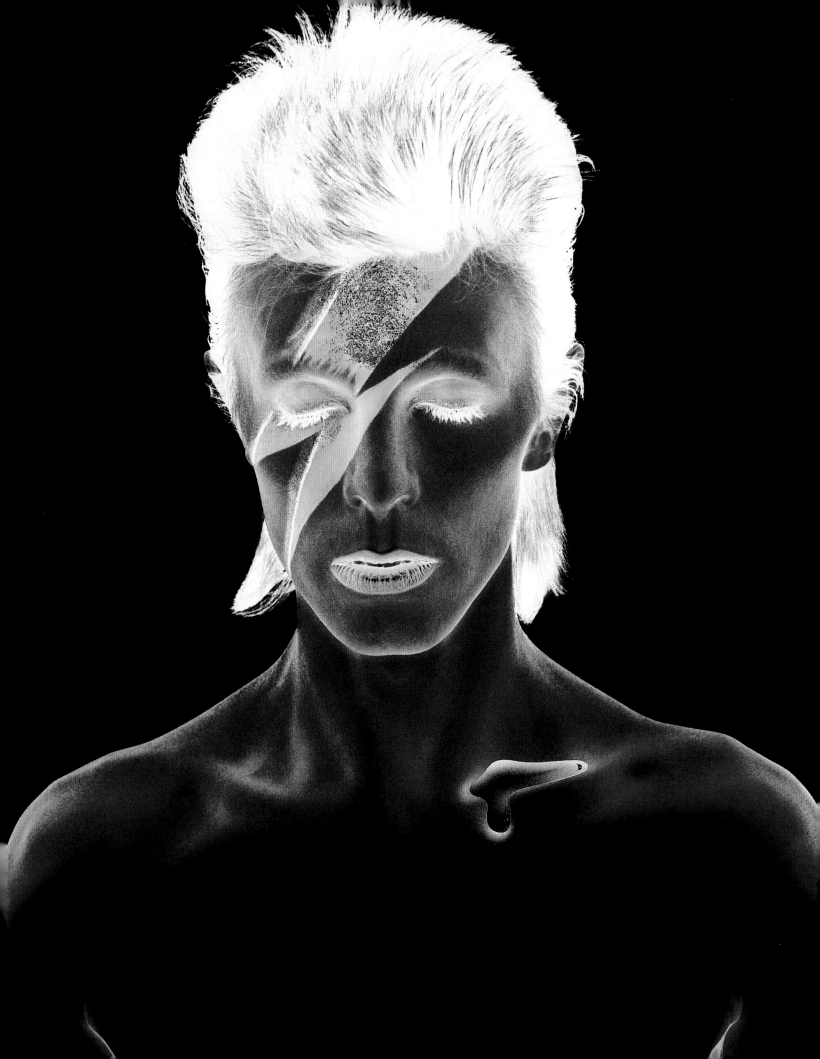

THE ALADDIN SANE shoot

GEOFFREY MARSH

who could imagine that the MOMENT DUFFY clicked the shutter on the hasselblad in early 1973 that one of those IMAGES WOULD become known as a CULTURAL ICON?

A FEW HOURS IN NORTH LONDON

How does great art happen? *Billboard* magazine ranks *Aladdin Sane* at No. 25 on their 2015 list of "The 50 Greatest Album Covers of All Time", while *Rolling Stone* magazine ranked it No. 48 on their 2016 list of "100 Greatest Album Covers". The differences in the content of their overall listings shows how subjective such choices are. However, the leading British graphic designer Jonathan Barnbrook considers *Aladdin Sane* "one of the greatest album covers of all time". Since he designed the last four of Bowie's albums and studied all of them in forensic detail, his opinion is certainly worth taking seriously. However, the word *greatest* begs the question: "*Greatest at what?*" Selling an album? (This is usually the record company's view.) Communicating the contents? (The designer's view.) Highlighting the artist? (The performer's view.) Or creating a powerful emotional connection? (The purchaser's view.) Plus, lurking in the background are super critical journalists, tight-fisted accountants, ambitious marketeers and, watching over everything, the public censors. It is always difficult to meld these disparate requirements into a coherent design, particularly when an artist's previous albums may have defined a particular communication style. *Aladdin Sane* is certainly one of the greatest album covers, and this chapter considers the various cultural currents that came together in January 1973 to create it.

On Saturday, 13 January 1973 — a date confirmed for the first time recently by Kevin Cann — half a dozen people gathered in 151a King Henry's Road, a few minutes' walk from Swiss Cottage tube station in north London. Inside the building, the photographic studio of 39-year-old Brian Duffy, history was about to be made. Given the skills of the participants, a good outcome seemed probable, but an exceptional one? That was perhaps less certain. How did that magic dust arrive?

Walking along King Henry's Road today, you will pass expensive cars and chic apartments, so it's worth remembering how different the streets were 50 years ago. The whole area between Primrose Hill and Swiss Cottage had been blighted in the late 1940s by a post-war plan to construct a "motorway box" circling through inner London. Here, in the northern section, it would have been routed along modern Adelaide Road. Toward the east was bomb damage from Luftwaffe attempts during the Second World War to destroy the railway lines heading out of Euston. Many of the rundown former Victorian family houses had been split up into cheap rented bedsits. The area was described by Eugene Manzi (owner of the nearby Manzi Records, then one of the hippest record stores in London) as a "Bohemian and working-class neighbourhood with artists and students, immigrants and small factories", a world away from what it has become today. Songwriter Al Stewart, who arrived in the capital in 1964 and rented a bedsit in Swiss Cottage, said: "I came up to London when I was 19 with a corduroy jacket and a head full of dreams." He captured the late 1960s vibe in his song 'Bed Sitter Images', describing the loneliness of staring around a small room with a worn carpet and cracked window while the last train rattles away into the distance. These lyrics probably chimed with David Jones, then living in a

two-up two-down 24 km (15 miles) away, next door to Sundridge Park railway station among the sprawling suburbs of south London.

After the motorway scheme was abandoned, much of the property was bought up and then demolished by the recently created Camden Council. Here, they erected the huge Chalcots Estate to rehouse thousands of people displaced by slum clearance in Camden Town. As Brian Duffy walked to his studio in 1973, the five looming 23-storey tower blocks would have been completed only a few years earlier.

In the wider world, Edward Heath had been elected Conservative prime minister in 1970 and the British coal industry still employed 250,000 workers. An underground miner, following the seven-week miners' strike in 1972 and the associated "three-day week" power crisis, earned £27.29 a week in the new-fangled decimal currency. Two weeks earlier, on 1 January 1973, the United Kingdom joined the European Union. Changes were certainly underway.

THE CREATIVE TEAM

Tony Defries was the instigator of this ground-breaking session, the éminence grise of developing and projecting Bowie as a star. Defries has been heaped with such opprobrium over subsequent years that it is difficult now to appreciate what a dynamic force he was in the music business in the early 1970s. As a trained solicitor, Defries became increasingly involved in the music business, initially through helping photographers secure what would now be termed their intellectual property rights. In 1968, he helped establish the Association of Fashion and Advertising Photographers (now Association of Photographers). In 1969, he became directly involved in music by establishing the GEM Music Group, from 1972 MainMan, as a broad-based popular music management company. Convinced of Bowie's potential, he extracted David from his existing contracts and became his manager through to 1975 when they fell out over his contract. Defries was certain that David's unique talents could make him a global star, although he also chased after other musicians including, unsuccessfully, Stevie Wonder.

With David's rapid rise to stardom through 1972, Defries planned for total success in America. A May 1972 tour had to be pushed back until September, which allowed Defries to promote David on the back of *Ziggy Stardust*. The next album would be crucial to consolidating David's star status and Defries was already planning the next American tour for January 1973, followed by dates in Japan. This meant that David would be back in Britain for only about five weeks around Christmas. Apart from playing eight UK dates, recording for *Top of the Pops (TOTP)* and making other recordings, David had to fit in wrapping up *A Lad Insane*, the working title of his sixth studio album which had a release date pencilled in for mid-April. By then David would have finished touring America and would be in Japan, so something exceptional was needed to follow on from the success of *Ziggy Stardust*, which had shifted close to 200,000 copies in six months. There was only a narrow window of dates to photograph David in London if the new cover was to honour Bowie's insistence on using his own image to promote his albums, whether it involved others or not. Although Defries was

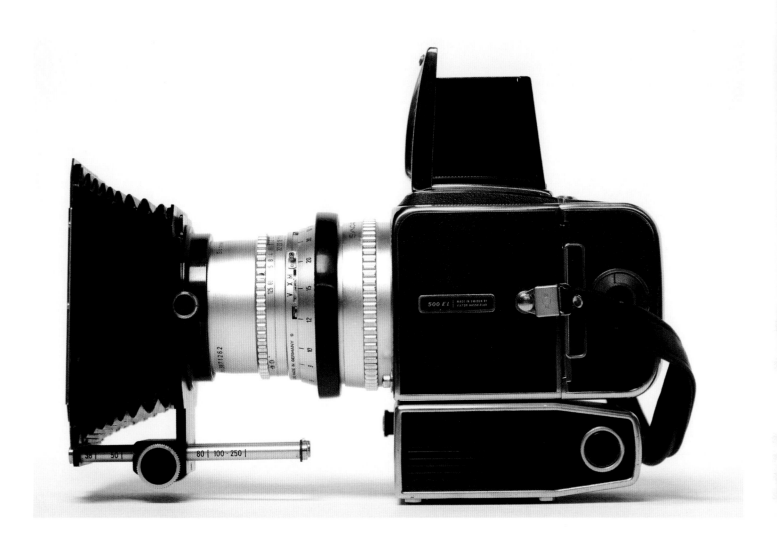

ABOVE — The Hasselblad 500
EL camera used by Duffy for the
Aladdin Sane session.

OVERLEAF — The exterior of
Duffy's north London studio on
King Henry's Road, NW3.

thinking big — he planned to use television adverts for the first time
to promote the album — he was also thinking very carefully. Bowie's claim
"I'm gay and always have been" in January in *Melody Maker* was a useful
attention-grabbing ploy in the emerging UK glam rock scene of glitter, make-
up and sexual ambiguity. However, it was a much trickier proposition for
the sexually conservative America stretching out beyond the liberal cities on
either coast.

Through his legal work, Defries had come into contact with the leading
photographers in the Swinging London of the mid to late 1960s. In summer
1972, he had asked Brian Duffy, David Bailey and the Japanese Masayoshi
Sukita to shoot David arrayed as Ziggy Stardust to expand the portfolio of
official photographs, normally taken by Mick Rock. Duffy's photographs of
Ziggy in his Freddie Burretti-designed quilted multicoloured outfit, as
seen on TOTP, remained unused. However, his slightly blurred, full-length,
assertive poses of Bowie convinced Defries that Duffy could deliver high
quality, intriguing and media-appealing images. Plus, with MainMan's
expenditure mounting, Defries needed to get RCA to invest heavily in his
star. As has become rock folklore, Defries' solution was to aim to create the
most expensive album cover possible, a gatefold using an extremely expensive
seven-colour printing technique. Defries recalls:

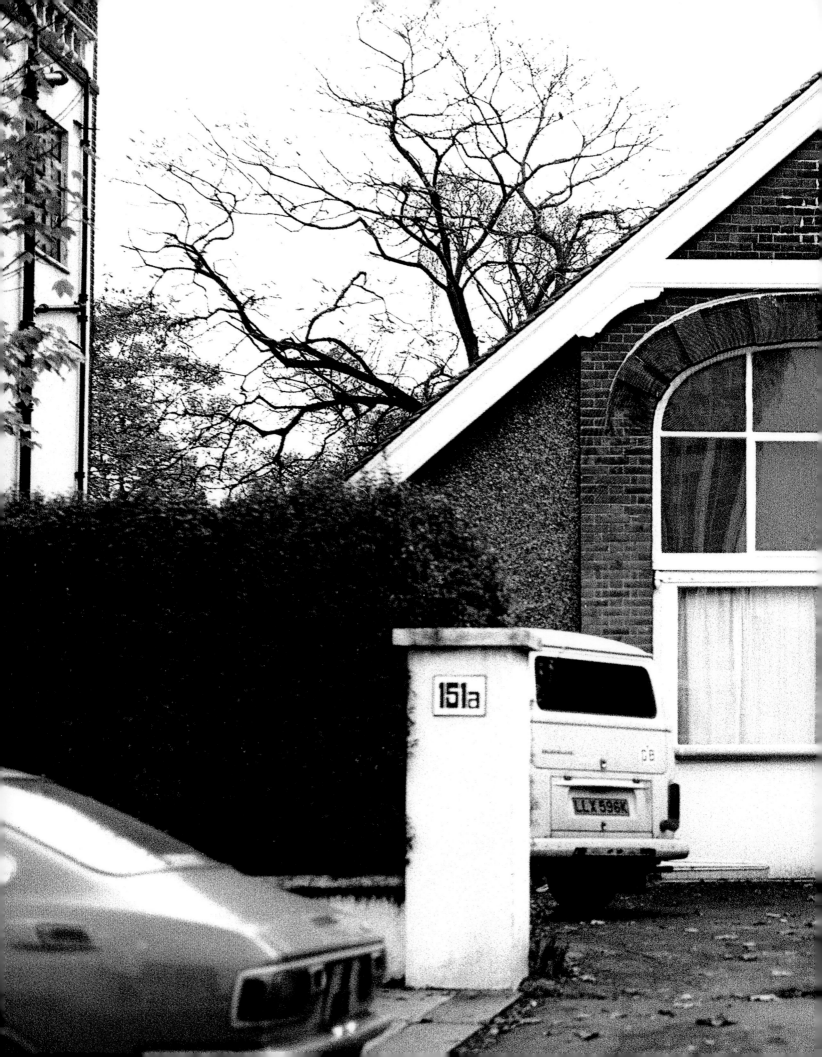

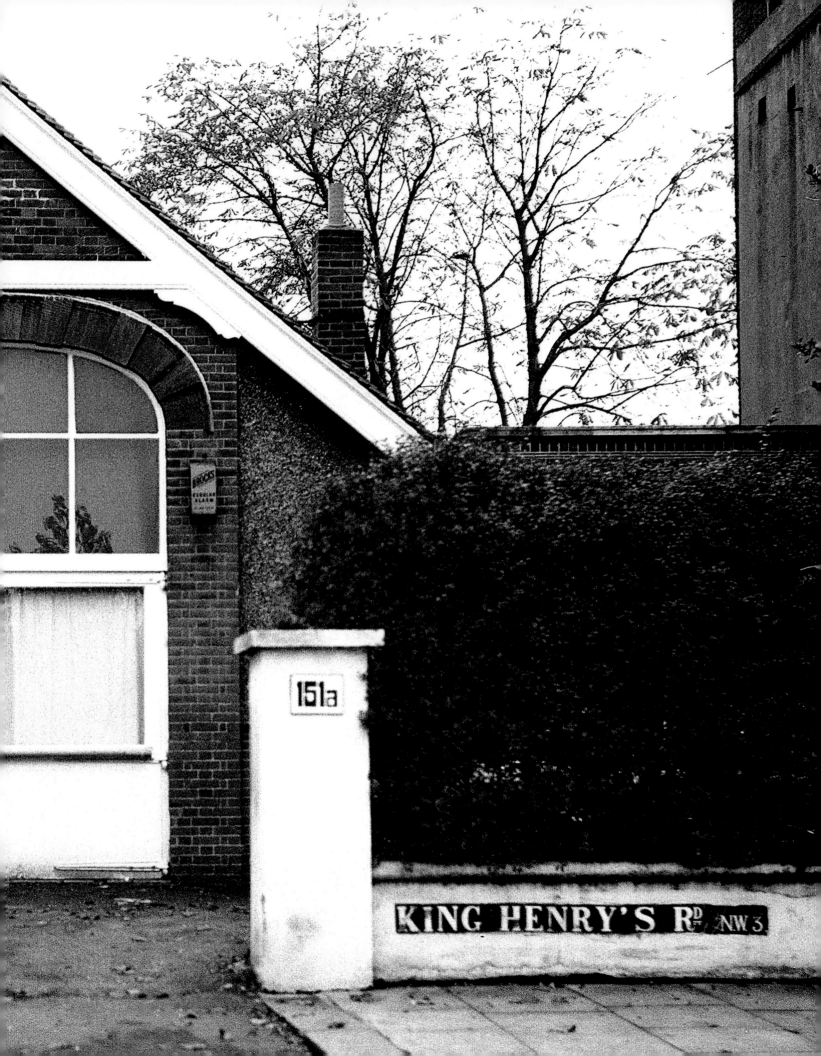

It was my plan to make Bowie a unique and absolute global megastar — the strategy included persuading RCA to support substantial long-term financing for personal appearances, marketing, PR, branding and advertising, including the then unheard-of suggestion that commercial TV spots should be made and used in the campaign for a specific artist/album. Historically, record companies at that time had never supported that type of TV marketing campaign or spend on an individual artist, much less on an individual album. I was looking for an iconic cover image and artwork that would help me to persuade RCA that Bowie was sufficiently important to warrant megastar treatment and funding in order to propel him to exactly that status. Engaging a master, world-class photographer to shoot the product brand and to design the artwork was the best way to send that message.

Duffy was happy to oblige and remembered:

> Defries said: *Can you make it expensive?* And I said *No problem, old love.* Using my experience on having done the previous Pirelli Calendar, which I realized that cost a few bob, I thought we'd utilize some of the same techniques. Some of the aesthetics. I like the fact, or Tony liked the fact it was going to cost more money. I proposed: (1) A dye transfer. A dye transfer is a genius method of being able to spend the most amount of money to get a reproduction from a colour transparency onto a piece of paper. (2) Get the plates made, where? Switzerland, the most expensive place in the world to get plates, then to employ me to design it and create it, even better and more wasteful. Then we went to Conway's, who were the most expensive typographical house. *More money?*

It's not known how much Defries and David discussed the specifics of the cover. One awaits a hoped-for account by Defries himself one day. However, Defries was shrewd enough to realize that, if the two men were left to their own devices, David's imagination and Duffy's technical skills could potentially create something haunting, innovative and, most importantly, unique.

By January 1973, his recent success and Defries' promotion meant that David Bowie was used to the trappings of rock stardom, the limos, upmarket hotels, expensive restaurants and waiting assistants. A photo shoot was nothing new and Bowie seems to have trusted Duffy, so as far as is known; there were no special props, costumes or other equipment brought into the studio. It is probable that everybody had agreed that the cover would be based around a close-up of David's face as with his previous albums apart from the elaborate stage set for *The Man Who Sold the World*, photographed at Haddon Hall, and the Heddon Street shot for Ziggy Stardust.

The third key player was Brian Duffy himself. Having photographed Bowie a few months previously and with a deep interest in popular music, he was well placed for the assignment. He was at the top of his game — and he knew it. If the shoot was not the meeting of equals, it was the opportunity for two intensely curious individuals to spar. Through his fashion work, Duffy was well experienced in working with distinctive faces, unusual gestures and unnatural poses, so he wasn't fazed by the challenge of capturing a new and unexpected image of David.

An important aspect of the shoot was that Duffy had agreed with Defries that he would design the whole album packaging, including the insert for the lyrics — more expense — rather than just shooting the front cover. He had recently established Duffy Design Concepts with the young designer Celia Philo, who recalls:

> I seem to remember that we had a couple of conversations with David, but I don't remember meeting him before the photo session. He sent me all the lyrics. When we got the lyrics, we started to think about what kind of image we wanted to use and because of the title, and 'The Jean Genie' reference, we decided we wanted to use the naked torso and lots of airbrushing. When David came along for the shoot, I remember we had an enormous layout pad to work on. We sat around it with David and Defries. I don't remember having too many preconceived ideas before the actual session, but I remember that it was David who suggested and was talking about the possibility of using a lightning flash. That is 100%. We were drawing lightning bolts, not necessarily over his face, but across his torso, similar to how the inner sleeve looked.

Also in the studio was Pierre Laroche, a make-up artist, who sadly died aged 45 of AIDS in August 1991. Brought up in Algeria, he was attuned to the use of kohl by heavily made-up Arab women. Laroche moved to London to join Elizabeth Arden before working for Bowie in 1972. He helped develop the look of Ziggy Stardust, and in 1973 he spoke about his work with Bowie: "He has the perfect face for make-up. He has even features, high cheekbones and a very good mouth. I have to be very careful, though, because his skin is very fine and some of the base powders that I use are very strong. They can make that face quite soft." After Bowie settled in America, Laroche designed innovative make-up for other projects including, in 1975, advising on the transformation of the heavy make-up of *The Rocky Horror Picture Show* for its film version. He then joined the Rolling Stones for their theatrically driven Tour of the Americas '75 as Mick Jagger's make-up artist.

The shoot

The final person at the shoot was Francis Newman, Duffy's studio manager, annoyed that he was being made to work at a weekend. Fifty years on, he still remembers the day.

> I remember the *Aladdin Sane* shoot very well. There was Duffy, Celia, Defries, Pierre Laroche and myself as the studio manager. I used to make Duffy nervous, if I stood behind him while he was at the camera, so although I would make sure that everything was ready and set right, I didn't stand and help him take the shots. I might load the film as well, that kind of thing. But I would tend, when he was shooting, to be in the little studio office at the front of the building. They spent the first couple of hours in Duffy's office at the other end of the corridor, talking through ideas and whatever. Every now and then, Bowie would amble down the corridor to have a fag outside the front doors, about every 20 minutes or so. Every time he came down, I came out and

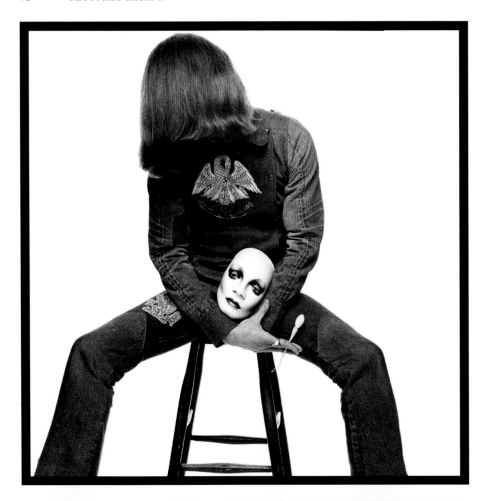

LEFT, ABOVE — Portrait of make-up artist Pierre Laroche by Duffy, 1973.

LEFT, BELOW — Celia Philo, designer at Duffy Design Concepts, in the garden of the King Henry's Road studio, August 1972.

OPPOSITE — Studio manager Francis Newman outside the King Henry's Road studio, April 1972.

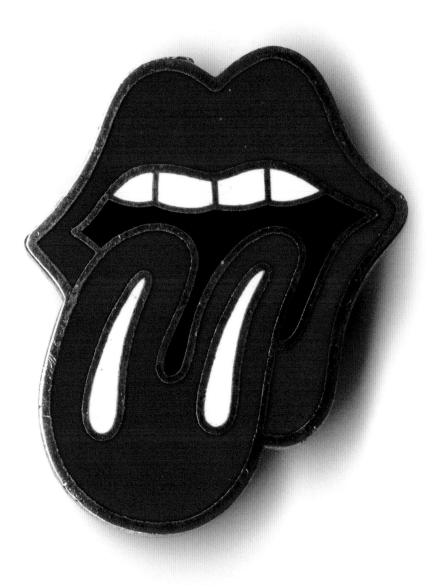

had a five-minute chat with him. It was very warm, sunny day. I remember we commentated, commented on it when we were outside talking. I do remember his piercing blue eyes very well, and just what a nice bloke David Bowie was … I remember also how yellow his teeth were from smoking.

The origin of the flash, where it came from and whose idea it was, has been recounted so many times that it has taken over from the remarkable impact of the final image and the fact that Bowie never wore it on stage. It was, literally, a flash in time which has remained forever. Probably, there is an element of truth in everybody's account. Chris Duffy has stressed Elvis' use of the lightning flash as part of his Taking Care of Business logo and Brian's interest in the Rolling Stones tongue and lips logo, with its powerful sense of rebelliousness — as well as some assistance from a certain Panasonic rice cooker, a recent introduction in Britain as the device had only been invented in Japan in 1955. Panasonic's identity was also prominent in the media at the time as, in 1970, the company had unveiled the largest neon sign in the world in Hong Kong, a giant version of their National flash logo. However,

ABOVE — The brooch given to Duffy by former au pair Sally Arnold.

this was in red and white and their logo seems to have usually been in this colour combination, or black and white. So it is less clear where the blue colouring came from.

Chris Duffy discussed the session with his father and records:

> David always had this flash element idea from the beginning. I think what made David and Duffy work so well together was the fact that David knew he could throw something abstract like that at Duffy and Duffy would interpret it and come up with something brilliant

Francis Newman adds:

> I wasn't actually party to the discussion about the flash on the face, so I can't say if it came off this rice cooker. In the studio, we had a sort of mobile make-up table with mirrors on it and on wheels so we could shift it around the studio. I remember David sitting in front of that with Pierre Laroche, and they had obviously talked about using this flash. Well, Pierre started to apply this tiny little flash on his face. And when Duffy saw it, he said: "No, not fucking like that. Like this" and literally drew it right across his face and said to Pierre: "Now fill that in." It was actually Duffy who did the initial shape — I'm not saying he did the actual make-up. It then took Pierre about an hour to apply properly. The red flash is so shiny because it was actually lipstick.

What is certain is that the colour images were taken with a Hasselblad EL500 on Ektachrome 120 film using a ring flash. The lighting, combined with the film, gave the images a slightly blueish tinge which contributed to the isolation of the figure. Duffy would have usually used Kodachrome, but in an era of chemical photo developing that would have taken longer. Time was of the essence and the film was sent for processing at Morgan and Swan in Parkway, Camden so that the results could be seen on Monday.

The photo session probably finished around four in the afternoon, and that was the end of David's direct involvement. However, as soon as the developed coloured transparencies had been received back, there was the choice of which image to use and how to enhance it further. The contact sheets show a wide variety of heads poses, look to the left, straight on, arms hidden, arms clasped around the neck. However, even a cursory glance shows the enigmatic power of the straight-on image with the arms hidden. But who made the decision to choose the "eyes shut" over the "eyes open" version, famously shown on the front cover of the V&A's David Bowie Is exhibition catalogue? Duffy was short of time and needed to get an image printed up as quickly as possible and sent across London to Philip Castle's studio in Fulham. He would do the silver airbrushing both to the cover image and the standing version on the inside. I have both images — eyes closed and eyes open — hanging together on a wall, and my sense is that Duffy was confident enough in his understanding of Bowie's ambitions that he decided on the eyes shut version with its air of enigma and alien distance. This also avoided the viewer focusing on David's differently coloured eyes.

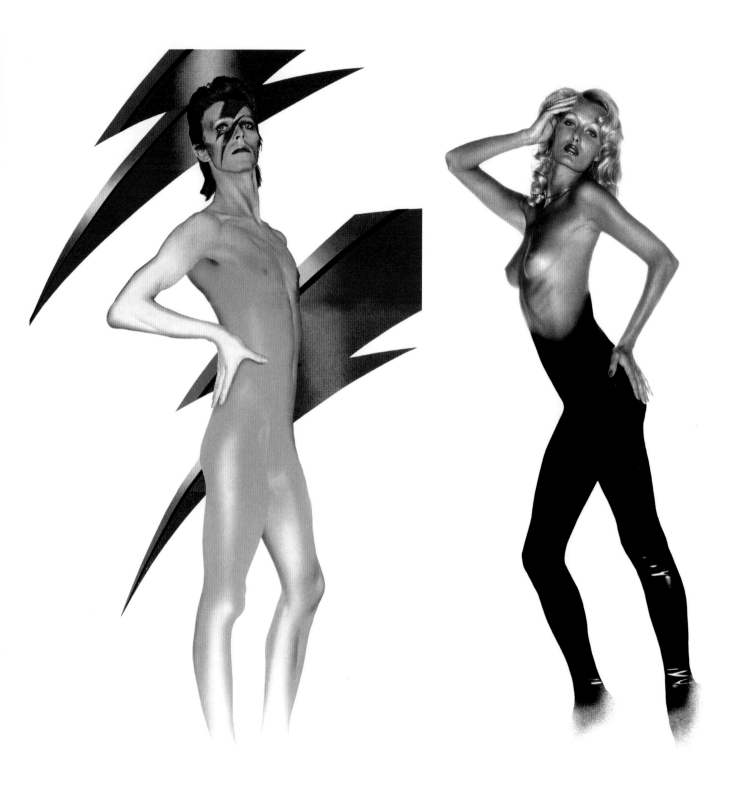

OPPOSITE — Artwork by
Philip Castle for the poster for
Stanley Kubrick's adaptation of
A Clockwork Orange.

ABOVE — A composite of Castle's
work showing the *Aladdin Sane*
album artwork (left) and his earlier
collaboration with Duffy on the
1973 Pirelli Calendar (shot in 1972).

July 3rd 73

Hammersmith
Odeon

make up.
Pierc
Laroche.

Bowie & spiders
Last concert
ever

I selected and decided
to call all lad insane
all adm sane . and
The flame symbol over
The I.

It was at a point in post-production that Duffy asked Philip Castle to add the "teardrop" on Bowie's left collarbone. Celia Philo recalls, "my recollection is that, apart from posing David and taking some spectacular photos, Duffy was obsessed with getting the airbrushing done, having that pool of water caught on his collarbone. I think he felt it added a kind of surreal, arty touch to it. Personally, it didn't really do anything for me in that it probably wouldn't have been there had it been left to me. That was very much Duffy's idea, and there it is." As has also been noted, a close examination of the image shows that Castle had to rework the lightning bolt to make it match across David's face, as well as put extra mascara on the eyelashes. Conway typography then added "David Bowie" and "Aladdin Sane", for the record, in a French decorative typeface, Rémy Peignot's Cristal (Deberny & Peignot, 1953), with a blue-white-red gradient. As referenced by his son Chris, Duffy's notes from 1973 record that he made the decision to change the title from *A Lad Insane* to *Aladdin Sane*, although presumably both Defries and David had agreed.

Meanwhile, Francis Newman and his assistant were working on the solarized outline image for the back cover:

> I'm actually more proud of the back cover than I am the front cover. To do that [front cover] now is easy. It would probably take you half an hour in Photoshop. But that [back cover] took us the best part of the day and cost someone his job. It was made using a film called Agfa contour. So we copied it onto this Agfa contour 5 x 4 film ... and we had three or four goes before we got the outline thin enough. You also get an outline of David's whole face as well, it looked solarized. Then Duffy used liquid opaque to remove the lines he didn't want and we then made a second generation copy from it.

With the airbrushing finished, the final images were sent to Photolitho Sturm in Berne, Switzerland for production of the seven separate colour plates for each of images. By the time everything was ready for the production of the album cover, David Bowie had left the building. On Thursday, January 25, David boarded the SS *Canberra* at Southampton with old friend Geoff MacCormack for a five-day sea journey to New York. What was his reaction to first seeing the finished *Aladdin Sane* album? Alas, that has gone unrecorded.

THURSDAY 19 APRIL 1973 — RELEASE DAY

Aladdin Sane was released one day ahead of the traditional Friday slot due to Good Friday falling on the 20th. With 100,000 advance orders the record immediately went gold and was No. 1 in the UK album chart. Fifty years ago, Francis Newman did not even get a free copy of *Aladdin Sane*. He had to walk over to the Finchley Road to buy it at the legendary record shop of the late lamented Eugene Manzi — there was a vending machine outside where it was possible to buy 45 rpm singles at any time, night or day. The music was the main interest for everybody, but Francis also finally saw the outcome of the photo session three months earlier and still owns "his" *Aladdin Sane*.

OPPOSITE — Duffy's handwritten reference notes for the session, including a suggestion to tweak the album's title from *A Lad Insane* to *Aladdin Sane* (albeit misspelt).

The cover was an instant talking point, but it is hard now to imagine how strange the cover looked half a century ago. There were plenty of distinctive albums with sophisticated artwork in 1973, ranging from Pink Floyd's *The Dark Side of the Moon* and Yes' *Tales from Topographic Oceans* to Led Zeppelin's *House of the Holy* and Hawkwind's *Space Ritual*. However, *Aladdin Sane* was almost an anti-cover, a design that went its own way and stood out by ignoring the usual signifiers of rock and pop promotion. Chris Duffy has summarized:

> *Aladdin Sane* is, in essence, a very simple image on a white background — it's incredibly dynamic, incredibly impressive and powerful. But at the same time, it's also very complex too — there is a combined history of both men's careers captured in that moment. All of that history, that energy and thought process was funnelled into the image. Who could imagine that the moment Duffy clicked the shutter on the Hasselblad in early 1973 that one of those images would become known as a cultural icon?

Let's pick up the album and deconstruct the image to see what lies within it. First, an expensive gatefold cover but containing only a single disc — the thickness speaks importance underlined by an above standard retail price. It's something special. Look at it from a distance. David is totally alone, isolated on a washed-out plain background — no props — just an eerie stillness. It's a portrait of sorts but sliced off at the bottom, just above the nipples, with clinical precision. It is a traditional bust portrayal but then it has been subverted. The arms and any activity are hidden from view, though the armpits are just showing. Camille Paglia noted:

> ... the inflamed creases of Ziggy's armpits, which look like fresh surgical scars as well as raw female genitalia. Like Prometheus, a rebel hero to the Romantics, he has lost his liver for stealing the fire of the gods. Like the solitary space traveller in 2001, he may be regressing to the embryonic stage to give birth to himself. With his smooth, lithe, hairless body, Aladdin Sane's rouged androgyne has evolved past gender, as blatantly dramatized by the full-length picture in the inside gatefold, where Ziggy's long legs and sleek, sexless torso are turning silver robotic ... The bust-like cover of *Aladdin Sane* shows the artist in creative process, having jettisoned the mundane appetites of belly and genitals. This dreaming head is lifting off into a shamanistic zone of vision purged of people and matter itself.

If we ignore the flash for a moment, and without any eyes, the dominant feature is the shock of red hair, neither messy or refined but abruptly swept back to frame the pale face and disconnect it from the silent background. The eyeless face has a strange uncertainty; is Bowie thinking, praying or dying — or perhaps all three simultaneously? Eyes shut always evoke separation but is he deliberately disregarding the viewer here or simply oblivious to normal existence?

But the flash is there and, with the heavily made-up eye sockets, eyelashes and slightly parted enigmatic lips, grabs the viewer's attention. Paglia again: "Bowie's face ... contains all of Romanticism, focused on the

artist as mutilated victim of his own febrile imagination. Like Herman Melville's Captain Ahab, whose body was scarred by lightning in his quest for the white whale, Bowie as Ziggy is a voyager who has defied ordinary human limits and paid the price ... A jolt of artistic inspiration has stunned him into trance or catatonia. He is blind to the outer world and its 'social contacts'."

These features are fixed in all the photographs taken at the shoot, but then the final selected image is augmented by postproduction processing. The silver airbrushing emphasizes the corpse-like nature of Bowie's body. Then our eye line drops to the "teardrop", apparently about to run down his chest, creating a sense of movement on the motionless body or corpse. Camille Paglia describes it thus: "The background blankness is encroaching like a freezing cryogenic wave upon the figure. It's as clinical as an autopsy, with a glob of extracted flesh lodged on the collarbone. This teardrop of phalliform jelly resembles the unidentifiable bits of protoplasm and biomorphic conglomerations that stud the sexualized landscapes of Salvador Dalí."

The graphics, completing the design, are ultra-simple, just artist and title, but they repeat the colouration of the flash and pull the entire cover together. Finally, Duffy asked for the dot over the "I" of Aladdin to be replaced with a flame, creating an allusion to his magical lamp. A tiny change but one that underlines the magic and mystery contained inside. Anyone who travels on the London Tube will know how special the dot over the i and j can be in its Johnston typeface.

Since Duffy added that final detail, millions of people have pored over the resulting image. There have been many reviews and attempts to place it in a broader art/design context. The sheer range of viewpoints testifies to the image's enduring interest. To cite just one recent critique, see Igor Juricevic's 2017 essay "Aladdin Sane and Close-Up Eye Asymmetry: David Bowie's Contribution to Comic Book Visual Language", published in The Comics Grid: Journal of Comics Scholarship. It concludes: "In sum, according to a Visual Grammar analysis, the cover image for *Aladdin Sane* presents a character that is at once like the viewer and also unlike the viewer, reflecting a duality in the nature of the character. This duality is metaphorically communicated to the viewer by the simultaneous use of close-up and the asymmetrical placement of the lightning bolt over David Bowie's right eye." As ever, David leaves it up to each of us to make our own interpretation.

AND THEN ...

When Francis Newman went to Manzi's record store, Ziggy was already far away. Bowie was performing at the Koseinenkin Kaikan in Osaka, halfway through his Japanese tour, having completed a dozen dates across the United States. What was the media reaction to *Aladdin Sane* in the United Kingdom?

Well, *Melody Maker* on 19 April was less than enthusiastic, under the title "Aladdin's lamp burns bright ... but cold" their review announced "Homo superior or The Man Who Fooled The World? I'm beginning to wonder."

Followed by:

Oh, he's good all right. Image-wise, he carries it all off with a dazzling, effortless sense of style, which makes every other band in the glam/glitter/outrage/theatre-rock field look like something out of a Camping For Beginners. And musically, he and Mick Ronson and Mick Woodmansey and Trevor Bolder and the rest are light years ahead in their cruel precision.

But how deep does it go? Is David Bowie really saying anything much at all? As Ziggy Stardust, rock and roller, he gets it on, no doubt about it. But judged against the standards of the astral image which he and his followers have nurtured — the whole Starman, Stranger In A Strange Land aura — his achievements have been disappointing.

However, over at *NME*, Charles Shaar Murray was typically more insightful and sardonic:

So, for better or for worse, here are a few snap impressions on my first day with *Aladdin Sane*.

Firstly, the cover, which will be a definite asset to any chic home. You'll see it strewn on Axminster carpets, in expensive colour supplement stereo ads and carried with token attempts at unobtrusiveness under the arms of the fashionable.

On the front is a head and shoulders shot of David with blush-pink make-up and a startling red and blue lightning bolt painted across his face and a small pool of liquid behind one collarbone. Inside with more lightning bolts is David nude, but with a silver-grey solarization that hides the naughty bits.

However, it is probably fair to say that while the cover was remarkable, it was a slow burn in terms of overall importance. The release of *Diamond Dogs* in May 1974, with its extraordinary and censored painting of Bowie as half man/half dog by Guy Peellaert, based on photographs by Terry O'Neill, supplanted it in sheer strangeness. It is worth noting that the flash has moved from David's face to be incorporated into a Bowie logo. However, over the subsequent decades, *Diamond Dogs* and the others have been left behind and *Aladdin Sane* has cemented its position as *the* Bowie album cover. The one that not only combines in one image all of David's remarkable artistry but also the impact his career had on social values, freedom of expression and the potential for everybody to choose who they want to be.

OPPOSITE — A *Music Week* Sleeve Design Award won by Duffy Design Concepts for the *Aladdin Sane* album artwork.

MUSIC WEEK

Sleeve Design Award

1973

Popular Albums
2nd. David Bowie
'Aladdin Sane'-RCA
Designer: Brian Duffy
of Duffy Design Concepts

Editorial director _Mike Hennessey_

Editor _Brian Mulligan_

THE SPIDERS FROM MARS

In early January 1973, around the time of the session with David, Duffy photographed each member of The Spiders from Mars. These shots were intended to feature in the album artwork but ultimately weren't used.
In an interview with Chris Duffy, drummer "Woody" Woodmansey recalled:
"We did some shots and [Duffy] said, 'It's *Aladdin Sane*. Just look insane.'
And we did our best!"

Z/1258 8 Z/1258 7 Z/1258 6 Z/1258 5

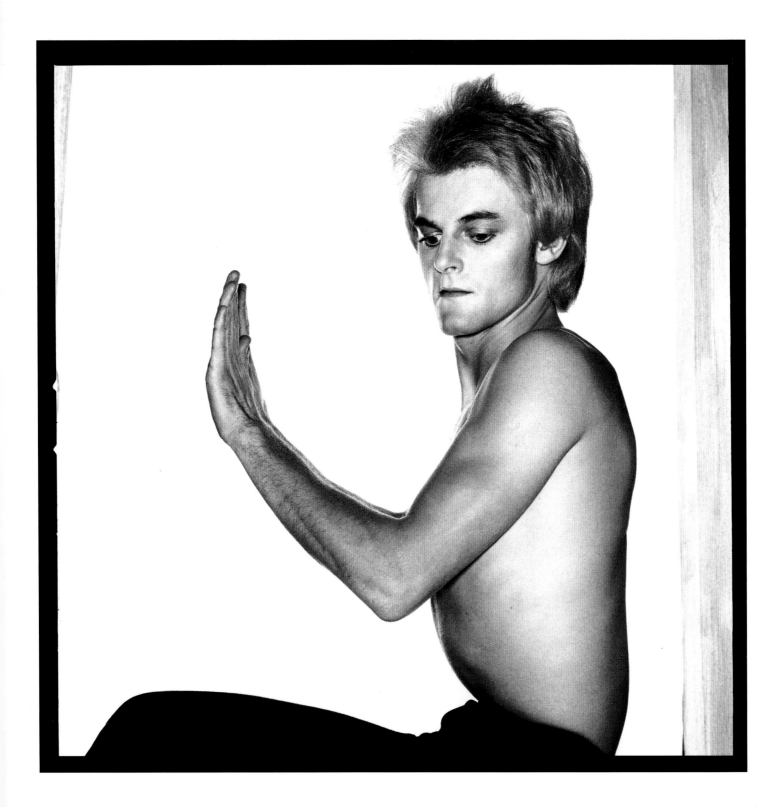

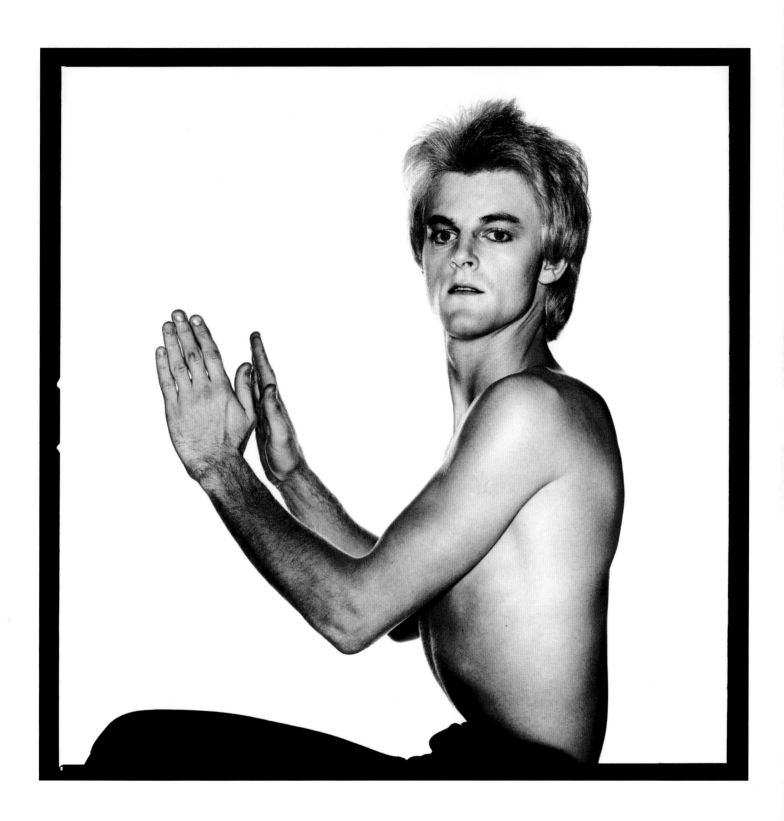

PREVIOUS PAGE AND ABOVE —
Drummer Mick "Woody"
Woodmansey.

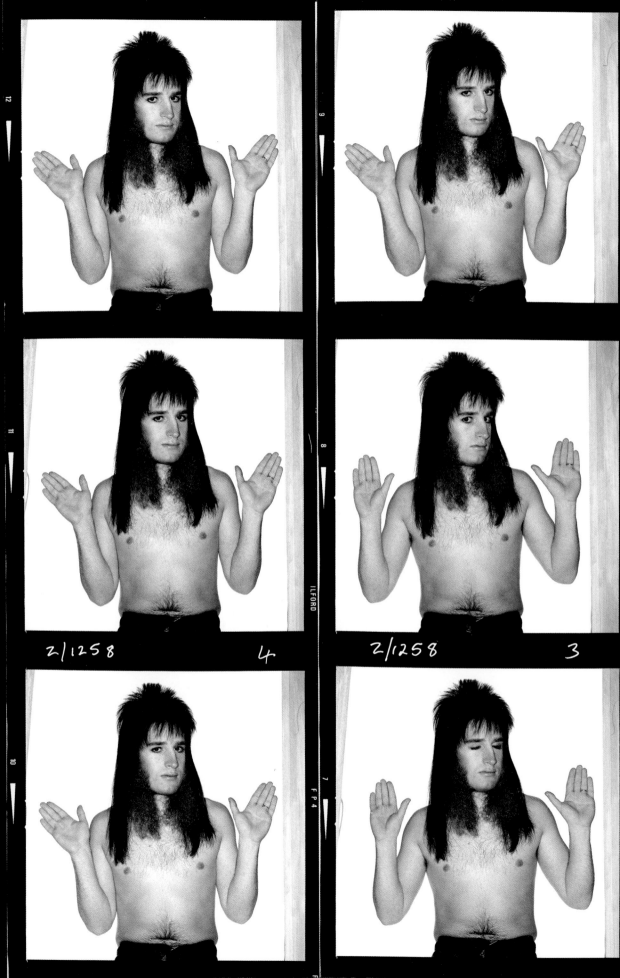

2/1258 4

2/1258 3

2/1258 2

Z/1258

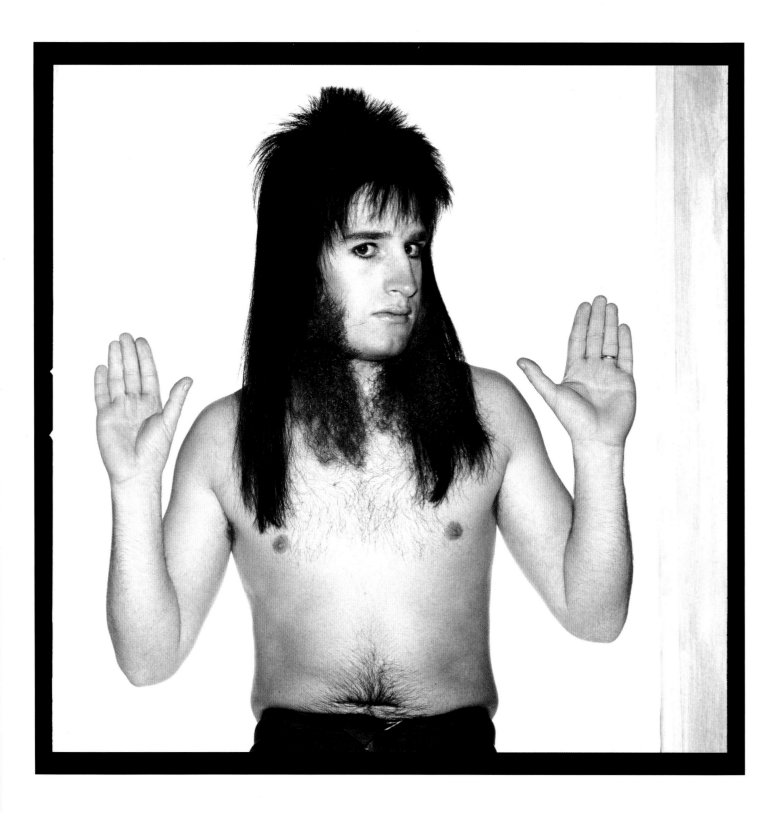

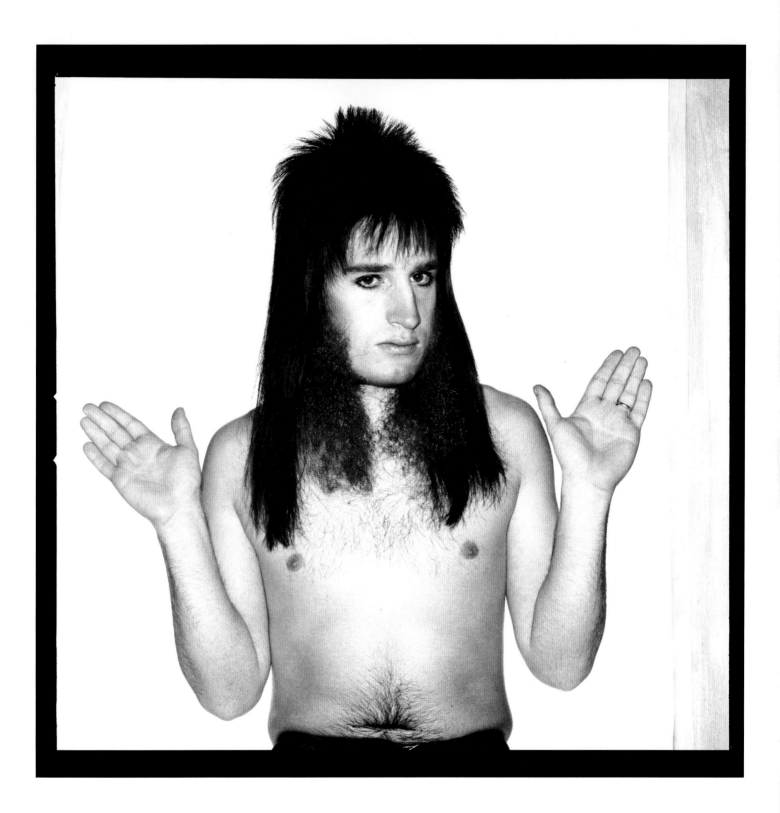

PREVIOUS PAGE AND ABOVE —
Bass player Trevor Bolder.

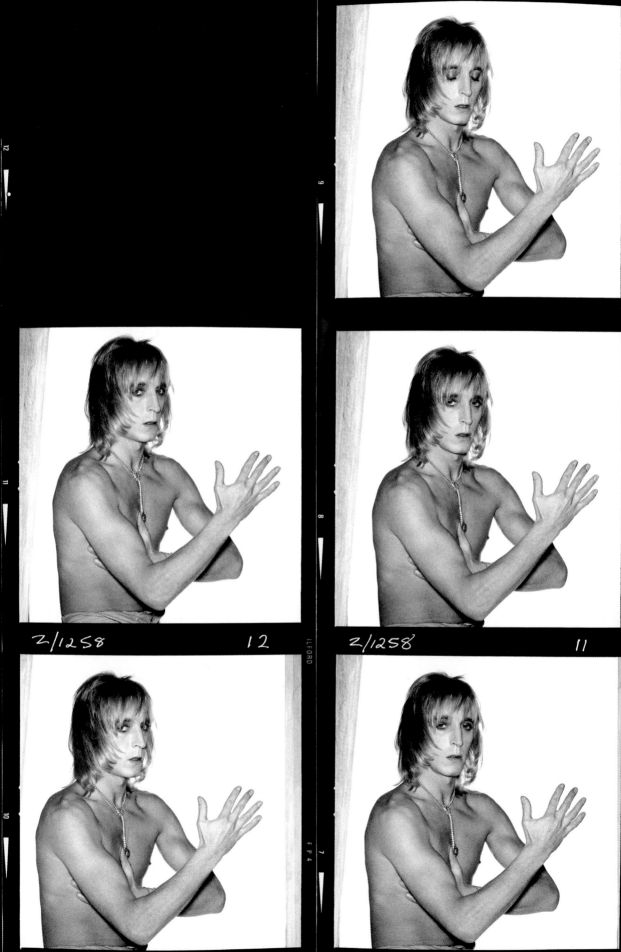

Z/1258 12

Z/1258 11

Z/1258 10

Z/1258 9

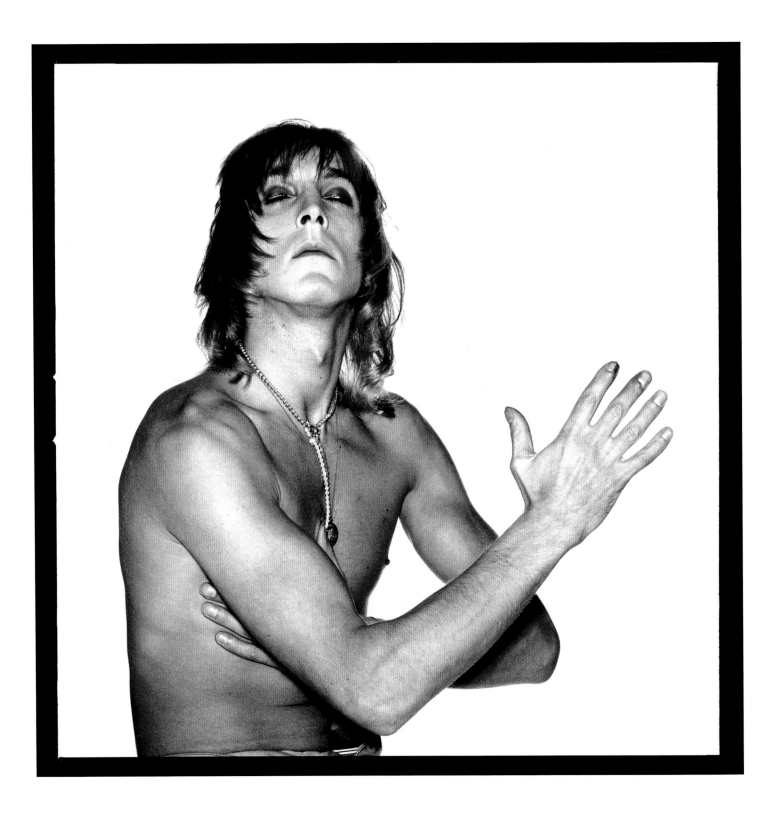

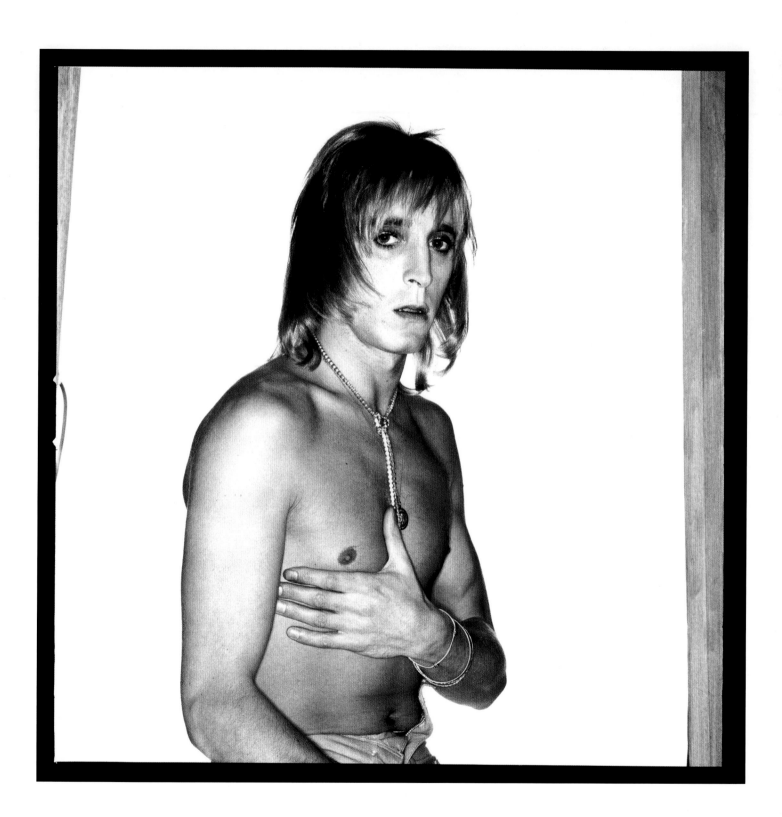

PREVIOUS PAGE AND ABOVE—
Guitarist Mick Ronson.

01.
WATCH
THAT MAN

PAUL MORLEY

DAVID BOWIE'S LATEST
SHOW IS BEGINNING,
WITH THE END
ALREADY IN SIGHT.
IT ALL COMES TO LIFE.
ANYTHING CAN
HAPPEN IN THIS
KIND OF THEATRE.

HERE we go. Can you believe it? I couldn't at the teenage time, not long after David Bowie had got into my blood, when the 1970s were spinning out of control and we really needed his voice. It still takes my breath away half a century later, and now I'm four times as old. I still feel the heat of such anticipation. *What's he up to now?* What a moment.

We've reached the opening track of a new David Bowie album, the one after the myths, mysteries and starry visions of the *Ziggy Stardust* album had sunk in, now that he's famous, an actual rags-to-riches pop star, now that he's been/can't stop being Ziggy Stardust. He's changing his mind, changing his look, almost week by week, driven by a primal need for a change of scenery.

He went into Ziggy in early 1972 playing pubs as almost a quirky, lovable psychedelic extension of English music hall; a few months later, he aggressively sheds Ziggy in real time on the now big-time Ziggy Stardust tour and plunges into a violent, elusive and demented America, an infernal, grisly paradise best explained by Kafka, Brecht, Henry Miller and William Burroughs. Quickly Americanized, sucked into its lethal promise, Bowie becomes addicted to the power of invention, the ability to reinvent yourself or identity over and over again, to make of yourself a project. You can do or say what you please. Howl at the moon, run wild in the streets, walk back alleys in search of a fix, give yourself up to the void, dance again and again beyond the mind's control, no peace for the wicked in this or any other life. It'll take a few years to get the American Nightmare out of his system. It was f** while it lasted. Ha.

For now, with a privileged new place in a fierce, corrupting world and a sensational new role, all he had to do was look around him to encounter incredible things and people and parties and lovers and chaos to write, think and sing about. He puts himself where the Rolling Stones and the New York Dolls are — playing the fucked-up blues and reminding the disenfranchised and disheartened how liberating a great, grungy guitar riff can be — but Bowie being Bowie, he's diving into other depths.

Endlessly craving the menacing and mind blowing to set the juices flowing, he's also hooked on more extreme, placeless magic, including the distorted dark corners and degenerate jazz of prog hell boys Van Der Graaf Generator and the head-over-heels, freak-out stream of consciousness of Annette Peacock. It's David Bowie: he's flown from Little Richard to the Velvet Underground, from Anthony Newley to Alistair Crowley, and he's not going anywhere without packing all kinds of elements, both strange and absurd, to spike the metallic rock, the baroque pop, the enigmatic, philosopher-of-the-night crooning.

The album still featured the Spiders from Mars playing for one last time on vinyl their no-nonsense rock music but hanging onto themselves: Ronson, Boulder and Woodmansey together in the studio with the steady, resourceful Ken Scott, spirited retainers and sisters under the skin — but there was a shift toward the piano to add some of that deluxe transgressive dissonance, that time-bending, bohemian non-commercial decoration Bowie so consistently liked.

Previously, any piano had been a little functional or a little studio bound courtesy of Rick Wakeman, but this time the starving, versatile jazz

man Mike Garson came flying through space onto the Ziggy tour from the uncanny, off-kilter world of Annette Peacock, wondering how he would fit in with the square rock beats and the pop fancy dress. He didn't have to worry. Bowie, the avaricious and hypersensitive opportunist, knew what he wanted. Working on *Aladdin Sane* tracks as the band toured, losing their bearings for the hell of it, he finds in Garson the new man of his dreams.

For the record, Bowie tuned him in and out like a radio picking up tantalizing signals from the American twentieth century — jumped up honky-tonk through abrasive high jinks all the way out to the visceral flux of free jazz — encouraging a gleeful, improvisational Garson to add to the gaiety and gravity of things, making himself a key part of the album's bittersweet soundtrack that captures a general disquiet, a lack of roots. The nerves are jangling, Bowie's shifting through an already shifting perspective, experiencing a grotesque, haywire masquerade, his reality splitting at the seams — as Garson's piano takes him tumbling from the sleazy to the sublime.

On 'Watch That Man', Bowie's the transparent observer circling a sun of energy, inside a mad house, a social scene transformed into something elemental and profound, somewhere between the Mad Hatter's (drugged) tea party where everything tastes nice and something hosted by the Great Gatsby. It's his job to pass on information, to be a witness in the shadows as much as a participant in the flesh, the victor and the victim, to communicate the uproar, using the trashed, razor-slashed rock 'n' roll of the day — mixed in an elegantly murky tribute to the Stones' intoxicating, near ghoulish *Exile on Main Street*, brought to you straight from the dank, kinky zone of no return.

Now he's arrived somewhere as a conspicuous someone, Bowie uses the opening track to report on the hyperbolic cacophony of the subterranean New York after-party he finds himself at, a disorienting labyrinth filled with the sexualized foam of fame. He's watching through cracked glass the king of the wild things licking his lips, the queen of the night on the outskirts of lost and found — oh what fun, he's getting some clues about how to be, how not to be, how to find the role of a lifetime, revel in the big city spotlight, track the queer agenda, lose his precious celebrity mind, crawl back into waking reality, and then move on, always moving, churning, sharing, flickering, sparking, hunting, bewitched. He can't stop himself.

Such excess is as threatening and damaging as it is exciting and glamorous, and Bowie is part of it, trying to be apart from it, loving that he's made it this far in the world, anxious that he can't keep up, always working out how to remove himself from the very place he always wanted to be. Everyone's living on borrowed time. He needs to write (another) song about what's happening to him, to make sense of it all apart from anything else.

The first song on an album of songs circling different cities lifts a curtain before the alternate realities, events and traumas to come. It's a rock album recorded in expensive studios and released on corporate RCA but it heads toward a series of images, a set of illusions about party animals, teen spirits, crazed strangers, hangers-on, desperate flirts, wannabe revolutionaries, 1970s drifters, edgy refugees, indulgent writers, dope fiends, Warhol superstars, ferocious groupies, heroic traitors, pseudo stars, undercover agents, gender fluids, comic nihilists, evil cults, drug

dealers, social X-rays, bright young things, poet-thieves, mysterious muses, supernatural hustlers, animated narrators, the self-chosen few, the wasted and burnt out, the seriously messed up, the ones who almost never are who they are. The first song tells us we are where things are always getting weird — in the best way, or maybe just the only way they can. It sets the tone.

It already had a lot to live up to, not just because of all the Ziggy fuss and his tumultuous culture-changing transformation from restless outsider to ultimate shape-shifting influencer, but because of the cover. Oh, the cover. What an object to come across in your local record shop, and eventually the whole wide world. Can any song live up to the cover image?

A photograph that could never be forgotten, capturing a pale, weightless ghost of the future growing wings, basking in decadent moonlight, captured as though at the exact moment inspiration hit him, an album sleeve containing more meaning and mystery than even the greatest books and films do — even though Bowie was someone for whom meaning rarely took on a stable form. The photograph is a tremendous performance in itself, the calm at the centre of a wild storm, a tremendous moment of transition. What kind of world, what kind of spooky carnival, is this unfathomable creature in motionless existence going to present to us? What and who on earth will it sound like?

This impromptu new character had already got inside our heads, months before Bowie officially cancelled Ziggy and changed the way we thought about faces and eyes, skin and sex, power and presence, good and evil, alien and human, music and magic. What will David Bowie sound like now he appears to be Aladdin Sane, Ziggy Stardust struck by lightning and reborn in a blur of make-up, make-believe, second-guessing and endless nights, poised somewhere between pop high priest and debauched, paranoid futurist, quickly finding a permanent place in the expanding fictions of culture?

We watch that man, this self-made concept, and wonder what he's thinking behind those closed eyes, and then we play the album — invited, amazingly, to join the party, the tour, the behind the scenes, to see the forbidden sights — and we understand. David Bowie's latest show is beginning, with the end already in sight. It all comes to life. Anything can happen in this kind of theatre. Let the outside in, all those ravishing outsiders, those teeming agitated Aladdin Sanes with their mental freedom and ulterior motives behaving oddly, shrewdly, shockingly, or with seeming self-destructiveness, which somehow and up to a point has its creative advantages.

The party is in full flow, darkness mixed with light. He's where he belongs, but there's always somewhere else. He leaves halfway to change his costume, touch up his make-up, chase more drama and charming possibility, to generate more ideas about himself. The end of the opening track; we've been taken; my head feels like it's about to burst. Mission accomplished. We're as ready as we'll ever be for what comes next. We should be so lucky — to lurk so closely to a world wonderfully out of joint.

BLACK
AND WHITE
headshots

As part of the Aladdin Sane session, Duffy shot a series of headshots of David on black and white film — possibly shot with press and promotional opportunities in mind. The negatives show the photographer's hand-drawn crop marks and mark-ups.

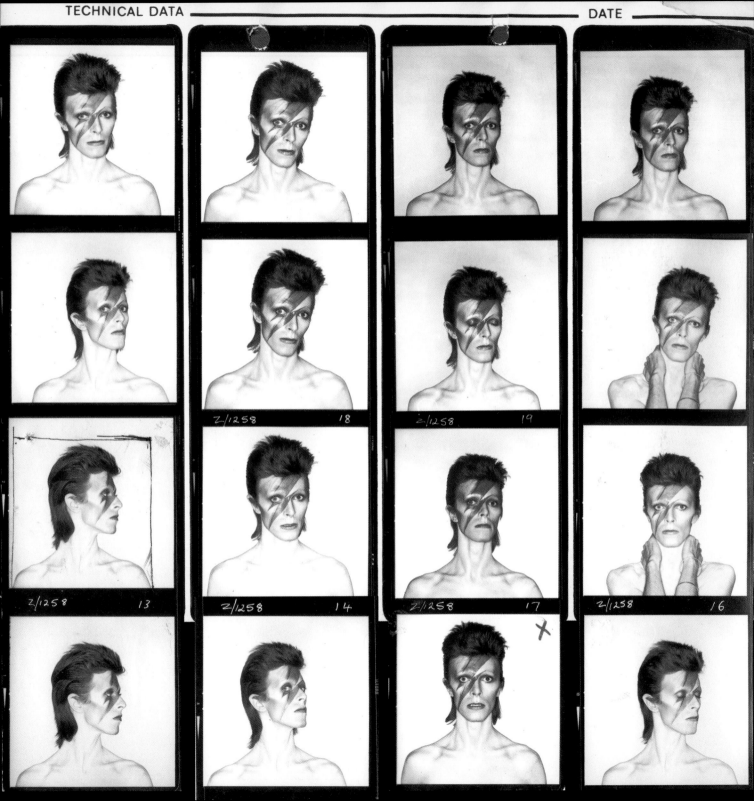

Z/1258 18
Z/1258 19
Z/1258 13
Z/1258 14
Z/1258 17
Z/1258 16

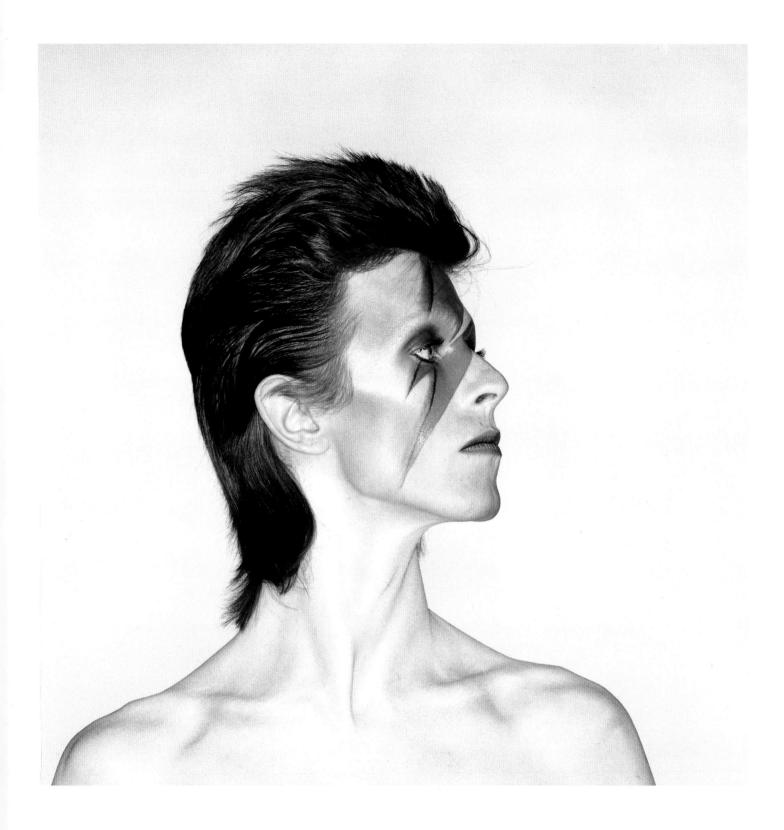

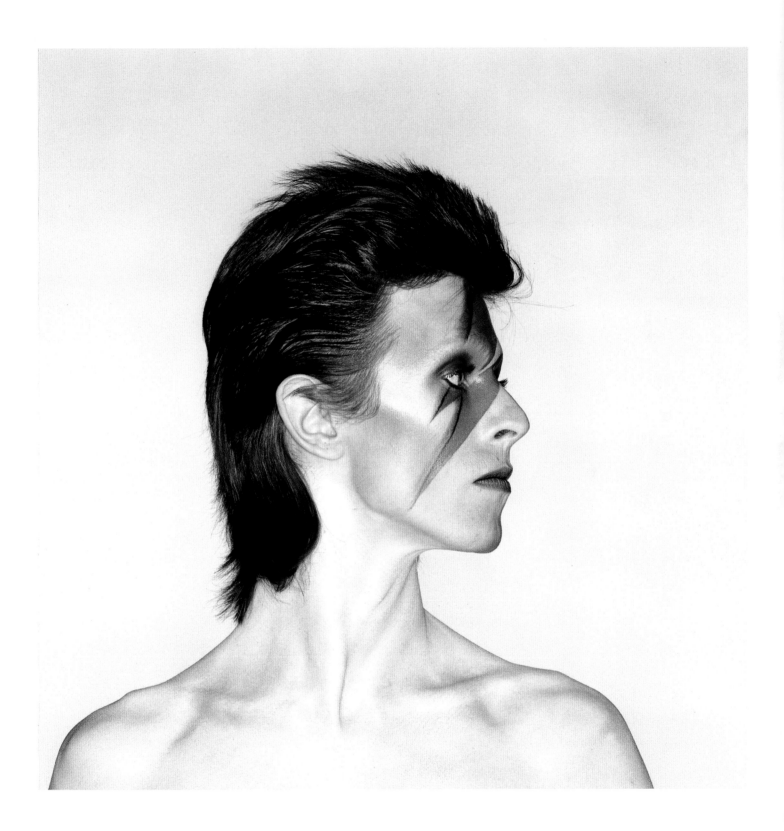

ABOVE — Headshots BW01–02.

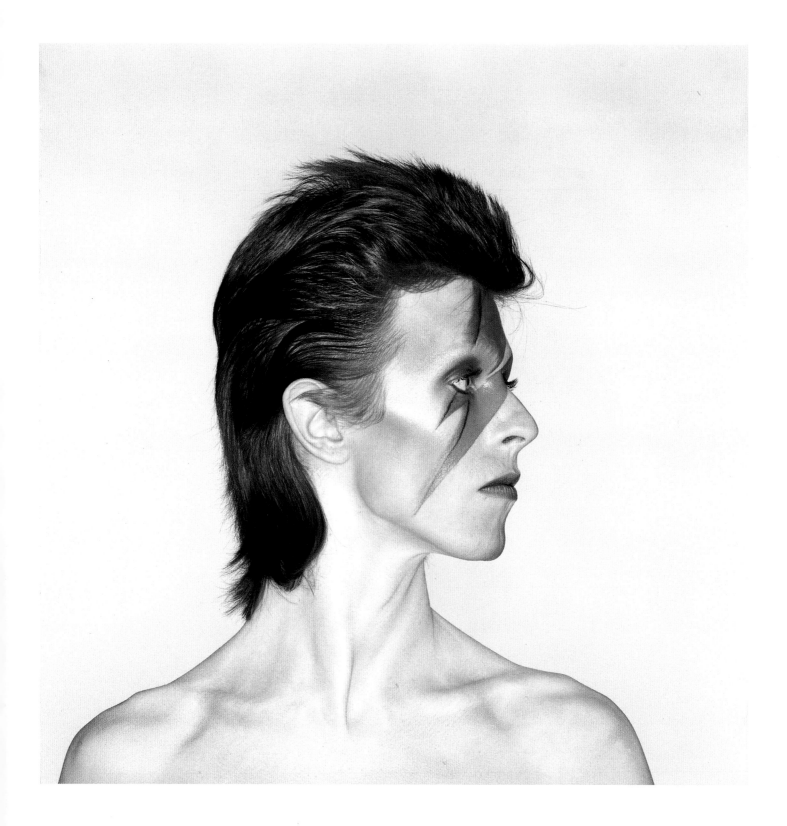

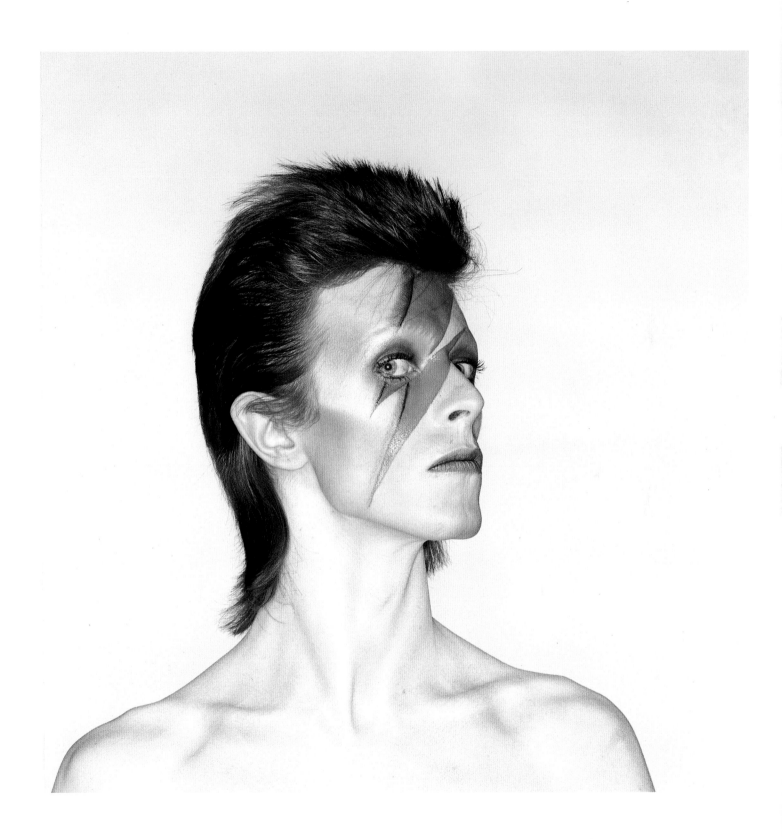

ABOVE — Headshots BW03–04.

FOLLOWING PAGES — Headshots
BW05–14.

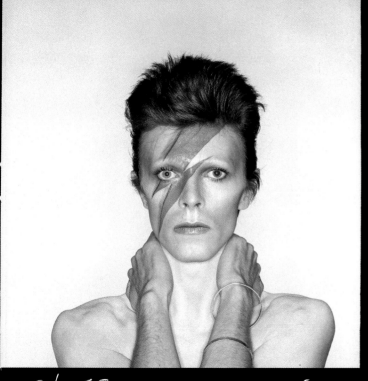
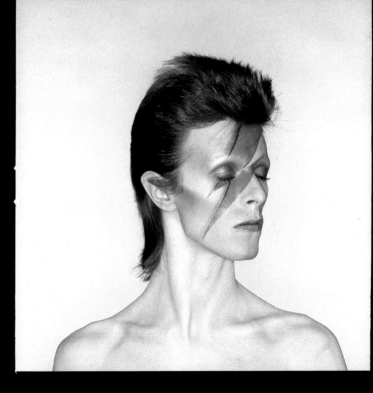

2/258 16

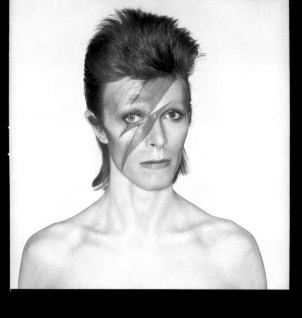

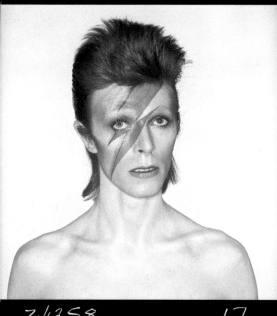

Z/1258 17

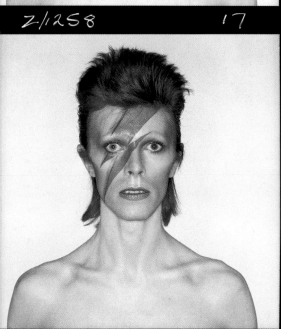

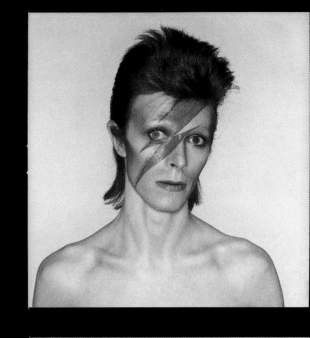

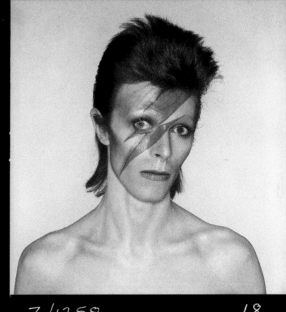

Z/1258 18

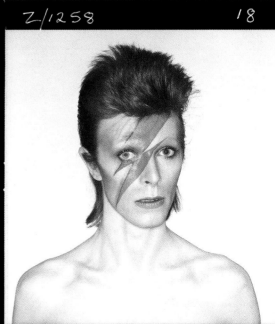

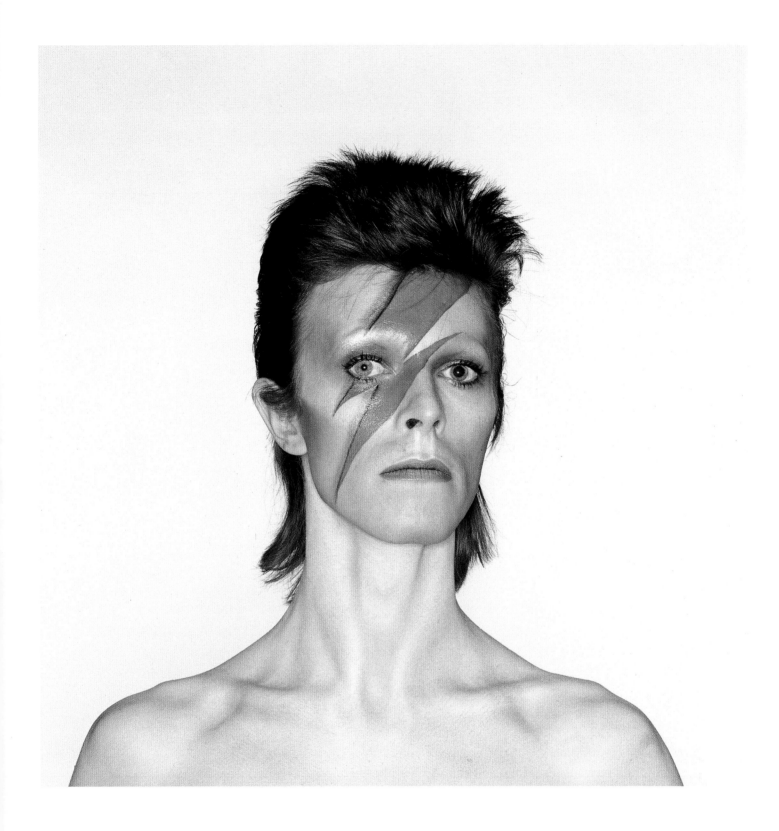

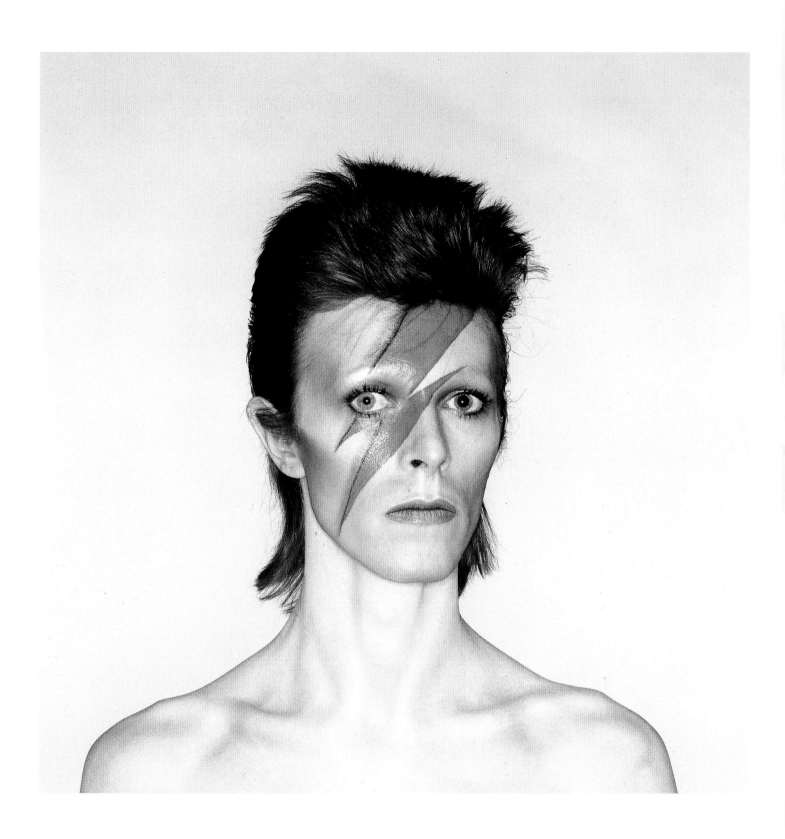

ABOVE — Headshots BW15–16.

OVERLEAF — Headshots BW17
and BW18, containing Duffy's
hand-drawn crop marks.

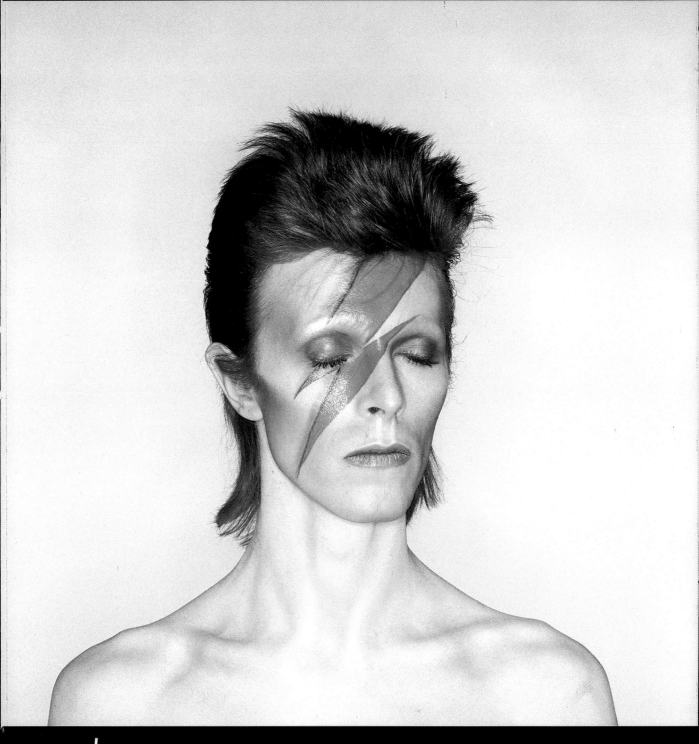

2/1258 20

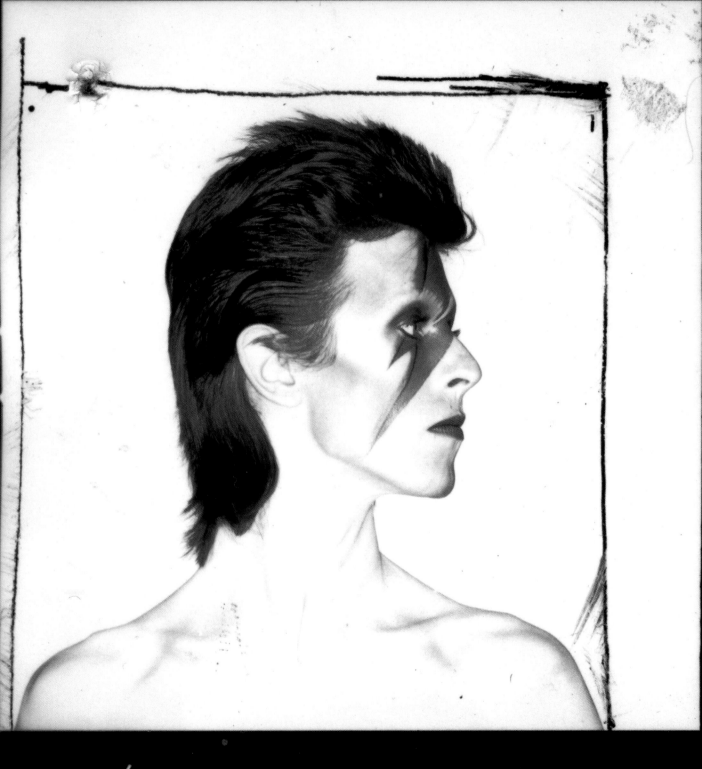

Z/1258 13

02.
ALADDIN SANE
(1913-1938-197?)

KEVIN CANN

IT WAS AT ONCE BOTH
THRILLING AND
TESTING THE METTLE
OF REVIEWERS AND
FANS ALIKE, SO VERY
DIFFERENT WAS IT
TO ANYTHING MOST HAD
EXPERIENCED ON ANY
PREVIOUS ALBUM
OF POPULAR MUSIC.

when quizzed about his new creation, Bowie informed the world that Aladdin Sane was Ziggy Stardust, a kind of shell-shocked remnant of his former self, an Americanized beatnik doppelganger. And central to this colourful hybrid creation was the inimitable title track, instantly recognizable, compelling and unique.

Aladdin Sane, the album, would stand alone, being David Bowie's first long-playing statement delivered from a position of fame. It's hard to believe now that when *Ziggy Stardust* first hit the shelves the previous summer, Bowie had still been thought of as a cult-recording artist, known only for one late 1960s hit single and a couple of "promising" (now classic) albums. But just 10 months on from the arrival of Ziggy, following some clever marketing and sage management decisions, the emergence of *Aladdin Sane* was up there among the most anticipated and heralded music industry moments of the year.

In this regard, given the expectation resting firmly on David's shoulders at this time, the pressure to deliver a quality product was immense. "You know that feeling you get in a car when someone is accelerating very, very fast and you're not driving," David told BBC's Alan Yentob while recalling this particular moment of his career, "and you get that feeling in your chest when you're being forced backward, and you're not sure if you like it or not. It was that kind of feeling, that's what success was like, the first thrust of being totally unknown to being very quickly known. It was very frightening for me, and coping with it was something I tried to do. Some of those albums were me coping, taking it all very seriously I was."

An album of such quality as *Aladdin Sane*, born out of such a fractured and chaotic touring and travelling timeframe is, on reflection, quite an achievement. And as unnerving as it clearly appeared to be for David at the time, having finally achieved the recognition he had worked so hard for a decade to realize — particularly after coming so close to success in the past — he somehow managed to channel that doubt and anxiety to work squarely in his favour.

Somehow, amidst the madness of it all at the peak of Ziggy, David retained his sangfroid and remained inspired; his creative flow undiminished. Even during that first US tour he was able to deliberate on and work up quality new songs, often translating random American observations — some uncomfortable, some challenging — into positive new material.

Aladdin Sane itself, in concept and song, can be traced directly to the mid-Atlantic in the winter of 1972. Although David's fear of flying left tour planners with serious logistical headaches, often resulting in musicians and crew lounging in cities for days waiting for Bowie to catch them up by road, train or boat, this particular phobia gifted David invaluable personal time and distance away from the maelstrom that was developing around him. Spending up to a week at sea once or twice a year (which would become pretty normal for Bowie over the next four or five years), gave him the space to read, relax and occasionally work on new material. And it was a journey home to England on the cruiser RHMS *Ellinis* in December 1972 that offered him the opportunity to formulate the themes and backdrop that shaped Aladdin Sane, with Evelyn Waugh's satirical novel *Vile Bodies* the essential catalyst.

Written in 1930 about Britain's promiscuous and generally unchallenged bright young things, *Vile Bodies* begins as a light-hearted poke at the English cocktail-swigging social butterfly, whose carefree lives partying in and around London shortly after the First World War were greatly at odds with a generally impoverished post-war populace. But it was the book's dark denouement that mainly piqued David's imagination, its often oblique narration another important aspect of its appeal: "All that succession and repetition of massed humanity ... Those vile bodies ..."

David's innate skill at evoking the feel of a louche 1920s dance band on this track, as well as on parts of 'Drive-In Saturday' and even a revised 'The Prettiest Star', additionally reveal a clever expression and assimilation of Waugh's challenging vision.

On the original LP cover, the title of the song is followed by "(1913–1938–197?) (RHMS *Ellenis*)", the dates alluding to premonitions of an imminent Armageddon, which had been fashioned, in part, by a conversation with an unnamed individual while David was on the road in America. Explaining later that during the tour he had "run into a very strange type of paranoid person", David was already wrestling with phobias of his own, some since the early 1970s, which included a fear of being shot dead on stage, black holes in space (and being stored in boxes on Earth), and copping it in an air accident. To that infamous collection, he now included a Third World War.

Experimental writing had fascinated Bowie ever since he had encountered Kerouac's *On The Road* in the early 1960s. By the early 1970s he was already dabbling with cut-ups, a form of creative writing where the writer takes a complete, linear text and randomly cuts it up into single or various words before rearranging them to form something partly related or new. This discovery had come via other Beat writers like William Burroughs and Alan Ginsberg, and David later discovered that examples of this kind of word association dated much further back to the leading avant-garde Dadaist poet Tristan Tzara (whom David would brilliantly champion at the end of the decade by revising one of his experimental costume creations for a memorable appearance on US TV's *Saturday Night Live*). Early Bowie cut-up experiments can certainly be detected on *Aladdin Sane* in various places, including the title track.

Essential to the drama of 'Aladdin Sane' was Mike Garson, the New York-based keyboard maestro deftly hired by Mick Ronson after playing a few effortless notes at audition. He had been suggested by fellow RCA stablemate Annette Peacock, and his experience of varied and improvised modern jazz techniques proved a critical element in the overall structure of the album, his knowledge of experimental jazz immediately rekindling David's appreciation of the genre, which dated back to childhood and the influence of his elder half-brother, Terry.

Garson's arrival to the fold, just as David was imagining the soundscape of 'Aladdin Sane', couldn't have been better timed: his brilliantly executed piano tumult (recorded in just one breathtaking take) vividly transports us through a singular moment of episodic anguish and trauma, while subtle and

intemperate flashbacks embedded deep within Garson's atonal piano skilfully reference classics like Gershwin's 'Rhapsody in Blue' and even The Champs' 'Tequila'. Behind it all, the ever-reliable Spiders — fully supported by David's empiric vocals and traumatized sax — remained fully attuned to the moment and delivered a perfectly delivered, hypnotic bedding to support the song's structure. The resulting simpatico between Garson, Bowie and band is both compelling and historic.

It was not for the first time that David had looked to a title track to express an overall vision — and while this song perfectly captured the unstable, schizophrenic make-up of David's new character, it was the brilliantly realized Brian Duffy/Celia Philo front cover photo and packaging which brought the character to life.

During most of the album preparation, David had used the working title *Love Aladdin Vein*, and even referred to it as such when interviewed by BBC Radio in early January 1973. The legendary *Aladdin Sane* photo session — conducted on Saturday 13 January* and completed within six hours ("The day that lightning struck," Celia Philo later recalled) — finally helped settle its identity. At this point, David was close to going with *A Lad Insane* (*Love Aladdin Vein* and *Vein* now rejected due to possible drug connotations). Duffy decided *Aladdin Sane* was even better and David agreed — the added association with both the Aladdin of both *One Thousand and One Nights* and the tradition of English pantomime yet another definite link with David's artistic DNA (the little Aladdin's lamp above the "I" on the cover another touch of Duffy genius).

'Aladdin Sane', the song, was immediately assimilated into David and the Spiders' live act (with Garson now an associate Spider), and the piece was first performed on tour in Scotland just days after being recorded. These live renditions often gave Mike the freedom to go full vamp crazy during the song's moment of mania, often extending his solo by minutes to push the experiment even further. David's faintly sung "lights on Broadway …" reference toward the end of the track (not featured in the printed lyric) was inspired by The Drifters' 1963 hit single 'On Broadway'. David would also add more from this lyric in his live show.

There may be better tracks on the album, but 'Aladdin Sane' is anything but unremarkable. It was at once both thrilling and testing the mettle of reviewers and fans alike, so very different was it to anything most had experienced on any previous album of popular music. No wonder we are analyzing it to this day.

* Date of photo session confirmed for the first time.

UNSEEN
headshots

During the shoot David moved through a series of poses, experimenting with different positions and expressions while Duffy continued to shoot. The following photographs have remained unseen until now, the fiftieth anniversary of the shoot.

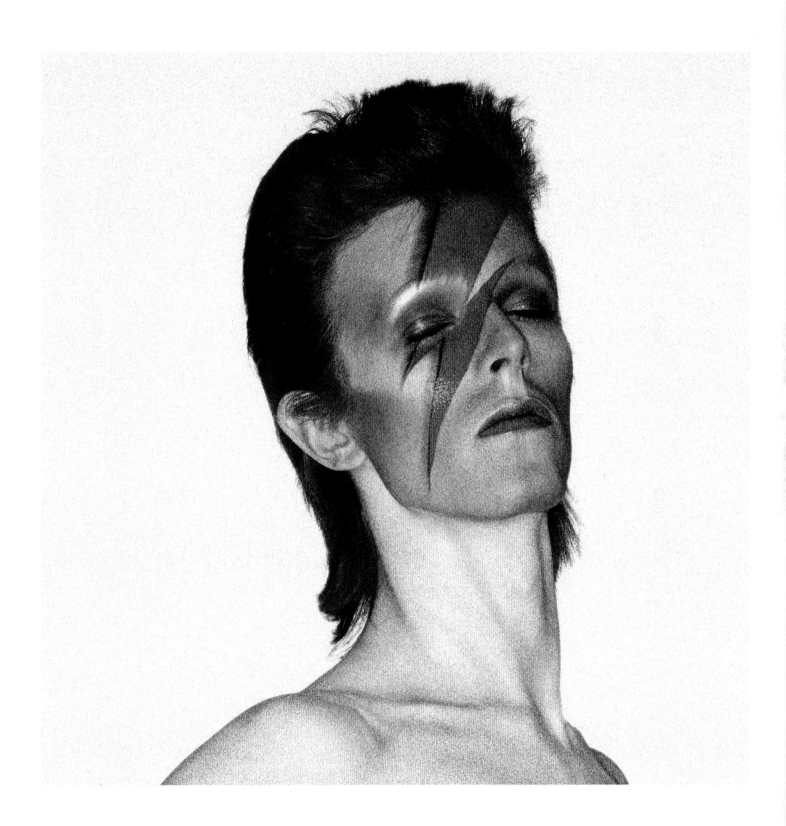

ABOVE — Headshot 01.

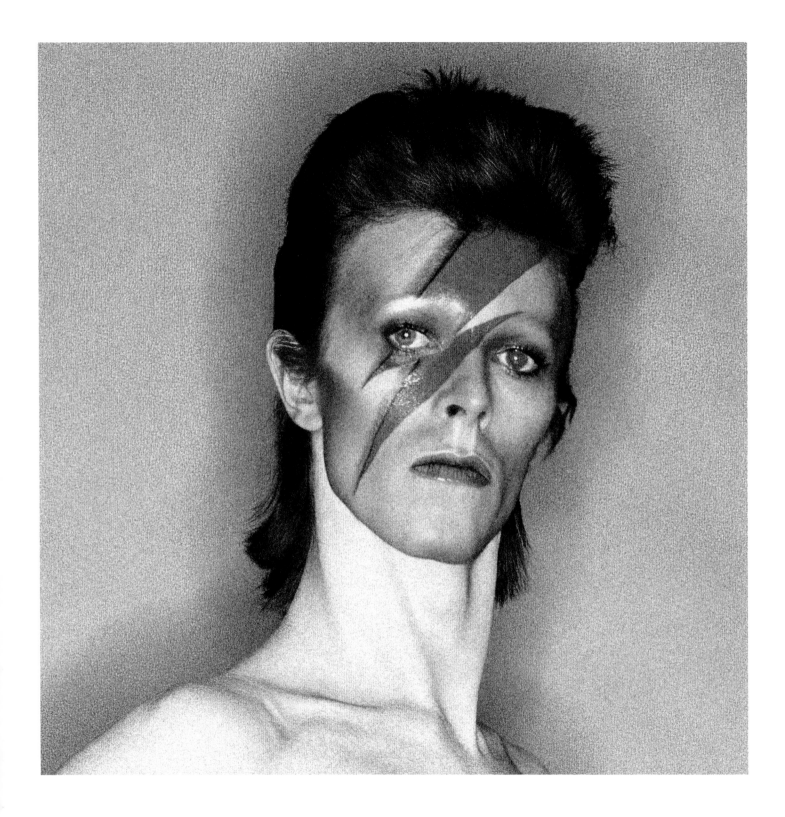

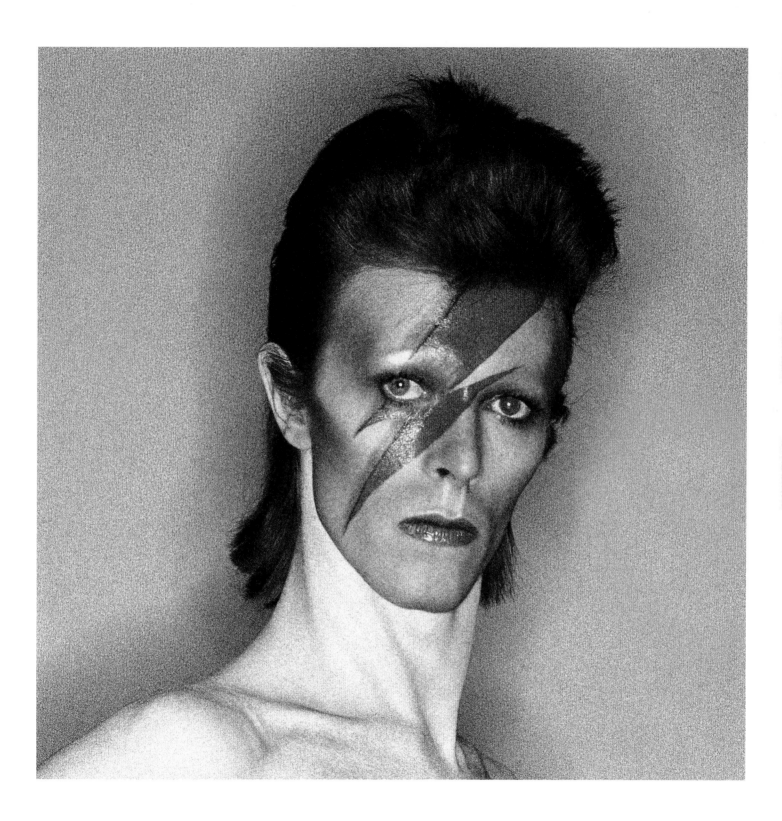

ABOVE — Headshots 02–03.

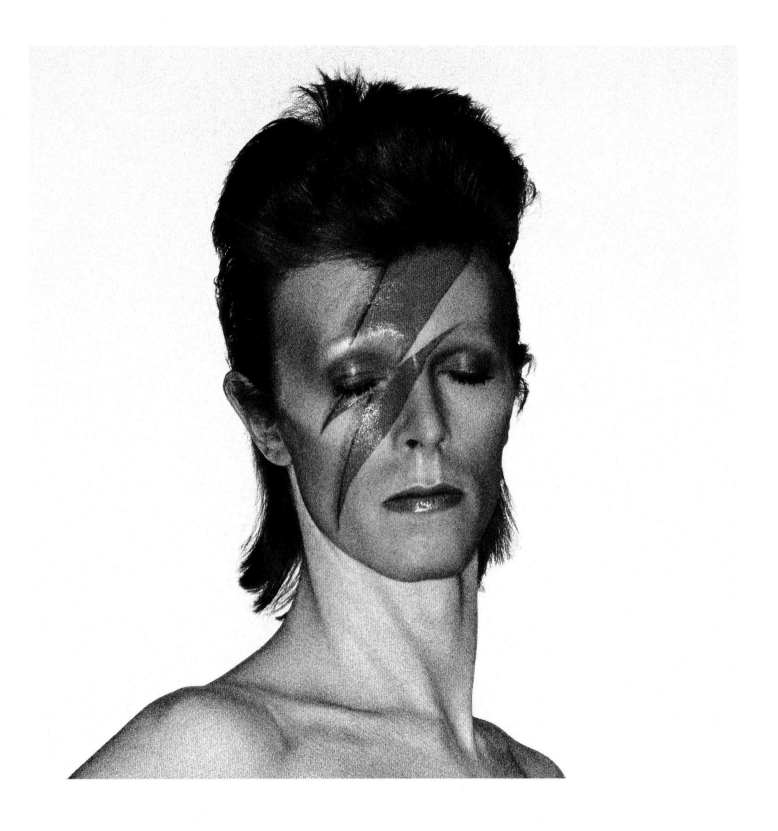

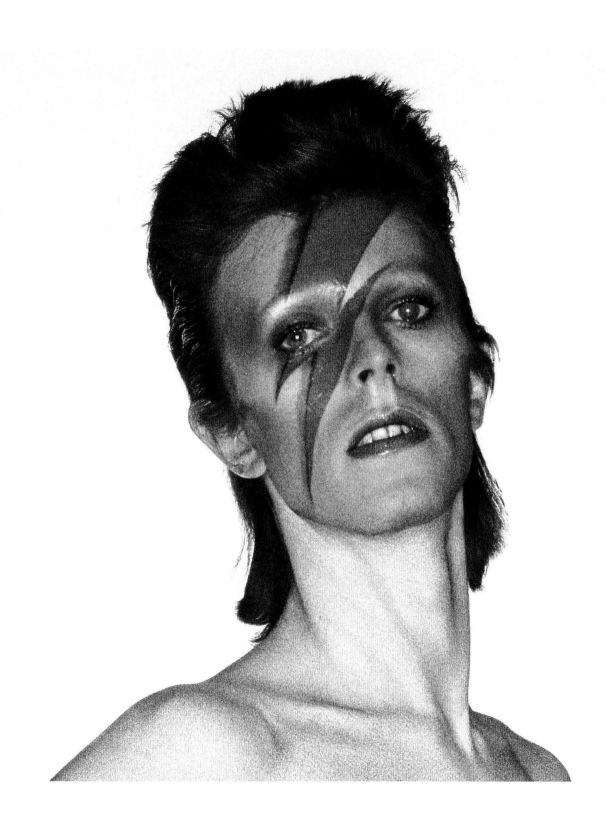

ABOVE — Headshots 04–05.

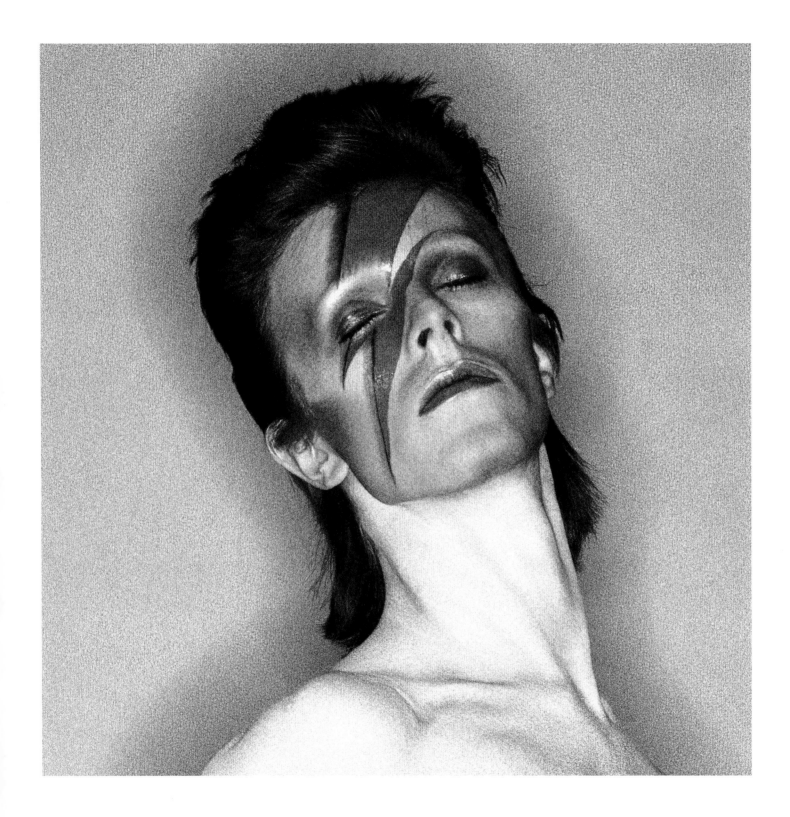

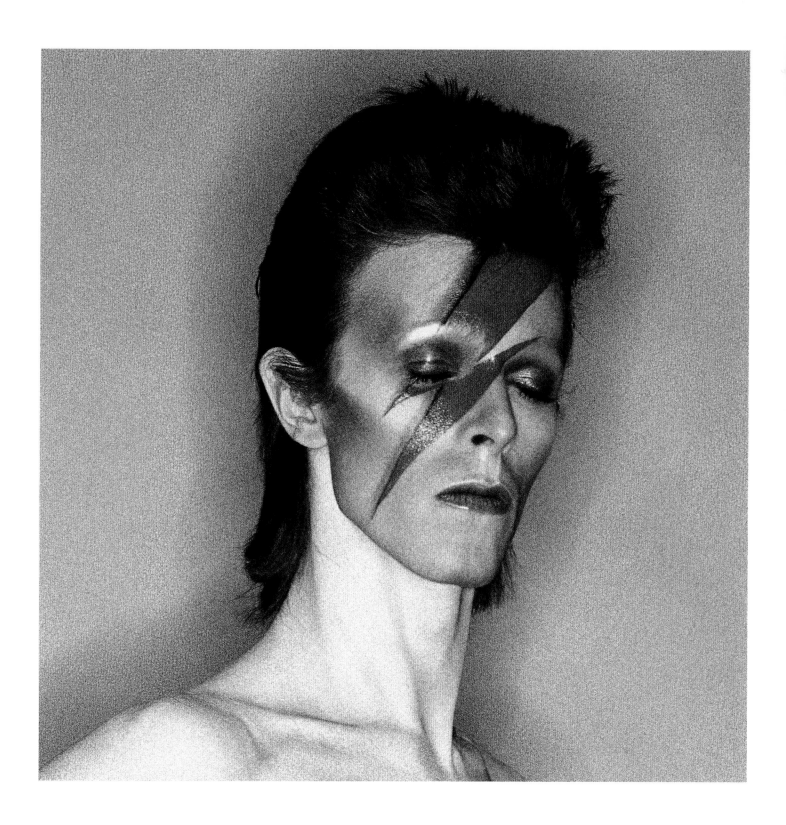

ABOVE — Headshots 06–07.

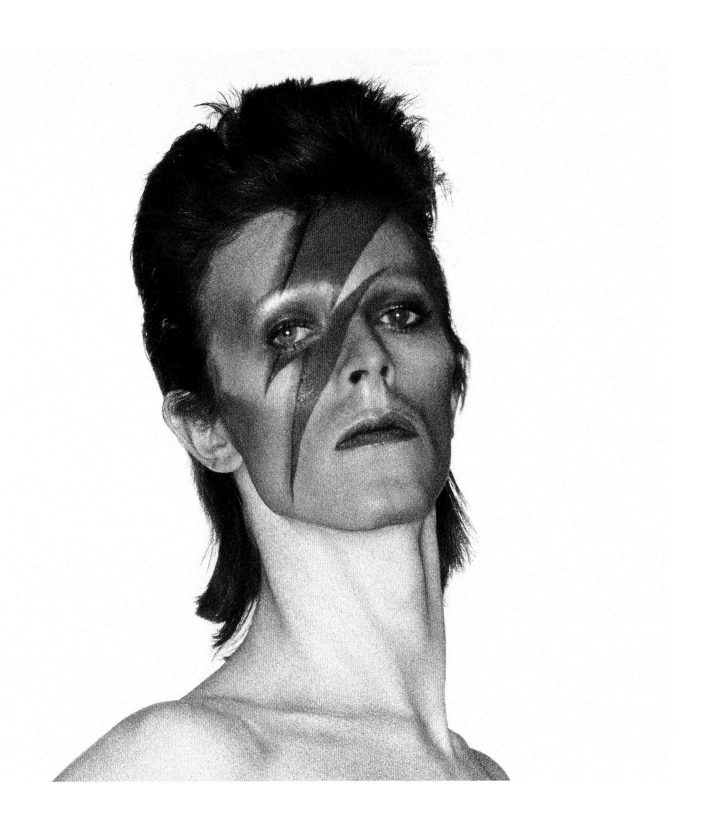

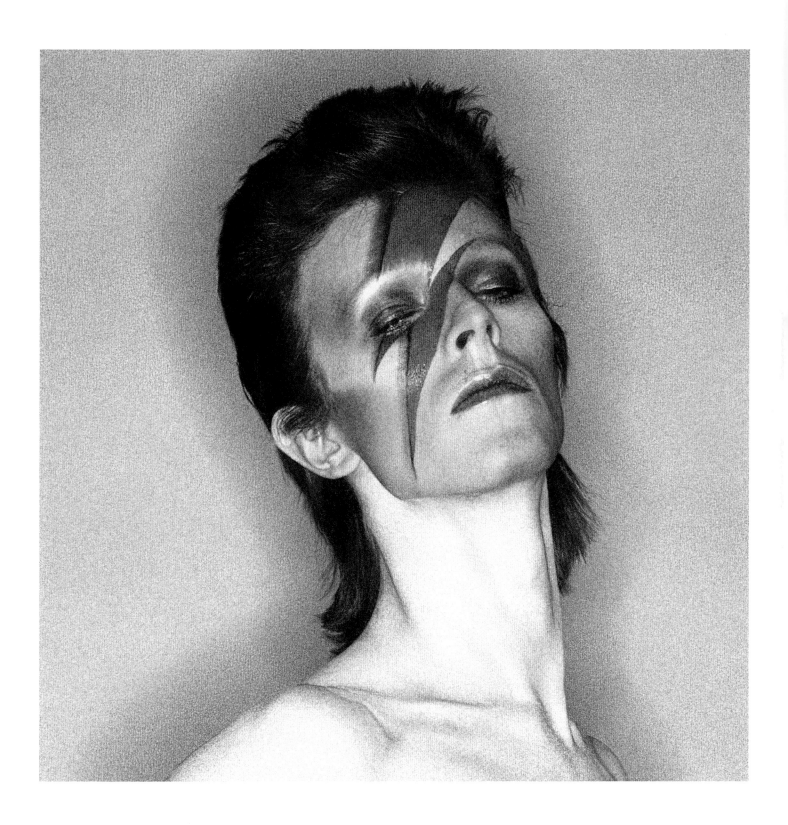

ABOVE — Headshots 08–09.

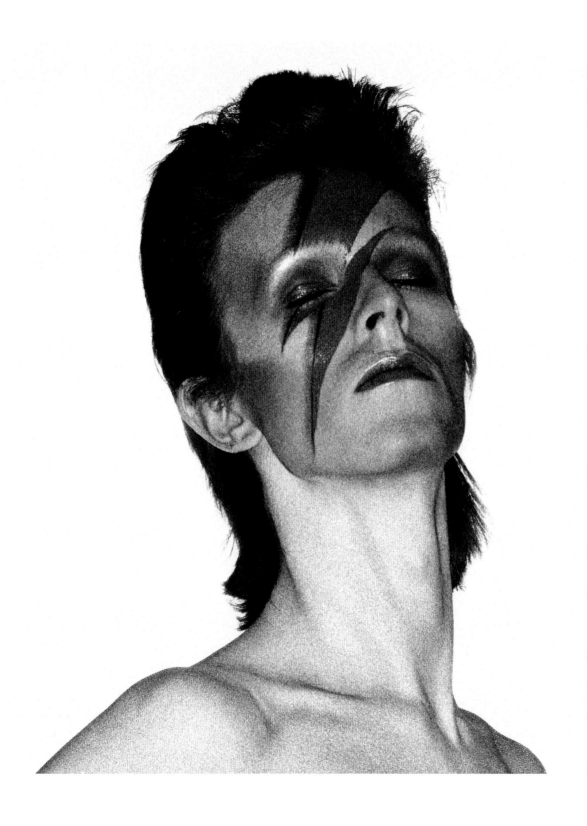

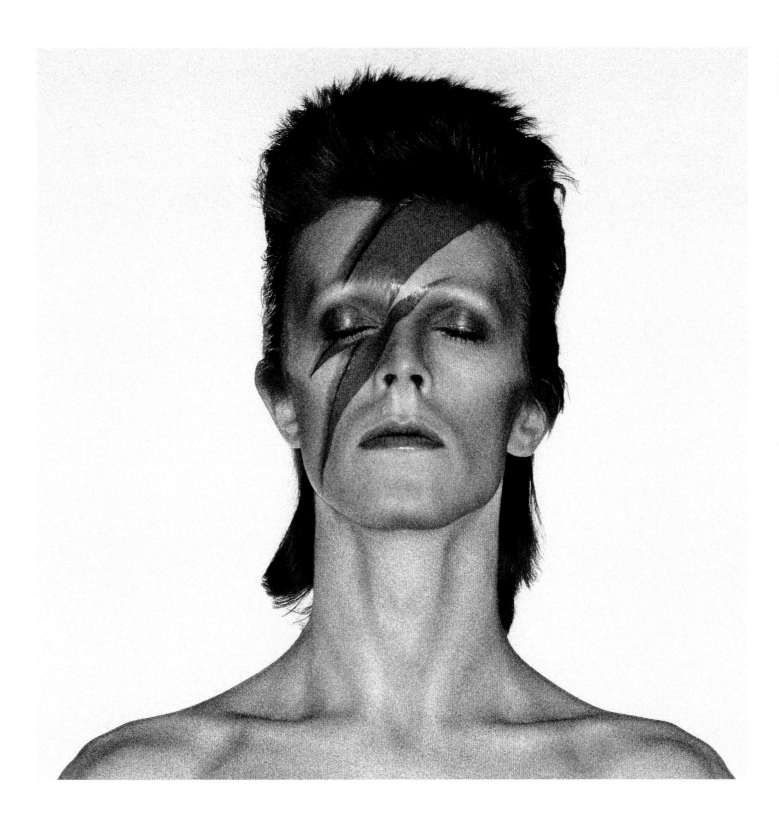

ABOVE — Headshots 10–11.

03.
DRIVE-IN
SATURDAY

CHARLES
SHAAR MURRAY

A CLARION CALL TO
GET IT ON WHILE WE
STILL HAVE THE CHANCE?
OR MAYBE BOWIE WAS
SIMPLY URGING US TO
LOVE EACH OTHER
WHILE WE STILL CAN.

HEREWITH, as promised, a crash course for the ravers.

Something awful has happened: a war of some kind. Maybe it's the war Bowie predicted in one of our interviews — "Prepare for your war, because it's going to be your war ... it's going to be civil, and not worldwide." Or maybe it's something worse.

The situation evoked in 'Drive-In Saturday' is infinitely worse. Human bodies are beginning to fail and human libido has almost disappeared. The song is "about a future where people have forgotten how to make love, so they go back onto video-films that they have kept from this century. This is after a catastrophe of some kind, and some people are living on the streets and some people are living in domes, and they borrow from one another and try to learn how to pick up the pieces."

It's a cornerstone of the *future nostalgia* subset of Bowie songs, in which he positions himself in the far future in order to "look back" on one of our possible near futures. "I work out probabilities. I see things that are happening at the moment and try and direct them to some focal point where they meet in the future. I usually pick different eras and go back and pick incidents that happen in the 1930s and 1940s and push them through to the 1980s and see what conclusion could come from what happened then.

> "I must explain that I don't necessarily know what I'm talking about in my writing. All I try to do in my writing is assemble points that interest me and puzzle through it, and that becomes a song and other people who listen to that song must take what they can get from it and see if information that they've assembled fits in with anything I've assembled and *what can we do now?* All I can say is say, 'have you noticed that and have you noticed that and — what does it mean?' That's all I can do with a song. I cannot say, *this is where it's at.* It cannot do that because I don't know, I don't know! All I can do is assemble information that I've received."

Unlike its game-changing predecessor *The Rise and Fall of Ziggy Stardust and the Spiders from Mars*, *Aladdin Sane* eschews narrative structure — rather, it offers vignettes, snapshots, fragments, with the chronology strictly in the eye of the beholder — and even a defined protagonist. "I don't think Aladdin is as clearly cut and defined a character as Ziggy was. Ziggy was meant to be clearly cut and well defined with areas for interplay, whereas Aladdin is pretty ephemeral. He's also a situation as opposed to just being an individual. I think he encompasses situations as well as just being a personality."

'Drive-In Saturday' arrives early in the album: Track 3, following straight after the uneasy eve-of-war scenario of the title track, in which Mike Garson's ornate, glossy night-club piano stylings gradually splinter into gleaming, razor-edged ice shards of notes. So, while it may represent an end of the line in terms of the narrative Bowie deliberately refuses to give us, there's still plenty of sex elsewhere in the album, be it raunchy ('The Jean Genie', 'Let's Spend the Night Together'), squalid ('Cracked Actor'), cosy ('The Prettiest Star') or just plain ecstatic ('Lady Grinning Soul'). There's even a nod to Bowie's apparent bisexuality, even though he claimed this was an accident.

"I've written a new song on the new album which is just called 'Time', and I thought it was about time, and I wrote very heavily about time, and the way I felt about time — at times — and I played it back after we recorded it and my God, it was a gay song! And I'd no intention of writing anything at all gay. When I'd listened to it back, I just did not believe it. I thought *well, that's the strangest ..."*

However, in the dismal world evoked in 'Drive-In Saturday', those still in love but now bereft of libido can only seek both instruction and simulation from ancient footage from the sex era or to try to borrow relevant books (*Kama Sutra,* anyone?) from "the strange ones in the dome" (possibly uncontaminated and therefore still having sex). It's based on an original, very mysterious, dome sighted by Bowie from his train while in transit between Seattle and Phoenix, which provided the speck of grit that seeded this pearl of a song.

Thus it is that cheap porn — even the tackiest, shabbiest and saddest variety in which his name was Buddy and he'd ask to say — attains not simply poignancy but a strange kind of dignity. Who — with the possible exception of Larry Flynt (or Hugh Hefner or David Bowie) — would have imagined that hardcore porno clips might end up saving our species from extinction?

And then there's the music.

For the song's musical setting, Bowie borrows the temp and chord changes of the urban doo-wop balladry of the 1950s. Derived from the a capella harmonizing of street-corner quartets and quintets, doo-wop had a vocal range stretching from basso to falsetto, with what devotee Frank Zappa classified as "low grumblings" and "high weaselings". (He would take time off from The Mothers of Invention to cut the parodic but affectionate *Cruising With Ruben & The Jets.*) The Beatles had inadvertently crushed doo-wop (though they paid their respects with a couple of early B-sides, 'This Boy' and 'Yes It Is'), and by the early 1970s it survived mainly as kitsch. At its sublime best, doo-wop was little short of ethereal, but when the maximum recommended saccharine levels were exceeded (as they often were), it could be little short of emetic. Especially if your tastes ran to pounding pianos, blaring saxes, thundering drums, twangy guitars and singers hollering with lust, frustration and (of course) frustrated lust.

In its heyday, doo-wop's swooning romanticism was established as early rock and roll's marker of courtly love (in marked contrast to the raunchiness of uptempo rock), thereby earning its place in the closing hour of US teen "record hops". After working up a righteous sweat shaking butts to the likes of Chuck Berry, Little Richard or Jerry Lee Lewis and chuckling over the double entendres, the kids could dance close and slow to "clinch numbers", all cushioned harmonies and sentimental lyrics promising eternal love. Doo-wop idealized chaste puppy love, which is emphatically *not* to suggest that the likes of the Flamingos, the Orioles, the Moonglows and many more (both black and white, but very rarely integrated) didn't provide the backdrop for early fumblings in cars and elsewhere, notably at the drive-in pitcha shows, which we didn't have in the Yew Kay, though we knew what they were. And were we jealous! American kids had drive-ins, as well as — according to US teen movies, TV shows and comics — soda fountains, their

own cars and the right to wear their own clothes to school, as opposed to horrible uniforms. We sent the song to Number 3 in the singles charts, though in the homeland of drive-ins it didn't so much as trouble the Top 100.

Bowie had used those tempi and harmonic structures before — most notably on *The Rise and Fall of Ziggy Stardust and the Spiders from Mars*: the opening 'Five Years' and the final curtain of 'Rock 'n' Roll Suicide'. Here, he's added backing vocals (those *dum-doo-wahs*) which specifically evoke the nonsense-syllable stacked harmonies that earned the genre its nickname, juxtaposing them with discreet phasing tickling Mick Ronson's palm-muted intro arpeggios, and eerie synthesizer whooshes and squibbles. These latter served almost as a working definition of *future nostalgia* — a seam also mined by Roxy Music, who'd opened shows for Bowie resplendent in quiffs and glitter, representing a 1950s revival show taking place half a century or more in the future, garnished with science-fiction synth noises provided by Brian Eno, who would later play a considerable role in Bowie's own saga.

It is a mark — one of many, needless to say — of Bowie's artistry that he was able to use the tropes of the sweetest, most innocent and ultimately the least carnal and most romantic musical subgenre ever to huddle under rock's umbrella to depict the death of not just an individual, specific relationship, but of erotic desire itself. And more than that: a barely hidden subtext tells us that, if this also means the end of sex and procreation, the song is leading us to visualize the final days, the death knell of humanity itself.

Finally: a pre-sexual music to signify a post-sexual age? 'Drive-In Saturday' as a requiem for the lost days (and nights) of physical love? A clarion call to get it on while we still have the chance? Or maybe Bowie was simply urging us to love each other while we still can. Whatever it is, 'Drive-In Saturday' may just have been "one of the more commercial numbers" on *Aladdin Sane* ... but it was always more than that, and always will be.

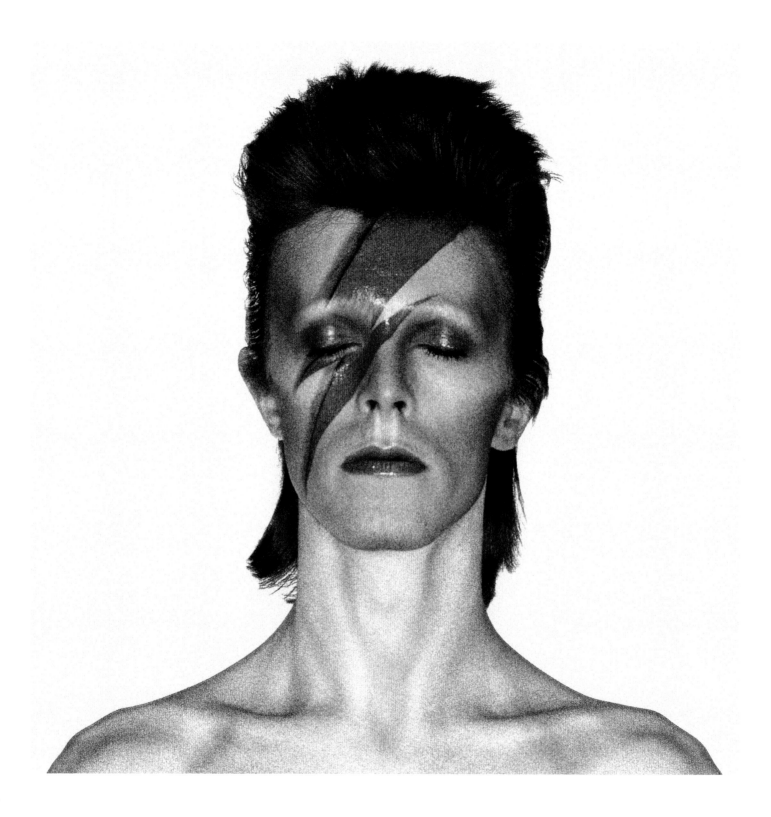

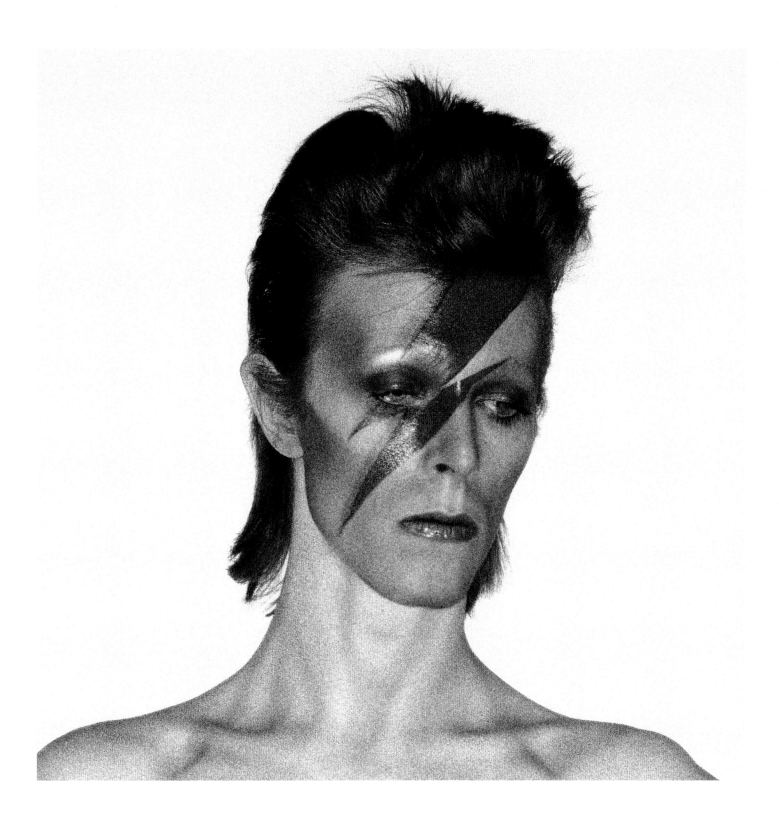

ABOVE — Headshots 12–13.

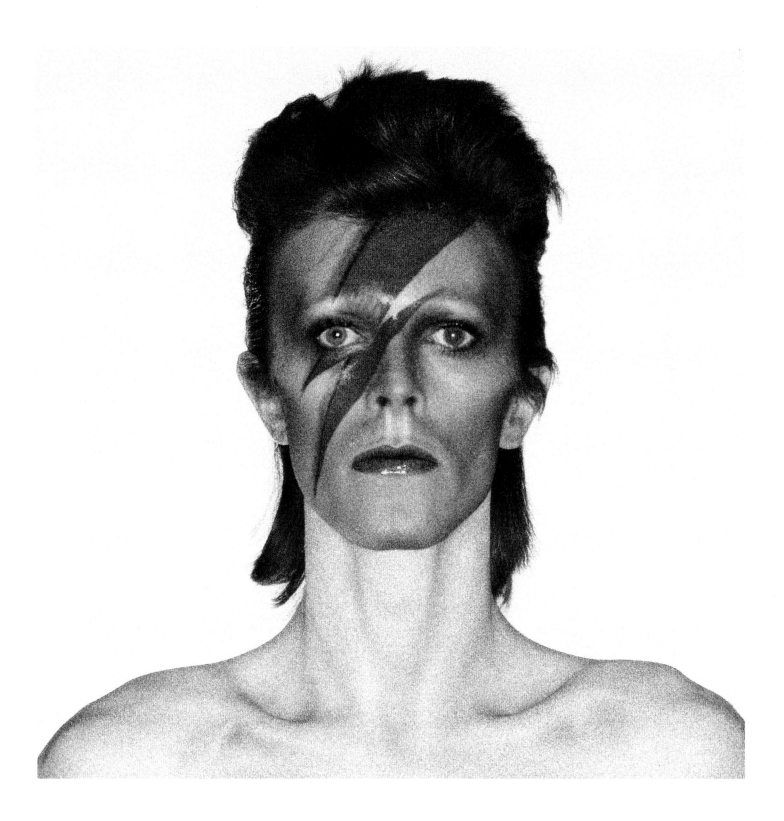

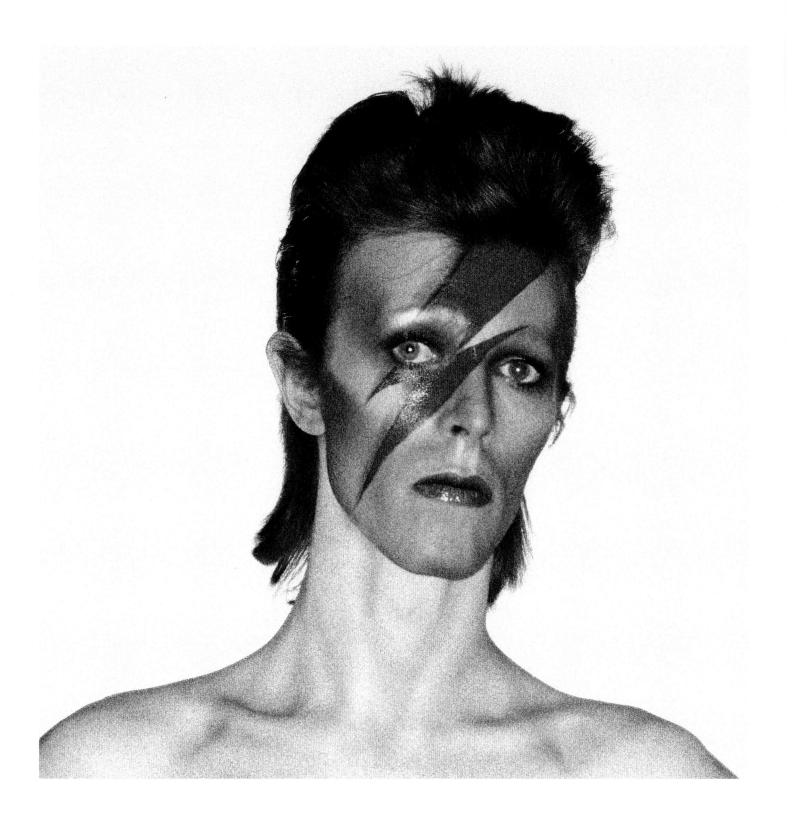

ABOVE — Headshots 14–15.

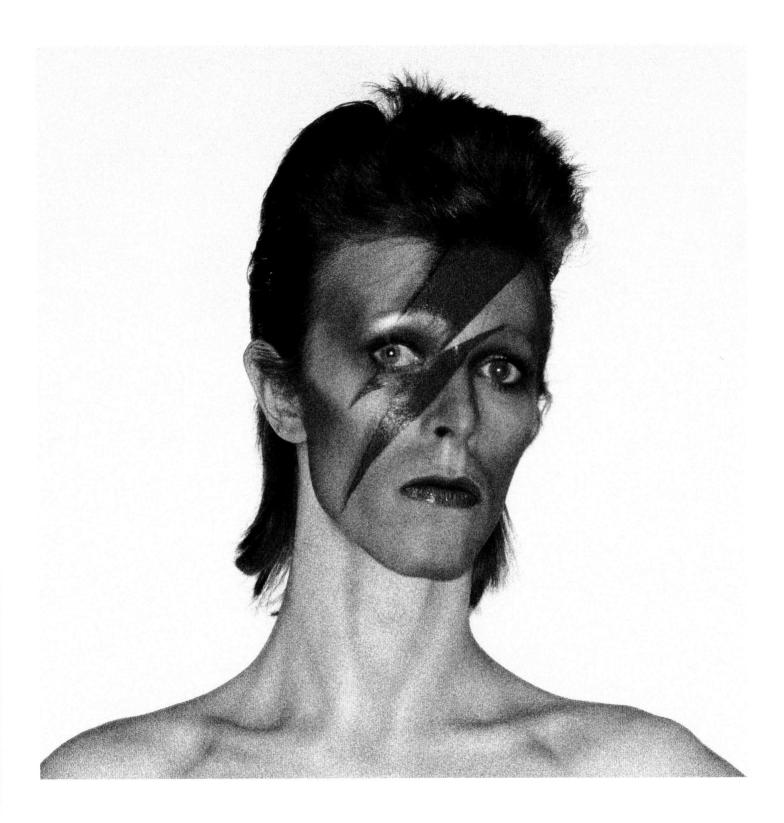

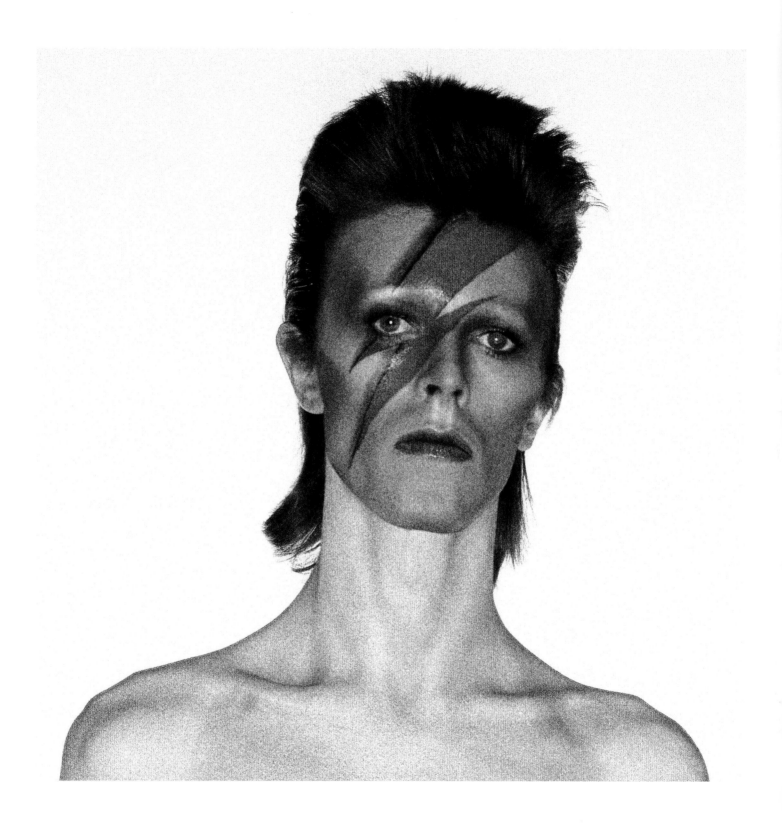

ABOVE — Headshots 16–17.

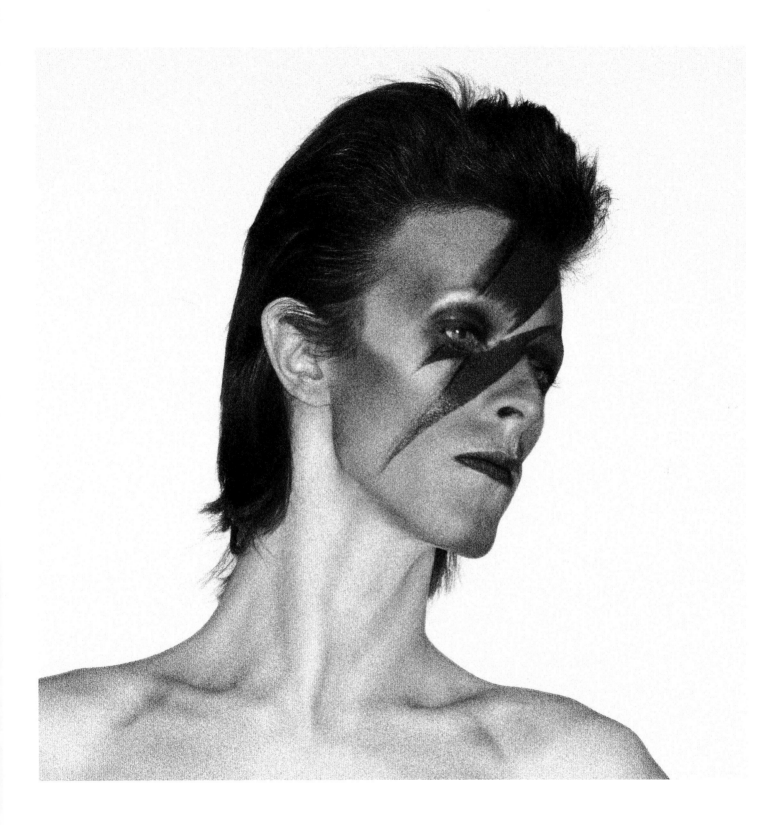

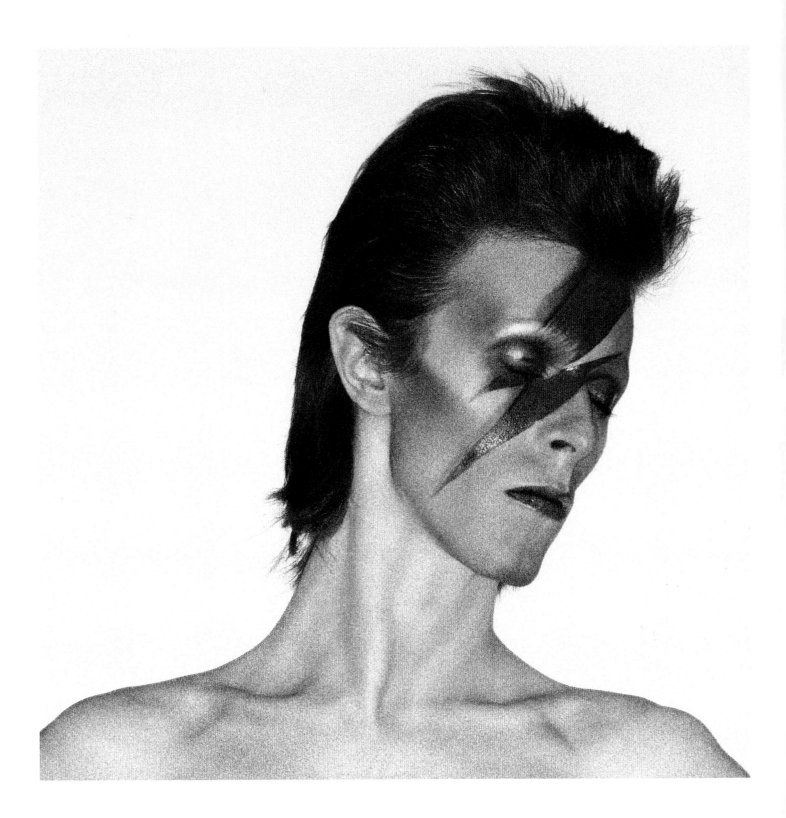

ABOVE — Headshots 18–19.

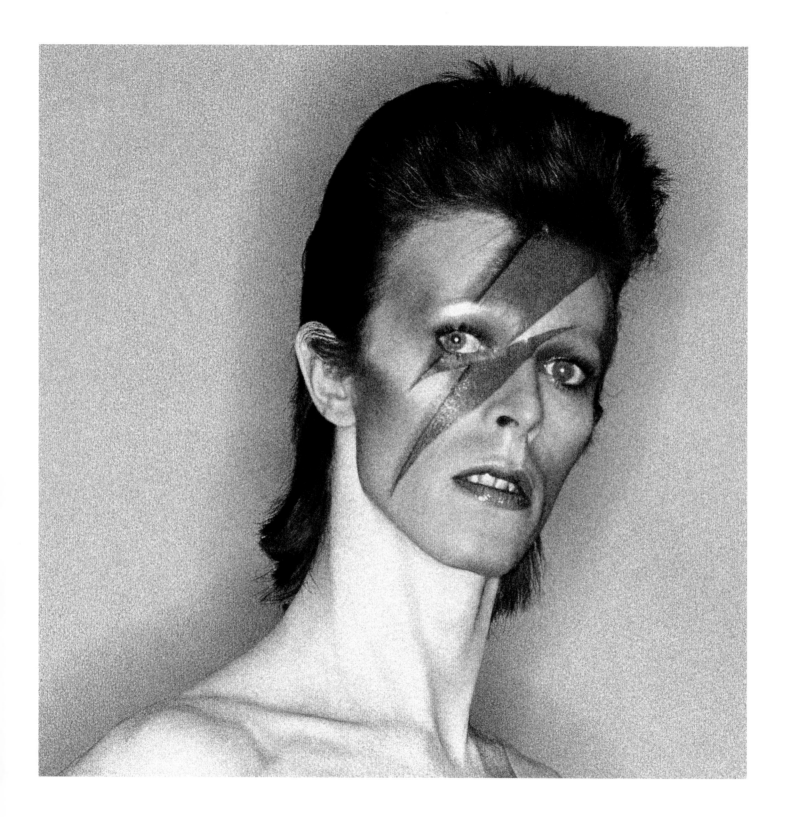

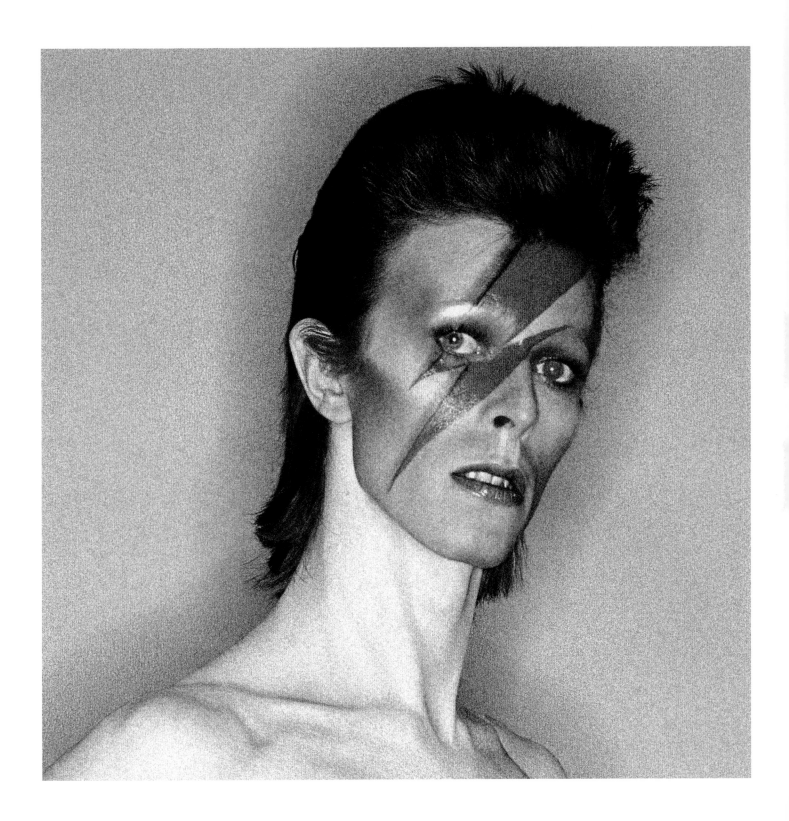

ABOVE — Headshots 20–21.

04.
PANIC
IN DETROIT

NICHOLAS PEGG

ITS GRITTY IMAGES
OF URBAN MELTDOWN,
ITS JITTERY VIBE
OF NERVOUS
DESPERATION, AND ITS
BACKGROUND HINTS AT
A DEVELOPING INTEREST
IN THE TEXTURES
OF AMERICAN SOUL.

IT'S an observable phenomenon that on most David Bowie albums, you'll find one particular song which drops a hint about what's coming next. Thus, for example, the title track of *Station to Station* offers a preview of Bowie's forthcoming "European canon", while amid the piano-led ballads of *Hunky Dory*, the turbo-charged guitar of 'Queen Bitch' explodes like a box of fireworks and heralds the shape of things to come on *Ziggy Stardust.*

Perhaps uniquely, *Aladdin Sane* might be said to feature two such tracks. The high-octane reboot of 'Let's Spend the Night Together' sets the scene for the covers project *Pin Ups*, but if we're to look beyond that to the next Bowie-penned album, then there's another track that points the way. With its gritty images of urban meltdown, its jittery vibe of nervous desperation, and its background hints at a developing interest in the textures of American soul, 'Panic in Detroit' is more than just a key track on *Aladdin Sane*: it's also a scene-setter for *Diamond Dogs.*

Some Bowie albums — *Diamond Dogs* among them — offer a narrative element. Others, like *Aladdin Sane*, are more akin to short story anthologies on a given theme — in this case, David's reactions to the people and places he encountered during his inaugural tour of America in 1972. 'Panic in Detroit' is among the most vivid of the vignettes: a bleak, violent, characteristically opaque little story narrated by an impressionable kid who idolizes a charismatic revolutionary, events swiftly escalating to a sticky end. It wasn't the first time Bowie had alighted on such subject matter, and it wouldn't be the last: gun-toting desperadoes rear their heads in 'Running Gun Blues', 'I'm Afraid of Americans' and many more besides. His penultimate album, *The Next Day*, positively bristles with them.

Initial inspiration for 'Panic in Detroit' came in the form of two separate encounters on the same night — 28 September 1972, to be precise — when Bowie and the Spiders played at New York's Carnegie Hall. Among those in attendance that evening was Iggy Pop, fresh from recording his album *Raw Power* in London. Following the after-party, Iggy sat up with David into the small hours, telling him tales of the colourful characters he had encountered during his youth in Michigan, of Detroit's infamous five-day riot in 1967, and of the city's countercultural icon John Sinclair. Jazz poet, activist and manager of the MC5 (whose 'Kick Out the Jams' Bowie had already referenced three years earlier in his own countercultural polemic 'Cygnet Committee'), Sinclair was a co-founder of the White Panther Party, the anti-racist collective whose stated aims included "fighting for a clean planet and the freeing of political prisoners", not to mention "rock'n'roll, dope, sex in the streets and the abolishing of capitalism."

In 1972, Sinclair was very much a talking point: the previous December he had been released from prison after serving two years of a ten-year sentence for offering marijuana to an undercover officer, a sanction so harsh that protests had mobilized behind such luminaries as John Lennon, Stevie Wonder and Allen Ginsberg. Then, just three months before David and Iggy sat up talking about him, Sinclair had been acquitted by the US Supreme Court on charges of conspiracy to destroy government property, the case thrown out owing to the authorities' illegal use of surveillance. Sinclair had

walked free, a villain to some but a hero to many: just the sort of character of whom any self-respecting rebel might happily ask for an autograph, as the young narrator does in Bowie's song.

But 'Panic in Detroit' isn't about any one individual; as ever in Bowie's scheme of things, it's a more nebulous construct than that. According to David, the second inspiration on that same night at Carnegie Hall was an old schoolmate from Bromley who unexpectedly turned up backstage: to David's astonishment, he was now a powerful drug dealer in South America. "He was the full bit, with the clothes and the piece and everything," Bowie later recalled, "and I thought, my God — *him?*"

A third allusion, its immediacy dulled by age and familiarity, is the opening gambit of Bowie's lyric. In the autumn of 1972, the Marxist revolutionary Che Guevara had been dead for only five years — in fact, for *precisely* five years. Recollections differ as to exactly when Bowie put pen to paper, but legend has it that he wrote the song in Detroit itself, where the Spiders played on October 8. If so, the timing was remarkable: the very next day was the fifth anniversary of Guevara's execution. To this day, the famous Korda photograph of Che Guevara adorns many a student bedroom, though its impact has inevitably been blunted by time. Back then, it was held aloft on protest marches for every cause under the sun: a cultural rallying point, a totem for all that was underground and subversive. For the teenage Bowie fan hearing *Aladdin Sane* for the first time back in 1973, the opening line of 'Panic in Detroit' was in its own way just as taboo as that naughty word in 'Time'.

It's worth remembering, too, that Bowie wasn't yet done with Che Guevara. The images adorning the inner gatefold of 1979's *Lodger* include the notorious mortuary photo of Guevara's laid-out corpse, set alongside Andrea Mantegna's fifteenth-century painting the *Lamentation of Christ*: each mirroring the other, and both of them echoing Bowie's sprawled body on the *Lodger* sleeve.

Another reverberation of past and future lies in that insistent rhythm pattern: 'Panic in Detroit' is one of several Bowie songs that cleave to the beat forever associated with Bo Diddley, the signature five-accented clave rhythm which has made its presence felt everywhere from the Who's 'Magic Bus' to George Michael's 'Faith'. For Bowie, the fidgety rhythm of the Bo Diddley beat seems to have recommended itself to songs tackling emotional or spiritual turmoil, from the self-lacerating anguish of 'Unwashed and Somewhat Slightly Dazed' to the philosophical enquiries of 'Up the Hill Backwards', or the unhappy heroines of 'God Knows I'm Good' and, many years later, 'God Bless the Girl'. During the recording of 'Panic in Detroit', drummer Woody Woodmansey initially rebelled against Bowie's request for a straightforward Bo Diddley rhythm, considering it corny and suggesting a more complex groove he had rehearsed, apparently influenced by John Bonham. "I'd worked out some cool drum fills," Woodmansey later recalled, but when he reluctantly capitulated and started playing the Bo Diddley beat, "immediately I knew he was right. It felt great to play and fitted the song perfectly." As ever, David Bowie knew precisely what his song required.

On the finished track, it's Mick Ronson who establishes the rhythm: 'Panic in Detroit' opens with his unaccompanied guitar playing the Bo Diddley figure before the drums and bass pick up the beat. Then, swooping across

the speakers, we hear *Aladdin Sane*'s unsung heroines, the backing vocalists Juanita Franklin and Linda Lewis. They hit the ground running at the top of the album in 'Watch That Man', but their showpiece is 'Panic in Detroit', those unearthly wails escalating as the song takes flight, Ronson's guitar spiralling from the wired tension of the intro to the frenzied mania of the final playout. Soaring above it all is Bowie's extraordinary vocal: brittle, passionate, high in the register, inhabiting the youthful character of the student narrator, vividly dramatizing the anxiety and desperation.

Perhaps surprisingly, 'Panic in Detroit' wasn't a regular live fixture for the Spiders, making only the occasional appearance during Ziggy's last few months on stage; but on the subsequent two tours it became a mainstay. It slotted perfectly into the dystopian setting of Hunger City for 1974's Diamond Dogs show, accompanied by an elaborate shadow-boxing routine in which Bowie fought an invisible opponent — and lost. A deliriously brilliant live recording appeared on the B-side of that year's 'Knock on Wood' single, and latterly on the full-length *David Live* album. When the Thin White Duke took to the road two years later, 'Panic in Detroit' was again a cornerstone of the setlist. On both tours, the number climaxed with a delicious breakdown section giving each player a moment in the spotlight, and in the 1976 iteration, pride of place went to drummer Dennis Davis, whose extravagant solos would sometimes extend 'Panic in Detroit' to more than 10 minutes in length. There's a gorgeous rendition to be heard on the live album recorded at Nassau Coliseum.

In 1979, Bowie recorded a brand-new studio version, initially intended for broadcast on a Kenny Everett TV special but shelved until it was issued as a bonus track some years later. It's a fast and furious rendition, recapturing the coiled-spring tension of the original, but in other respects quite different: producer Tony Visconti contributes an impersonation of the then-ubiquitous Speak & Spell toy, while Bowie imbues the narrator with a new kind of energy through the heightened mannerisms of his Brechtian *Scary Monsters*-era vocal style. Further revivals followed on world tours in the 1990s and 2000s, each successive resurrection revealing fresh facets to a great song which, like all Bowie's best, continued to evolve and never collected dust.

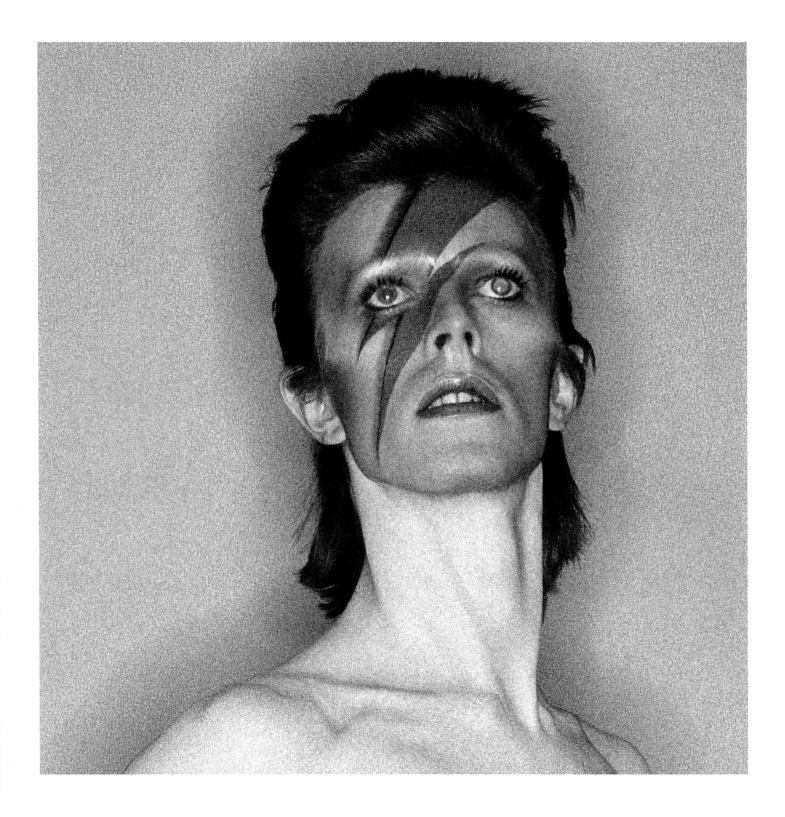

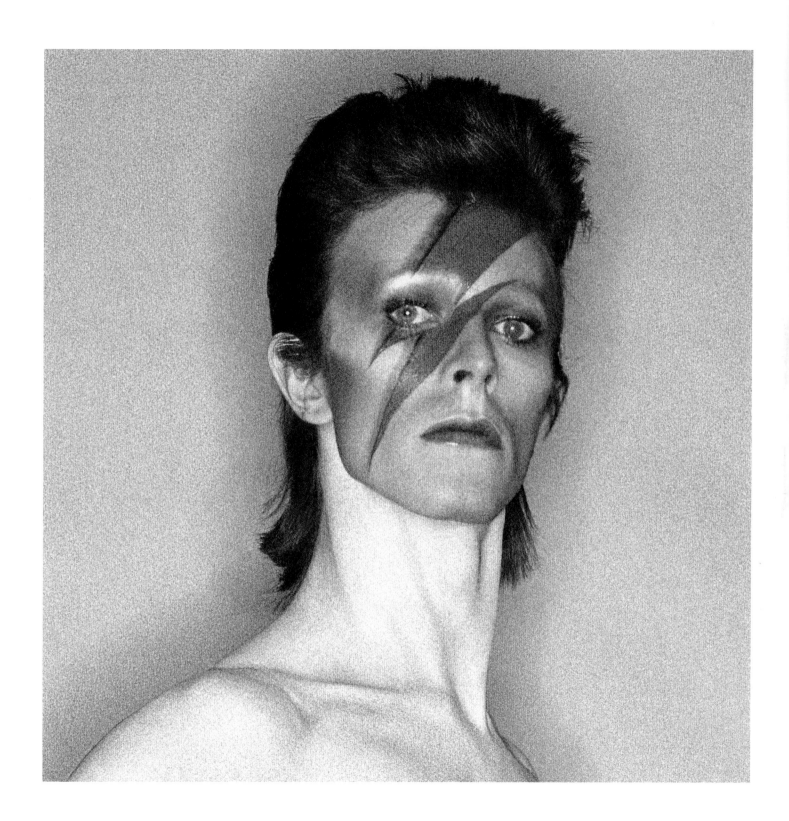

ABOVE — Headshots 22–23.

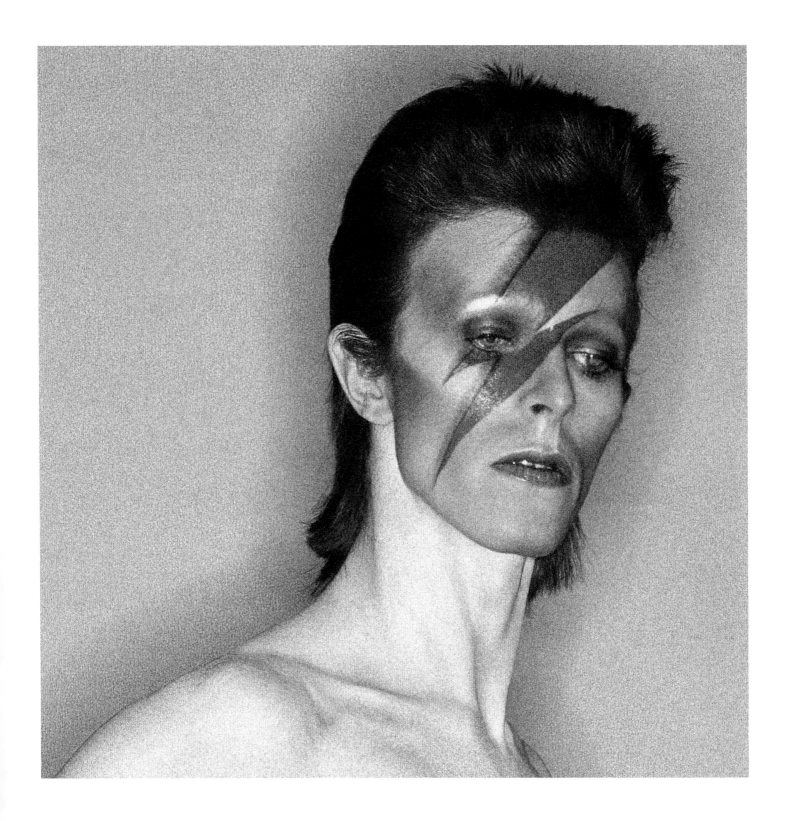

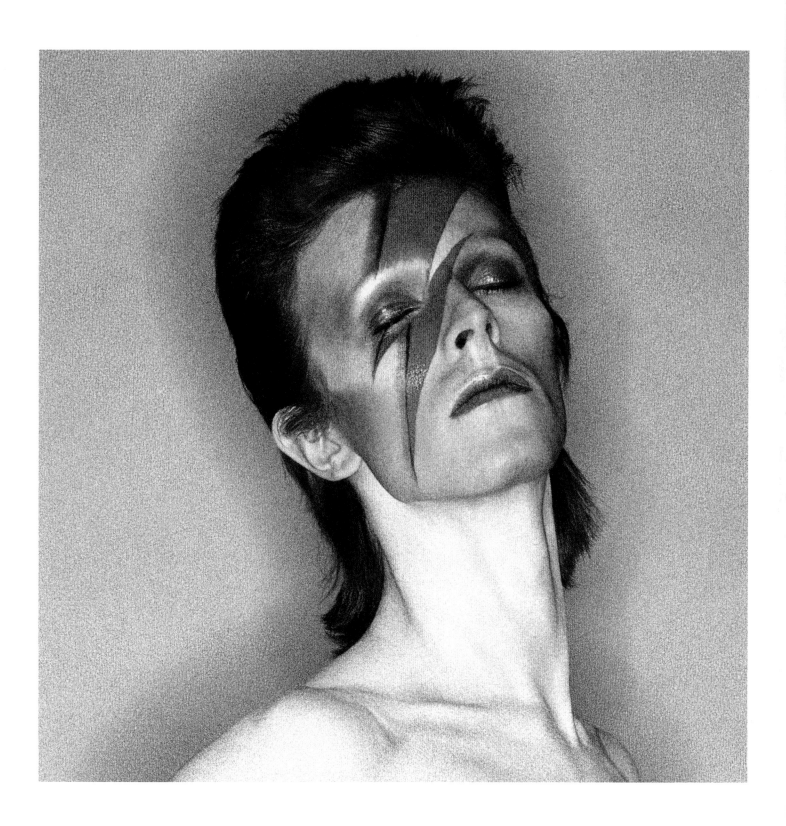

ABOVE — Headshots 24–25.

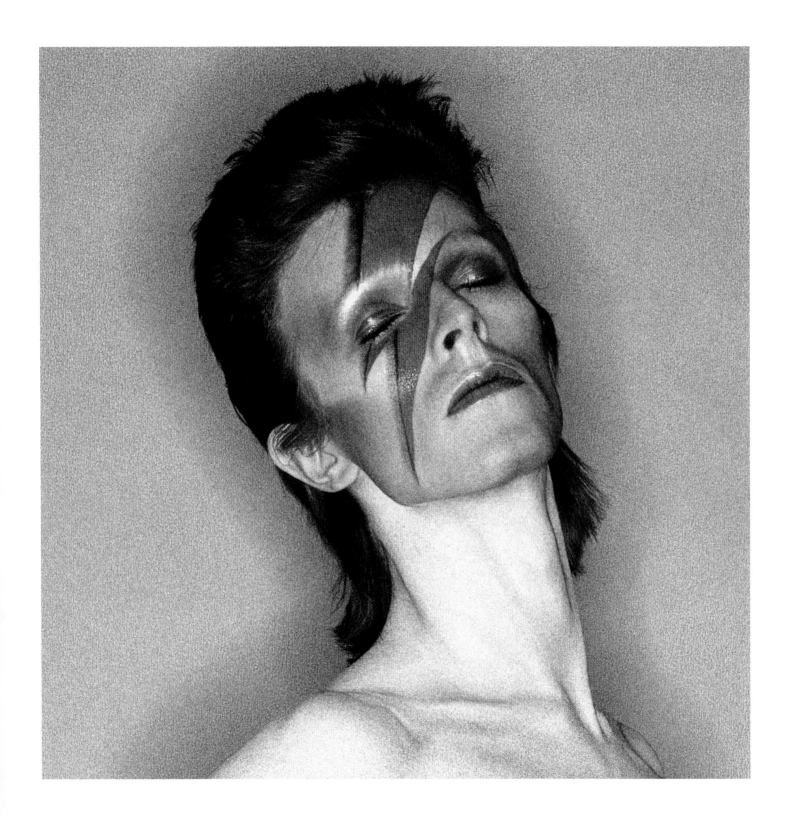

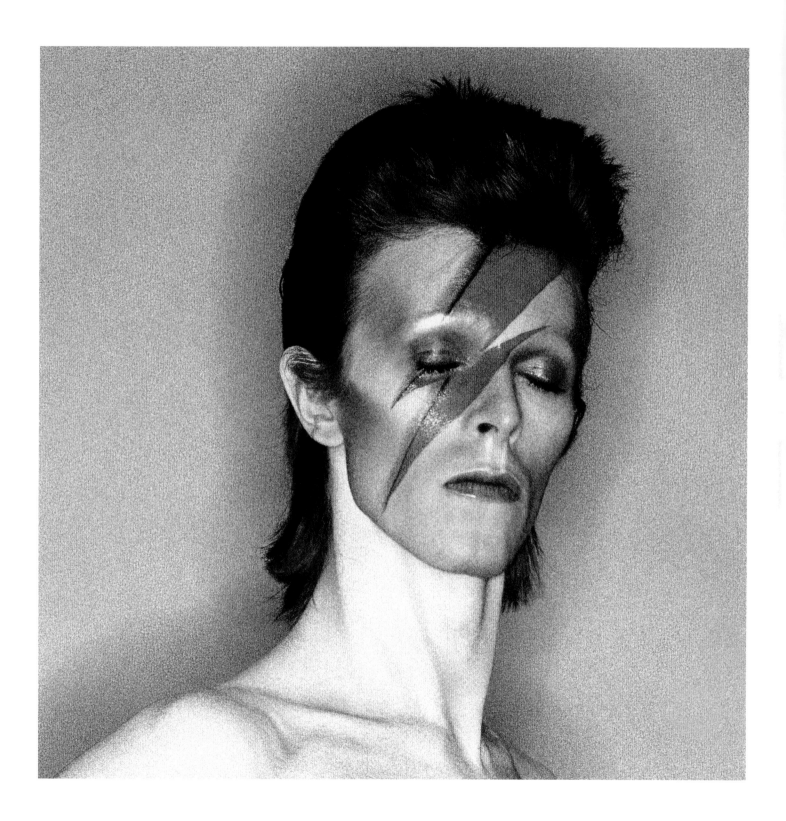

ABOVE — Headshots 26–27.

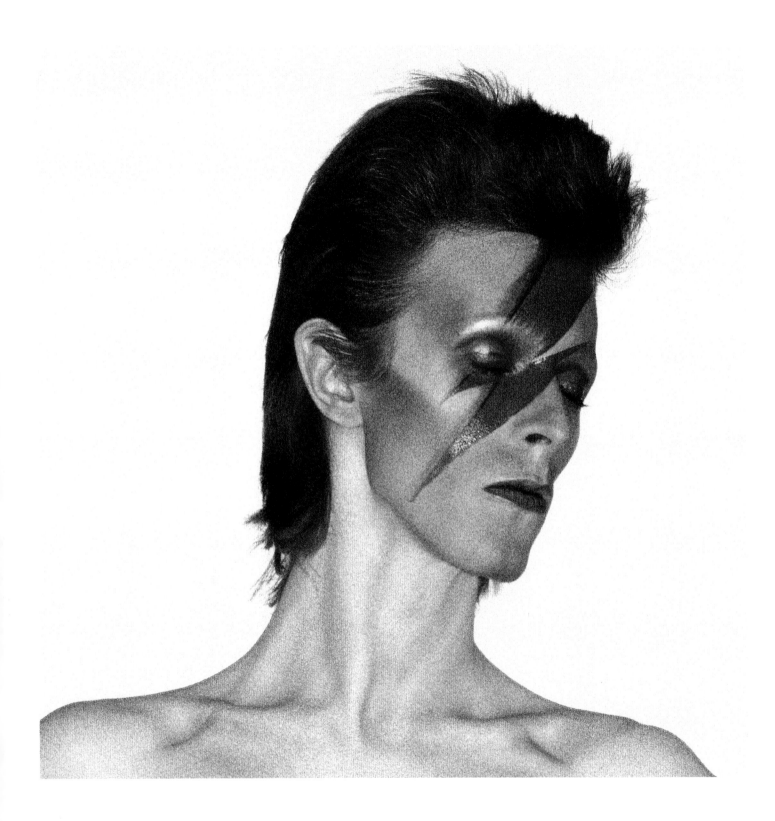

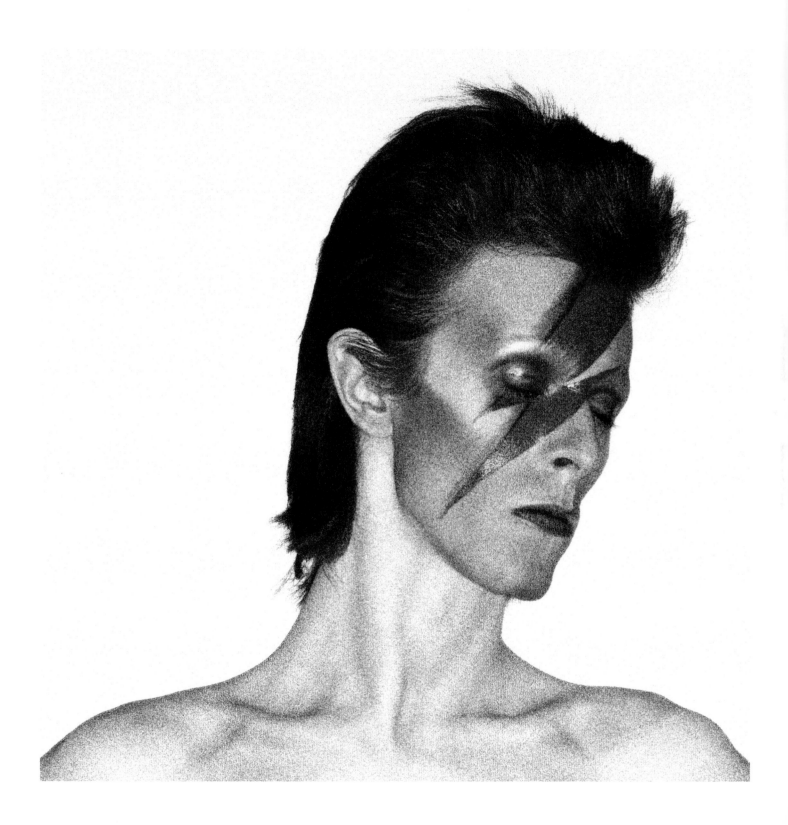

ABOVE — Headshots 28–29.

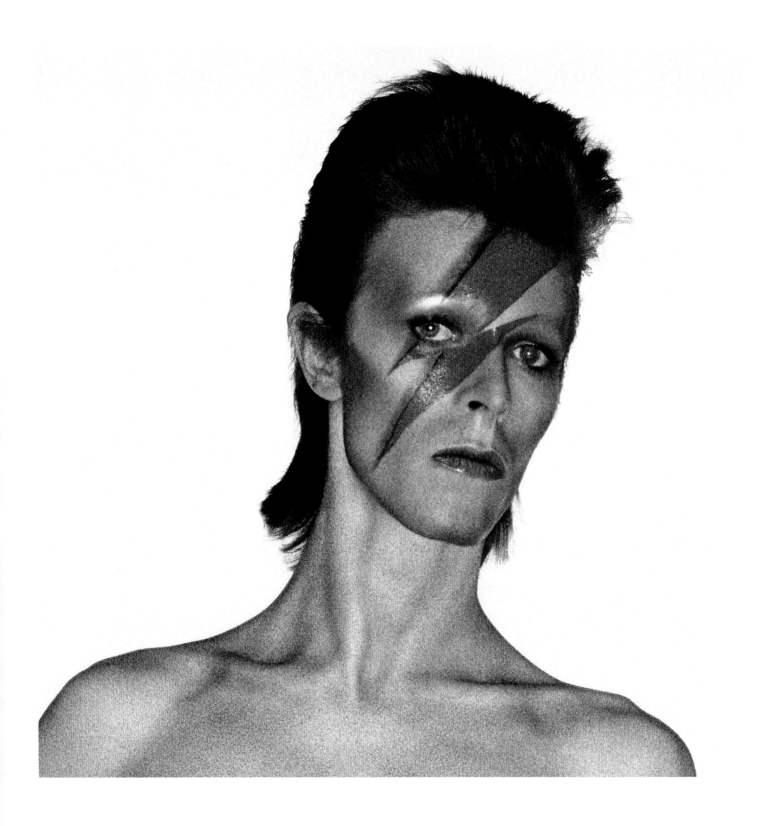

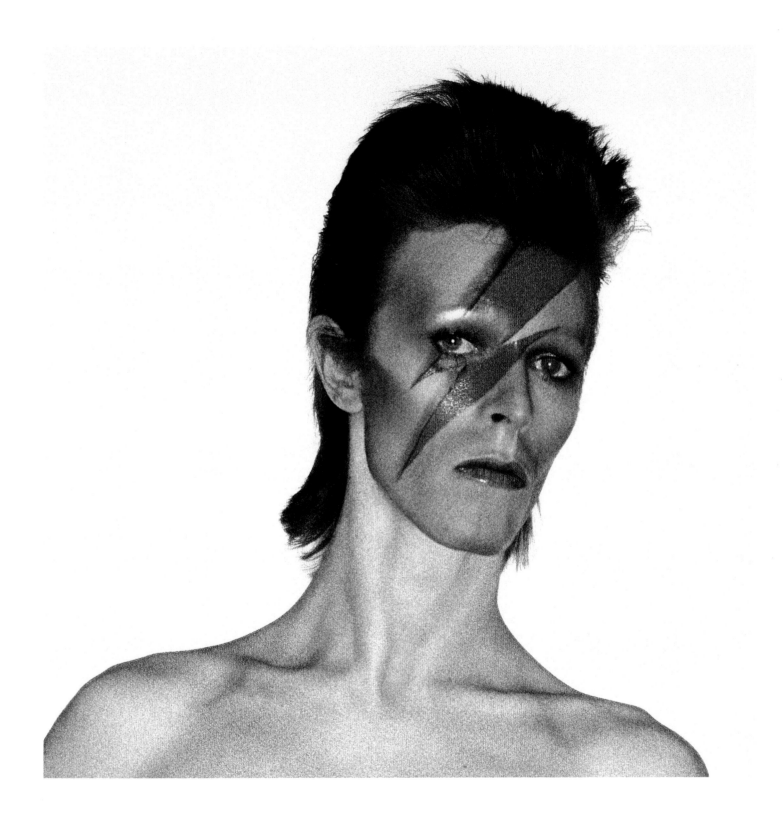

ABOVE — Headshots 30–31.

05.
CRACKED
ACTOR

JÉRÔME SOLIGNY

There is also,
unquestionably
(as would be confirmed
by any guitarist),
something Iberian
about 'Cracked Actor',
which ends the a-side of
Aladdin Sane on a note of
bloody-nosed rage.

IT was during the summer of 1973 that David Bowie heard, probably for the first time, of Carmen. Tony Visconti, who had last worked with him on *The Man Who Sold the World*, was now mixing the first album by this Anglo-American band at Air Studios near Piccadilly Circus, and had invited him to come and hear their music. On the release of *Fandangos in Space*, the press would call it "prog rock *flamenco*". And curiously enough, whereas that Spanish word has often been used to describe the instrumental part of 'Lady Grinning Soul' — the second song I have been asked to write about for this book — there is also, unquestionably (as would be confirmed by any guitarist), something Iberian about 'Cracked Actor', which ends the A-side of *Aladdin Sane* on a note of bloody-nosed rage.

Of course, the sound of Mick Ronson's guitar — a Les Paul Gibson played through a Marshall amp pushed to its limits — is a lot more brutal than the instruments, mainly with nylon strings, used by flamenco guitarists. What's more, we're hearing guitars plural; from the very first seconds of the song, we can distinguish two rhythm guitar tracks, each played differently and panned left and right in the stereo mix. And yet Ronson, whose guitar is more prominent (played more aggressively and louder in the mix) on *Aladdin Sane* than on the two albums that preceded it, was using only a basic but effective distortion pedal (Tonebender) and a wah-wah pedal (Cry Baby) — and not leaning on them too heavily. Once he had found a good setting, Mick made use of it more as a frequency stabilizer, a kind of equalizer.

And so, what gives 'Cracked Actor' its Spanish feel — as a young scratcher of guitar strings, aged 13 when *Aladdin Sane* was released, I remember very clearly thinking this to myself as soon as I heard the song for the first time — is the chord progression in the introduction, repeated after each chorus and, of course, throughout the final section. An E, followed by an F, then a G ... this progression, even if played without open strings (a special characteristic of flamenco, particularly in the movement from E to F) immediately transported this *gamin* from the north-west of France to much further south, and even beyond the Pyrenees: to the land of Picasso, of Dalí and of bullfighting.

I don't agree with those critics — the bigwigs of English rock writing, no less — who detected in 'Cracked Actor' similarities with Lou Reed's solo recordings, and in particular 'Vicious', which just so happened to have been produced by Bowie and Ronson. The opening track on *Transformer*, which had come out six months earlier, is obviously extraordinary, but compared with 'Cracked Actor', it sounds totally laid-back, *à la* the Rolling Stones "in exile". Mick Jagger, who was only rarely caught red-handed doing "spoken word" (except in the verses of the marvellous, pseudo-country 'Far Away Eyes', which he would record with his group a bit later), always made it a point of honour to really "sing" the melodies he created with his guitarist accomplice Keith Richards. By contrast, Lou, genius that he was, sometimes gave the impression vocally of simply strolling through his own songs, figuring that the melodies were necessary guides but certainly not Olympic diving boards from which to launch an epic vocal rendition.

With a magnifying glass we could certainly find connections, as thin as hair (orange-red hair, for that matter ...) between the lyrics of 'Cracked Actor'

and of 'Vicious', but more in the musicality of the words (their sonority, their length, their placement on or off the beats of the bars) than in their meaning, once arranged in verses. In New York with David Bowie in 2003, in a suite at the Thompson Hotel just by his home, we spent a good 20 minutes laughing as we leafed through a book — whose title I will keep to myself — which "explained" his song lyrics. He himself was not often very sure about what they meant, and sometimes showed irritation about people thinking they could find rational explanations or logical meanings in his writing, which — without opening the floodgates here on other issues — was shaped and determined very often by ... chance.

Only very few of Bowie's musicians were ever told what any of his pieces were about, and that was just before recording them (that is, when he had just put the final touches to the songs). I know of only three, and it's been a great pleasure to talk to them. The only other person alive who has had the right to be given real and significant clarifications of this kind is Ivo van Hove. Before starting work on *Lazarus* in 2014, the director insisted on knowing more about all of the songs that would be performed in the musical. David, perhaps already ill, had taken the time to apply himself to the task. Later, Coco, his personal assistant for more than four decades and from whom no detail ever escaped, confided in Ivo van Hove that Bowie had never said as much to anybody else about his writing. Ivo took the hint, vowing never to reveal what he had been told.

So, if the challenge is to find, at any cost, an influence on 'Cracked Actor' (at least two of the songs on *Aladdin Sane* were written with a specific exemplar in mind, but not this one), then we would do better to look toward Iggy and the Stooges. There are at least two other tracks on *Aladdin Sane* which owe a similar debt (even more blatant and openly acknowledged): 'The Jean Genie' and 'Panic In Detroit'. But on 'Cracked Actor' it's the live performances of the band from Ann Arbor which set the pace. From the very first seconds, we hear Ronson's determination; he's tackling just one chord — but what a chord! E major! If you had to distil the entire history of rock into one chord, it would obviously be that one — and his guitar sounds raw, as if a cargo train hurtling at high speed is coming out of the Marshall, while the harmonica growls, played by the boss and made louder and "nastier" by Ken Scott's suggestion to put it through Mick's amp. All of this evokes the warlike feel of the Stooges playing live, giving no quarter. 'Cracked Actor' is not actually the fastest track on the album (126 beats per minute, whereas the cover of 'Let's Spend the Night Together' runs at 166), but in its energy, both brutal and rebellious though fiercely contained, we can discern allusions to the Stooges.

The piece certainly does not have the virulence of their firelighter 'Search And Destroy', but nor does any known track in the history of rock; it's a song that ignites the explosive *Raw Power*, the album mixed by Bowie at the end of the previous summer — triggering the ire of many who thought the album could or should have had a different sound (though James Williamson, guitarist and composer of the whole album, sees Bowie's mix as definitive). Work on the album seems to have brought some comfort to Ziggy Stardust though, its title track confirming that he, too, had been born to be wild. And since I am mentioning the last Iggy and the Stooges album to be released —

in October 1973 — before their comeback nearly 35 years later, it's amusing to point out that whereas David Bowie did indeed mix (though not produce) *Raw Power*, he was not present, except for during one song, at the final stage (before cutting) of the making of *Aladdin Sane*. This is apparently the reason why Iggy's voice (which David adored) is so loud on *Raw Power*, while his own (he did not regard himself as a great vocalist) is less prominent on *Aladdin Sane*. Ken Scott probably followed Bowie's instructions very much to the letter on 'Watch That Man', where the vocal is buried in the mix.

Aside from all these considerations, what elevates 'Cracked Actor' beyond being a banal rock track into a masterful song? Like most of David Bowie's compositions (and in addition to his voice), the answer lies in the chord progression and, primarily, the verse. Here again, he juxtaposed and bound together things which, outside of his songs, had nothing to do with each other. It took a magician like him to link this very pop, almost fantasy — even arrogant — section to a slightly less original but hugely effective chorus (the words "crack", "smack" and "suck" fall like cleavers on the beats of the bars) whose harmonic sequence is similar to the instrumental part of 'Moonage Daydream', itself something of a lift from Roxy Music.

Further, it must not be forgotten that this sleight of hand, like the whole album and the two preceding it, owes much to the other two Spiders from Hull: bassist Trevor Bolder, the nimble-fingered conjuror who also knew how to groove; and Woody Woodmansey, who asked Ken Scott to mix his drums louder this time, to the level Bowie expected.

For a moment, it's almost possible to forget that 'Cracked Actor', "written in Hollywood" according to its author, tells the story of an illicit sexual relationship (between an ageing film star and a young street girl) against a backdrop of drugs and disillusionment. And is that disillusionment not exactly the true subject of the song? David Bowie loved the idea of his words being thrown to the wind and open to multiple interpretations. In the song's ending — the three chords from the intro come back on a loop — where he pleads to God knows who, we can still feel, 50 years on from our first encounter with 'Cracked Actor', the symptoms of a disenchantment which Bowie (who would become a real one himself just two years later in New Mexico) had perhaps not planned for, but which he knew, from very early on, to be inescapable. And perhaps that is the reason why the "mistake", clearly audible at the start of an E chord section, a little less than one minute from the end, like that of Trevor Bolder on 'The Jean Genie', was kept. An artistic accident, a "crack" for sure, but a slight one compared with the irreversible fragmentation, fatal and seemingly already primed, which would soon no longer be possible to hide from anyone.

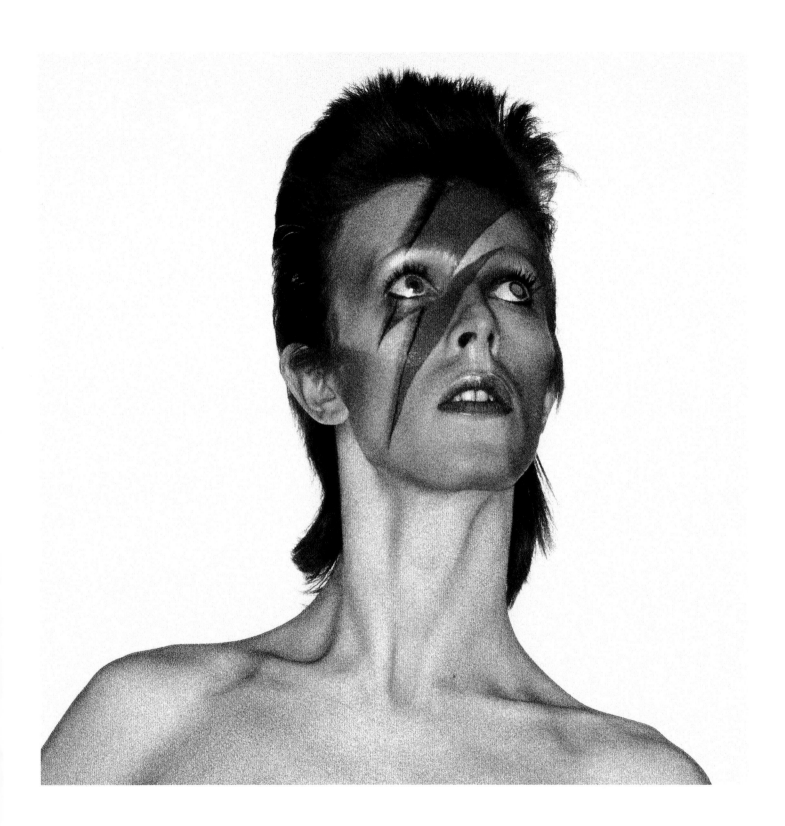

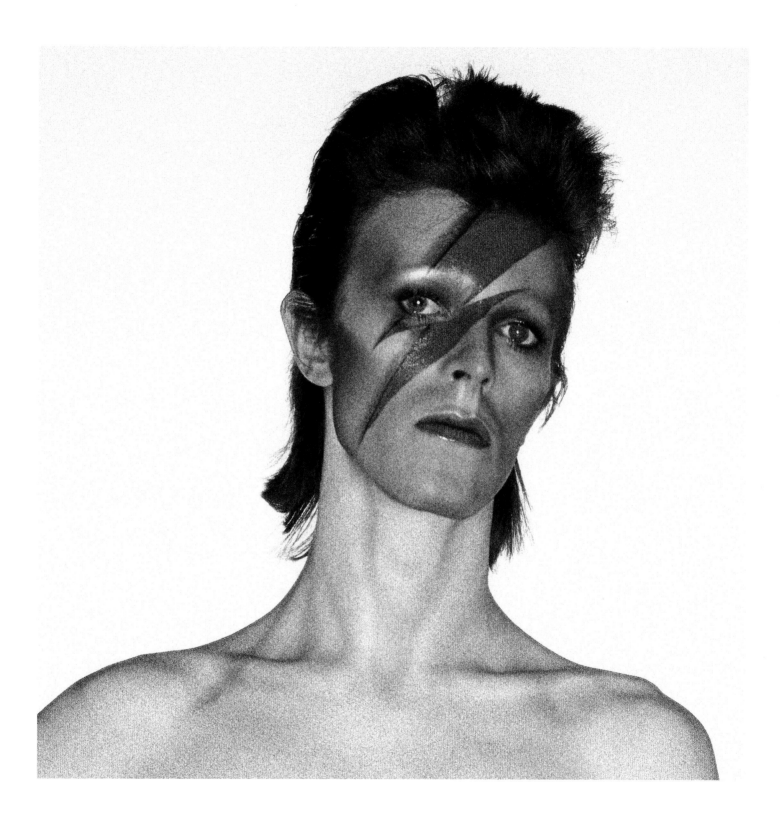

ABOVE — Headshots 32–33.

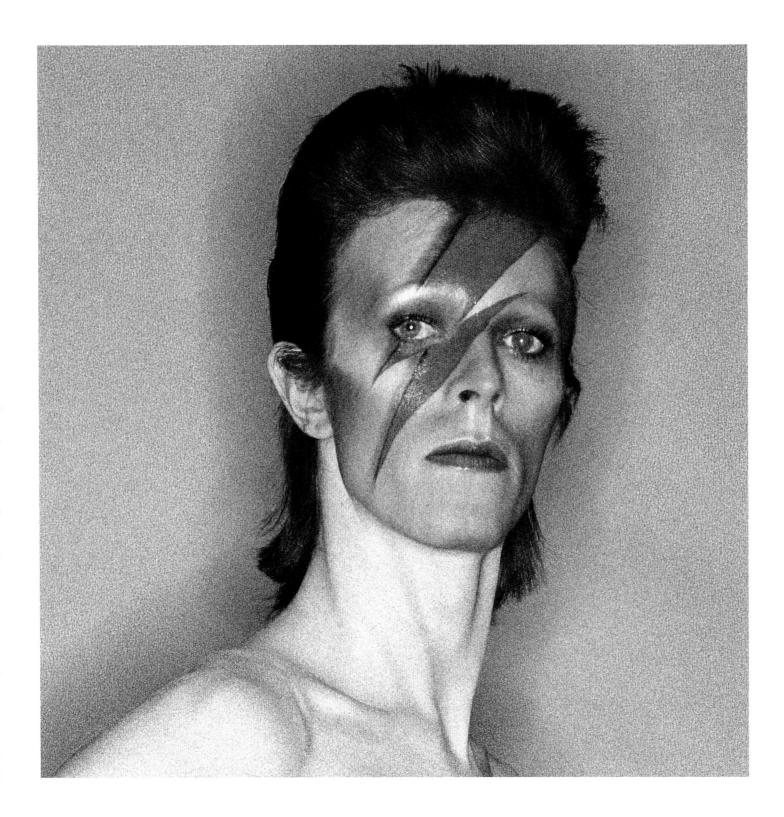

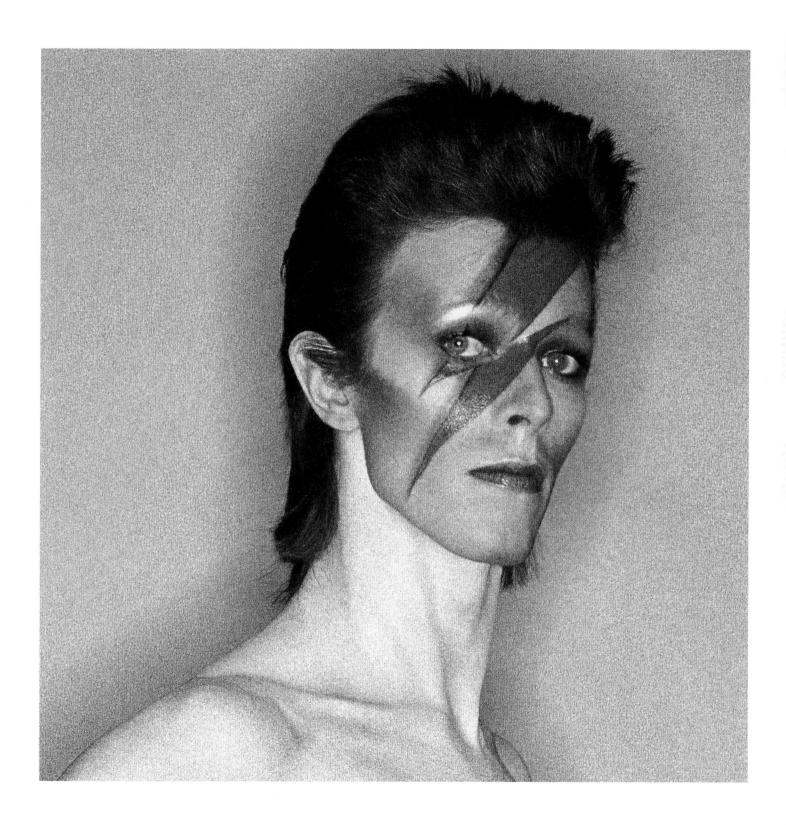

ABOVE — Headshots 34–35.

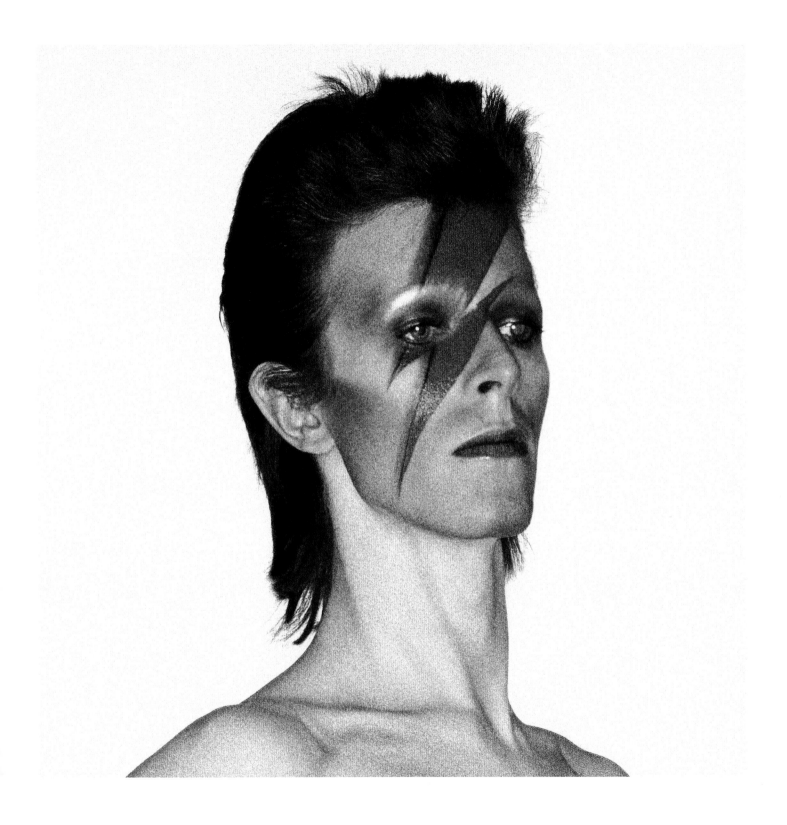

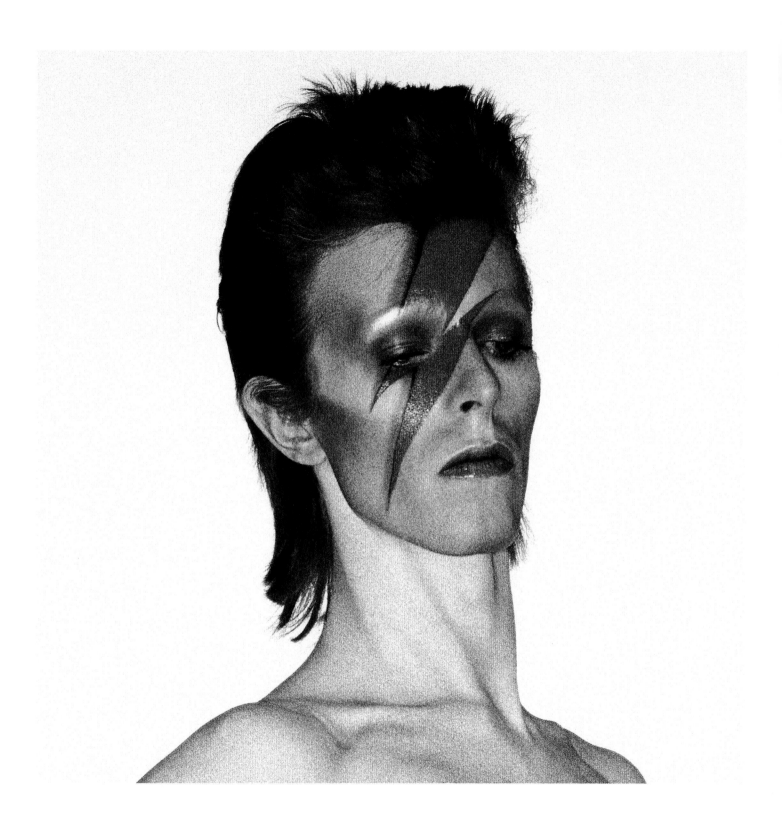

ABOVE — Headshots 36–37.

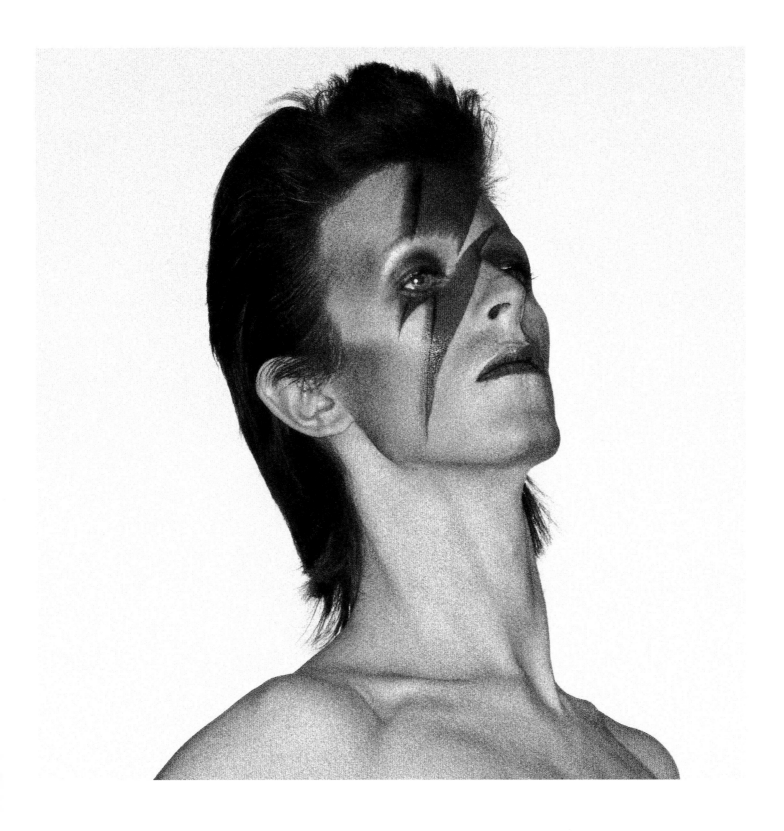

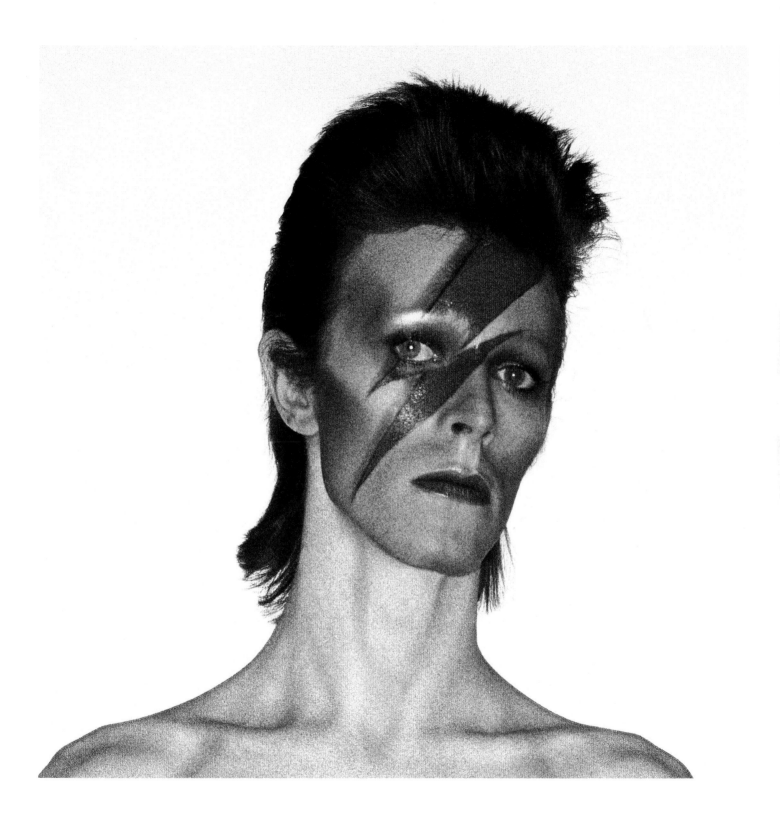

ABOVE — Headshots 38–39.

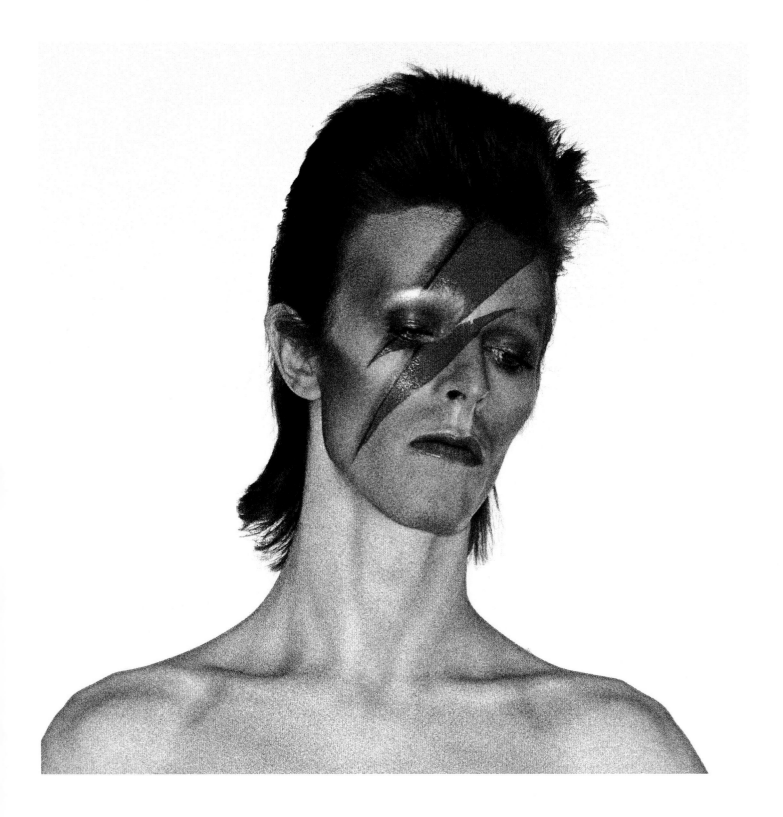

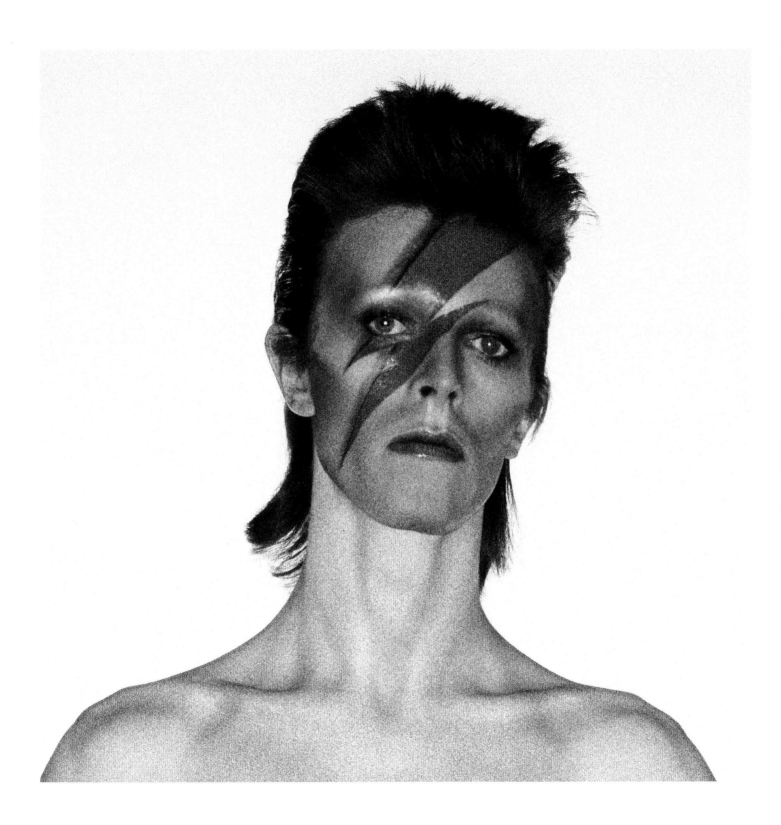

ABOVE — Headshots 40–41.

06.
TIME

PAUL MORLEY

BOWIE RETURNS FOR
ALADDIN SANE SIDE TWO,
WITH A UNIQUE SENSE
OF TIMING THAT WAS
LITERARY, THEATRICAL
AND EXISTENTIAL, AFTER
THE REMINISCENCES,
MIRAGES AND BREAKDOWNS
— AND BREAKTHROUGHS —
OF THE FIRST SIDE.

ONCE upon a time, after you had played side one of a record, especially in the first few days after it had come into your life, there would be the pause as you turned it over to continue the show. It was a kind of interval, a break. It didn't break the spell, though, especially when it was a new record by David Bowie, always somehow a coherent compilation of feelings and impressions however far-fetched and feverish, or abstract and cryptic, or disjointed and rushed.

There was naturally a beginning and an end to a vinyl album, and, at the beginning of the second side, a sort of middle, as much as it was also itself a beginning and an end, a world of its own with its own reason and logic. In the twentieth century, you dropped the needle and inside a dream pause watched the certain movement of the grooves before blast off. Now, in a world Bowie saw coming, where he's as in the moment as he ever was, you do what you have to do. You still take off.

No wonder albums inspired a love that still lingers even as technology moves on; listening to your favourites, you could have the time of your life, and lose yourself in an invented time. And no one understood the shape and structure of a record album and its singular capacity to stretch the imagination and reflect the mess and magnificence of the mind better than David Bowie.

Album songs went in a certain order and theoretically you could mix them up and play them in whatever order you wanted — eventually, all songs would be released into the streaming wild to fend for themselves, and record sides would become historical sites, sentimentalized remnants — but at the time, the running order of an album seemed exactly how things were meant to be. The order was sacred. Like a film, book or play, even one that played fast and loose with the order of time, this was how the story went, and you followed it as though it was a map of reality — and time — itself.

This amorphous pause between side one and side two was part of the performance. As a listener, you could join in with that performance, introducing your own sense of timing to proceedings, creating your own solemn ritual, helping the story continue as you turned the record over. With David Bowie, in that pause, there was always a lot to think about — and look at, because how Bowie decided to occupy a record cover, revealing and concealing himself all at once, would play such a huge part in opening up a new elsewhere.

So, a little bit of time, and then Bowie returns for *Aladdin Sane* side two, with a unique sense of timing that was literary, theatrical and existential, after the reminiscences, mirages and breakdowns — and breakthroughs — of the first side, the connections made between fiction and reality, the wonderfully told mental dramas exploring the relationship between madness and genius, the vagrancy and vulgarity flowing somewhere between the present and the past.

Miraculously refreshed, although who knows where he's been, he takes a trip away from discovering his America, mocks up a more explicitly neo-European scenario, and makes a stab at settling his nerves. He boldly tackles a subject that has excited the minds of many great thinkers throughout the centuries from Shakespeare's "tomorrow, tomorrow and tomorrow",

his "there's a time for all things", via Jagger's "time is on my side" to Auden's "you cannot conquer time". Before long, for Bowie (and to slightly paraphrase), time flexes like a whore and falls wanking to the floor. For some, he's lost it, for others, he's right on song. Both versions have their thrills.

All Bowie's songs were, as part of the way he shaped his life, about the passage of time, and how it shifts and bends, how it flies, how it freezes, how it turns things upside down and inside out, how it never stops but, of course, how it ends — and now, as if to try and pin down the very idea of now, here is a song actually called 'Time'. And if all his songs can seem like they come from imaginary musicals, this one more than most came romping and jerking into view out of some depraved musical that would never fully see the light of day, only to emerge in fragments, across albums, and the time it took to take him, as if he had been moving backward through life, to *Blackstar*.

'Time' plays around, somewhere between scholarly and tongue-in-cheek, with the form of musical theatre, of a play with music. Bowie, always ecstatically under the influence, reaches sideways through the narratively complex short stories set to the music of Lou Reed, the maudlin, distanced lusts and longing of Scott Walker, the diabolical sophistication of King Crimson and the jaunty, jaded angst-ridden cabarets of Kander and Ebb's — and Bob Fosse's — *Cabaret,* to Kurt Weill. Another great, intriguing and adaptive twentieth-century musical figure, Weill was as committed as Bowie to closing the gap between "serious" and "light" music, and freely mixed the severe and the swinging, the elegant and the tawdry, the serious and the trivial, the showbiz and the shamanic — whether he was in unhinged, end-of-the-world Berlin with Bertolt Brecht or on Golden Age Broadway with Ira Gershwin, Ben Hecht, Ogden Nash and Alan Jay Lerner. Weill was as nimble as Bowie at transcending a variety of different audiences.

'Time' could simply be about the ruinous effects of time, inspired by Shelley, Philip K Dick, Emily Dickinson and 'Time of the Season' by The Zombies. It could be from a musical set in the near future about the wretched anxieties involved in making the follow-up album to the winning *The Rise and Fall of Ziggy Stardust* as Bowie feels himself pulled into another life that feels less like a life and more like a spaced-out fantasy. A musical about some kind of precarious cross-country odyssey that goes out of its way to represent the fragmentary nature of experience, which on 'Time' means a lot of imploring, broken la la la's and haunted thoughts. It fits beautifully onto an album that could be about, you never know, how much it's a dangerous business exploring the self, especially as a high-functioning and famous performer endlessly fascinated by the nature of mental illness.

Bowie sings like he's having an out-of-body experience. He's still alive, but he feels like a ghost who's never seen the sky. He spirals between different timeframes, as though inspired by the references to time he'd found in a hotel room Bible — there is a time for every event under heaven, a time to tear down, a time to build up, a time to search and a time to give up as lost, a time to mourn and a time to dance. Or maybe it's Byron he's channelling — as much as the theatre of Artaud or the style of Lotte Lenya — and his "Oh, Time! the Beautifier of the dead, / ... Comforter / And only Healer when the heart has bled."

It was one of the last songs written for the record, with Mike Garson swiftly settling in as a more regular temp in Bowie's increasingly transitional backing bands, much more than merely a quick-thinking session musician who instinctively understood Bowie's impressionistic instructions. With Garson, Bowie has something extra to play with, a hint of new directions coming into focus, and Mick Ronson plays a valedictory, impassioned solo as if knowing his time's up, he can't keep up, there's a whole new post-rock wavelength materializing in Bowie's gloriously unreasonable changing mind, and the spiders are starting to scatter.

'Time' was thought up in New Orleans, which infects its mood, and Garson the piano medium calls up the kind of tricky, beguiling post-ragtime stride piano that would have turned the head of Weill, a Stravinsky and Mahler fan, in the 1920s, giving serialism a bracing, nightclub kick in the teeth. In the incidental time-travelling history of piano playing revealed during *Aladdin Sane* while Bowie burns the candle at both ends and struggles to work out his own place in history, we're moving on from exultant Fats Domino and heading toward the fractured abandon of Thelonious Monk and Cecil Taylor. The piano — and the kind of albums that David Bowie was making — as time machine.

At the end of 'Time', Bowie being Bowie at his most artistically self-conscious — teetering melodramatically on the edge of an unknown hereafter, after all the time he's kept or thrown away, the loss he feels for fallen friends — he's got nothing left. What the hell. It's time he was on stage. He's always due on stage. Where is the stage? There's just an empty space, a terrifying pointlessness, an awful sense of shame that might just be the truth. A last gasp of the title, one grand last 'time', and Garson gets the last word, the last note, a madcap stab in the dark, a sound effect for the Aladdin Sane lightning bolt, leaving Bowie to take the unreal applause in a world of his own.

He's got that out of his system. He's got certain stresses out of the way. Sometimes you write a song not to make sense but to make something go away, part of some sort of grieving, even though that might mean you'll have to live with it for a while, and keep singing the song, fixing it if you can as pure timeless, directionless performance, an escape from its own random intensity.

He's accepted time, at least for now. It will all lead to some blistering productivity over the next few years. For now, after one of those dying album pauses, it's time for the next track on side two. There's something else on his mind. It's time for some more regeneration, some more negotiation with the self, something else to show off. It's inevitable. Happily ever after or not.

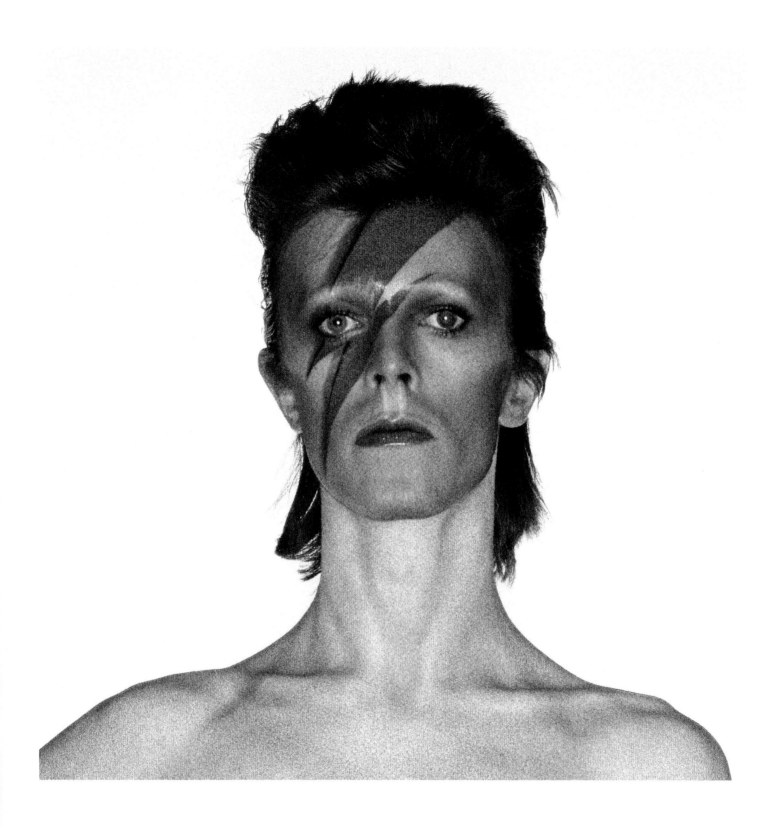

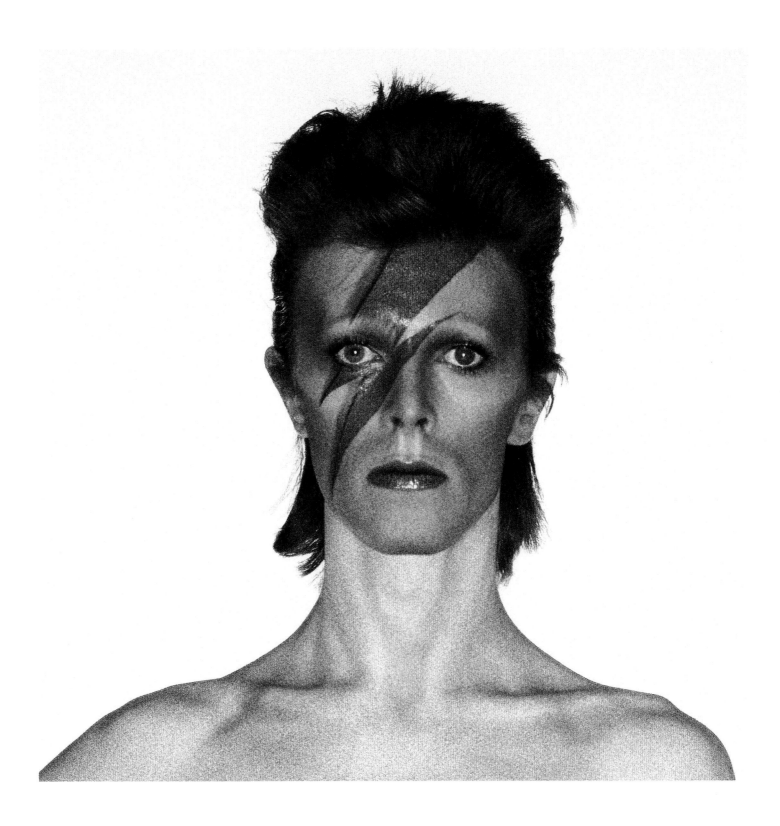

ABOVE — Headshots 42–43.

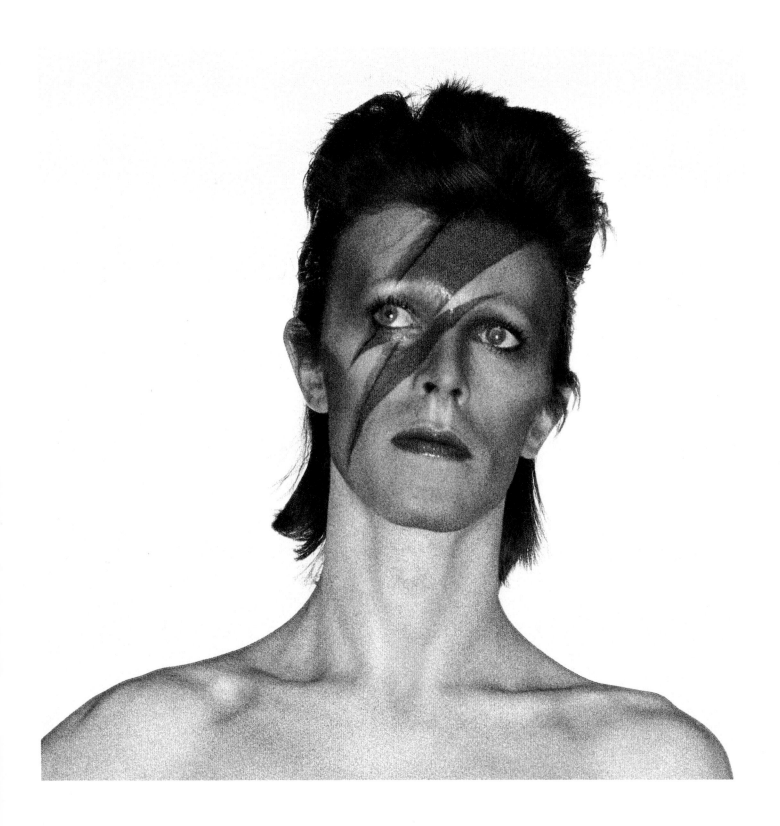

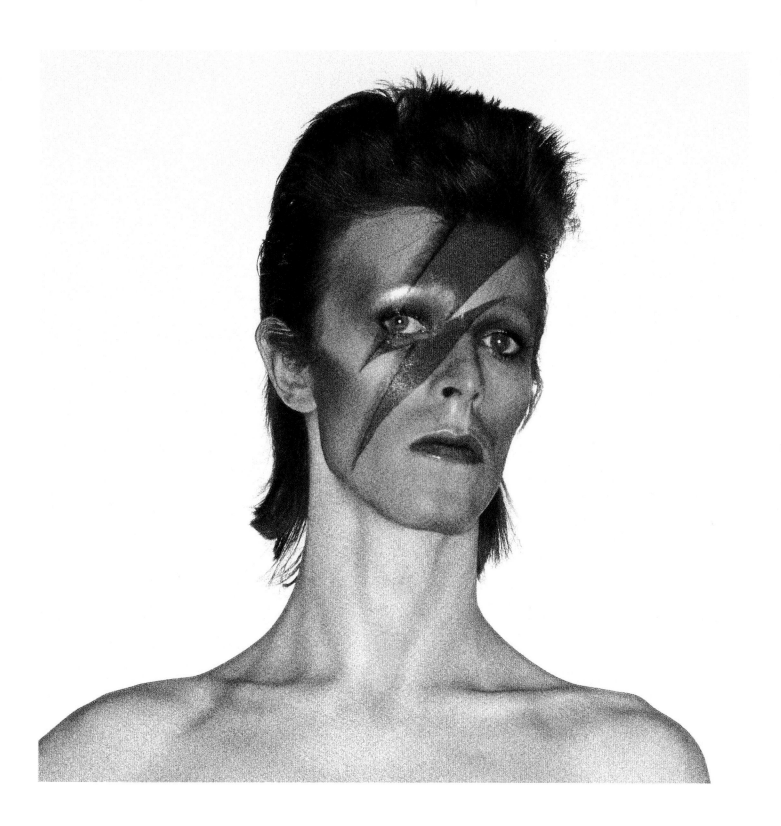

ABOVE — Headshots 44–45.

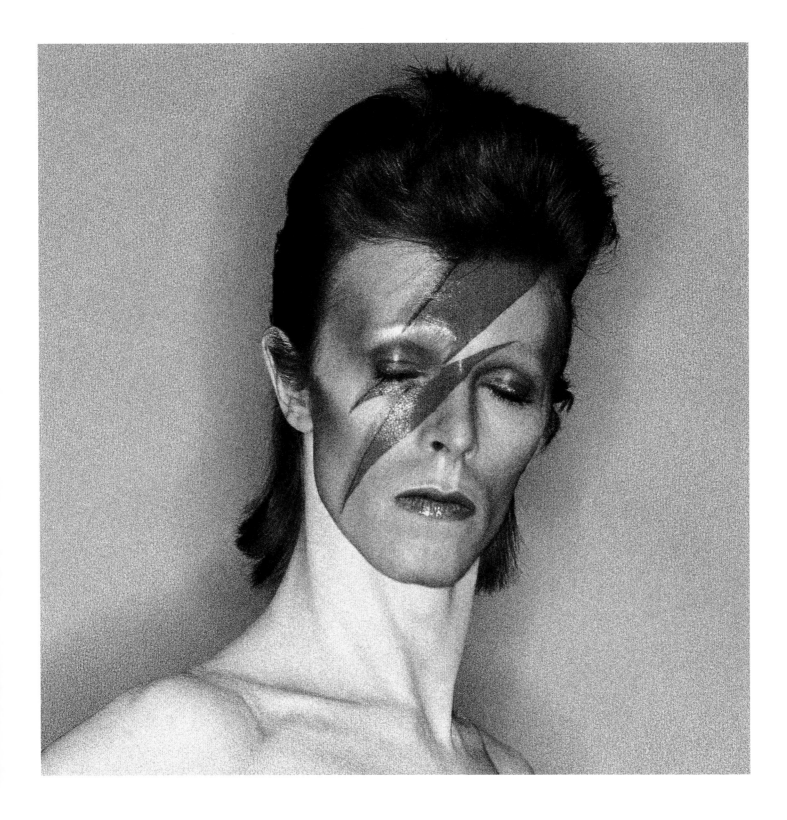

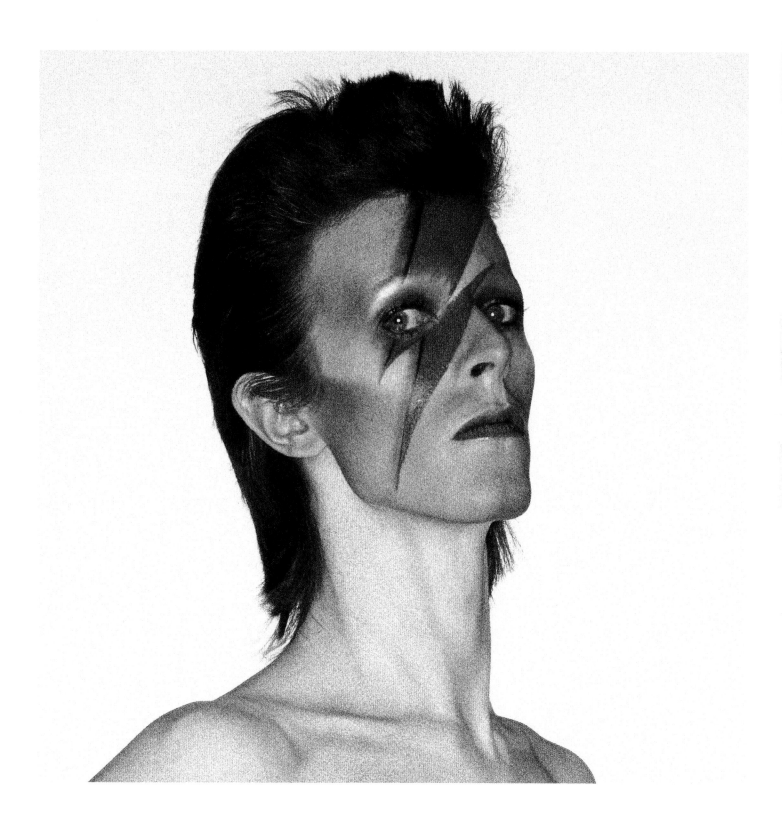

ABOVE — Headshots 46–47.

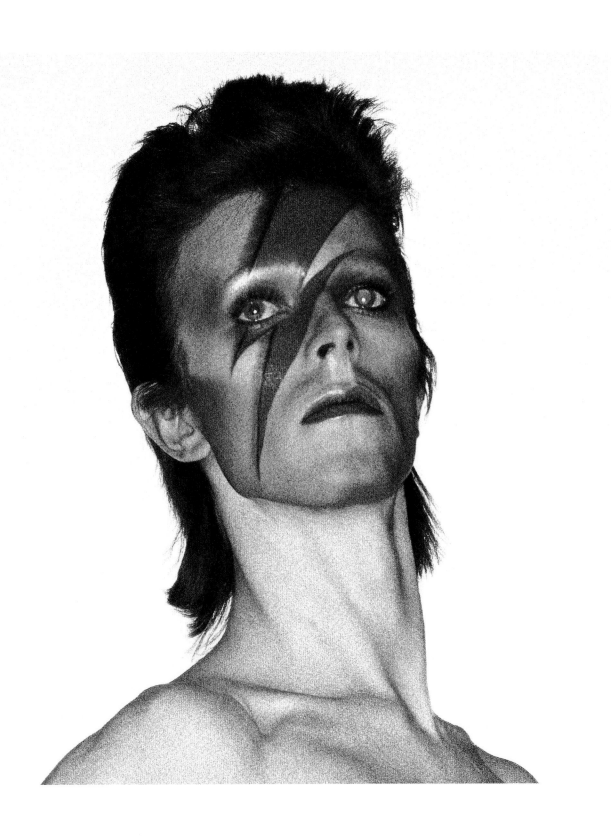

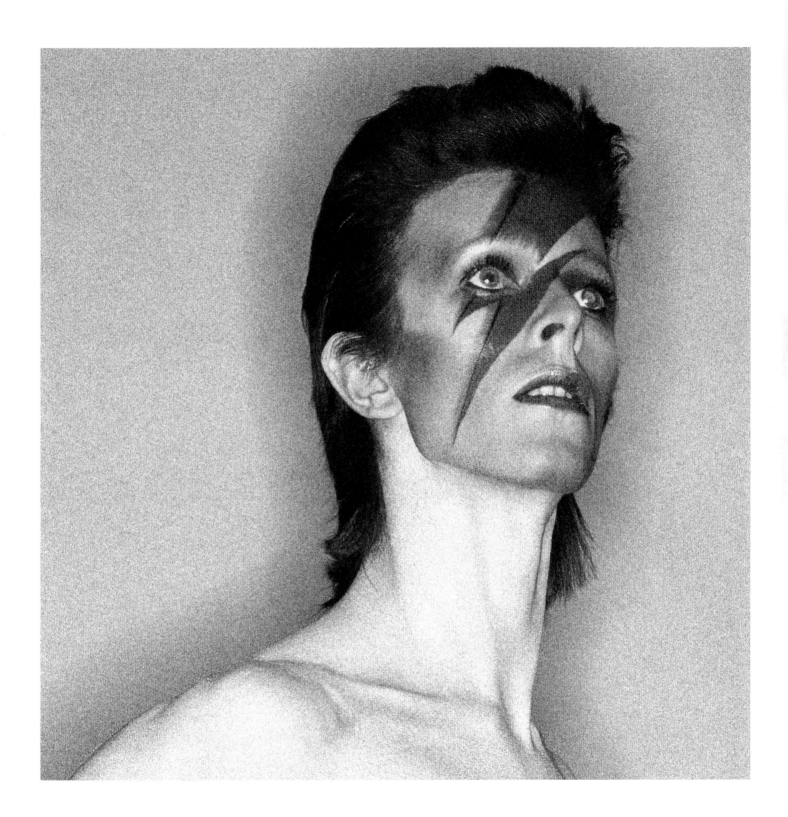

ABOVE — Headshots 48–49.

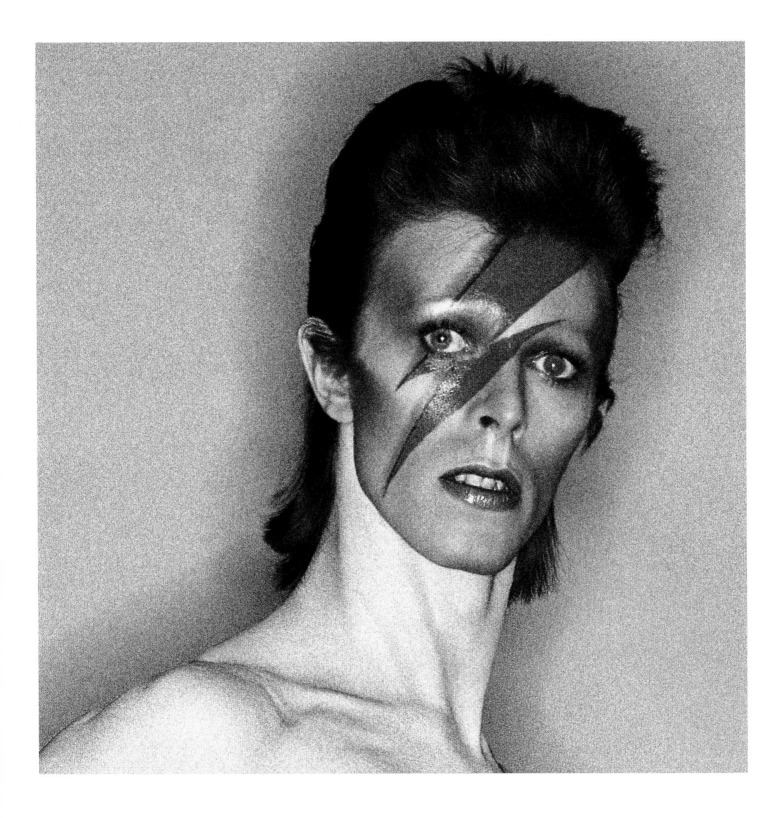

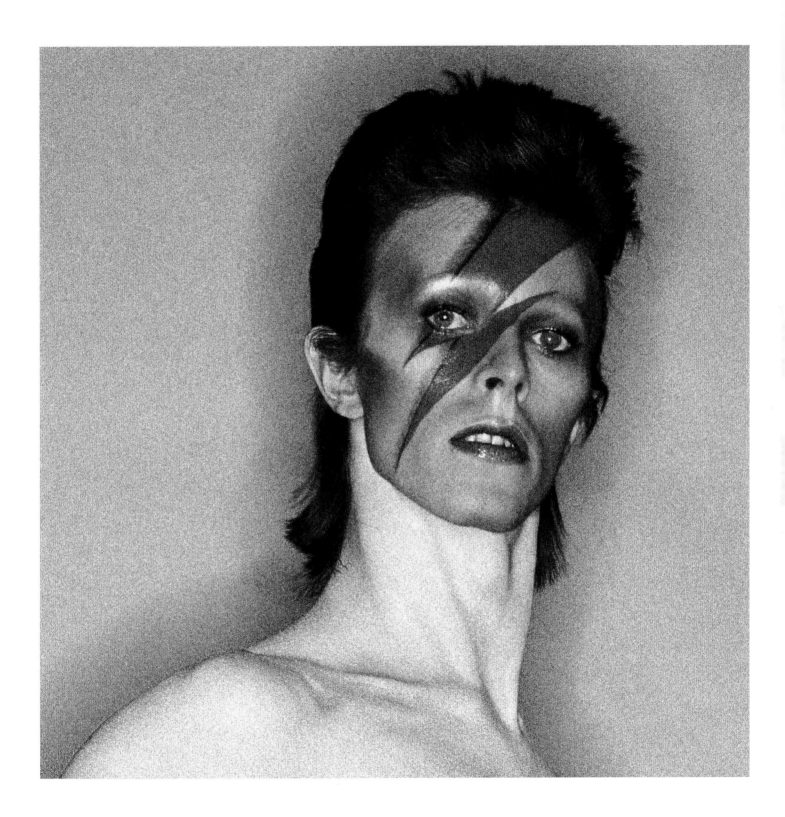

ABOVE — Headshots 50–51.

07.
the
PRETTIEST
STAR

KEVIN CANN

THEY WERE RECORDING A PIECE WITH SOME BRASS PLAYERS, (BUT) INSTEAD OF DESCRIBING THE TYPE OF SOUND HE WANTED FROM THEM IN A MUSICAL WAY, DAVID TALKED ABOUT SOUND IN TERMS OF COLOURS.

MATTHEW FISHER
EX-PROCOL HAREM KEYBOARD PLAYER

POSSIBLY one of the most unexpected inclusions on *Aladdin Sane* was a three-year-old song that had, against expectations on its first release, actually stalled the momentum of David's initial attempts at showbiz recognition. Surprisingly reimagined for Aladdin Sane, however, David's 'The Prettiest Star' (Mark 2) became a far more upbeat affair.

'The Prettiest Star' (with its associative celestial/showbiz title) had originally been recorded for Mercury Records on the eve of his 23rd birthday (in the early hours of 7 January 1970, to be precise) and released as a single the following March, following hard on the heels of his first Mercury album. But the single's release (the follow-up to 'Space Oddity' no less) received an unexpectedly disappointing reception and duly failed to trouble the charts.

The song had been written for and about his girlfriend at the time, Mary Angela Barnett, a young woman of American-Canadian descent and soon to be the first Mrs Bowie, and David had originally played it for her over the phone while she was visiting her parents in Cyprus. On reflection, its later inclusion on *Aladdin Sane* was as much a gift to Angie (though the marriage would badly sour a few years later), as it was a reminder to the world that there were also some intriguing songs in the Bowie back catalogue.

Notably included on the 1970 'The Prettiest Star' recording was David's old friend and occasional rival Marc Bolan, whom David had invited to play lead guitar (in fact, it was probably Bolan's plaintive input that ultimately persuaded David and producer Tony Visconti of the song's hit potential). The end result was almost a lamentation, due in no short measure to the emotion expressed in David's vocal — the recording session itself had certainly not been without tension. An aloof Bolan had kept himself to himself throughout while his girlfriend acted equally superior to all around them, including a genuinely laid-back and affable David.

Three years later and back at the same studio, the mood couldn't have been more contrasting, though by now Bolan was far too famous (and at the height of his rivalry with David) to appear on this particular Bowie song again, even if David had invited him.

In fact, Mick Ronson remained extremely respectful to Bolan's original guitar pattern throughout. Even though the pacier "shuffle" beat was more suited to Ronson's style of performance, and more suited to the sound of an electric guitar, echoes of Bolan's dexterity remain extant throughout. And just like the original, slightly haunting recording, the guitar's resonance once again comes to the fore, now emblematic of a different time.

The backing style — like some mid-Atlantic dance band, which also makes an appearance on 'Aladdin Sane' and 'Drive-In-Saturday' — is prevalent throughout the recording, the saxophone bedding led by Ken "Bux" Fordham on bux-saxophone and augmented confidently by David's own alto sax performance also proving key elements. At first, David's sax skills are kept low in producer Ken Scott's mix, slowly rising to the fore during the first chorus and then remaining distinct to the end.

Another reason for the inclusion of this particular number on *Aladdin Sane* was benevolent and deliberately intended to benefit his old manager, Kenneth Pitt, a man who had stoically supported him financially

through the leaner moments of his career up to 1970 and also helped steer him to initial chart success. Toward the end of their professional relationship, mindful of his debt to Pitt, David gifted the song's publishing to him. Well aware that his old manager would still be well out of pocket following the premature curtailing of their management agreement, David included the song on *Aladdin Sane* as a way to certify that he hadn't forgotten about Pitt. It was just one of many subtle, under-the-radar acts of kindness by David during his career.

Ex-Procol Harem keyboard man Matthew Fisher (who notably co-wrote the 1960s' classic 'A Whiter Shade of Pale') had helped David out during his Rainbow Theatre stint in the summer of 1972 and remained in touch with the band. While visiting Trident during the January 1973 sessions, he was fascinated to witness some of David's studio technique: watching him direct musicians on the studio floor, he was able to observe first-hand David's unique approach to sound production. "They were recording a piece with some brass players," he recalled in 2008. "(But) instead of describing the type of sound he wanted from them in a musical way, David talked about sound in terms of *colours*."

In late 1972 David spotted UK rock 'n' roll revival band Fumble on BBC 2's *The Old Grey Whistle Test* and, excited by their particularly vibrant and evocative performance, invited them to join him as his support act. David loved the band, and their energetic set was perfectly suited to rouse and animate the audience before his arrival on stage. It's perhaps not surprising, then, that Fumble's influence should also be assimilated on *Aladdin Sane*, David's updated 'The Prettiest Star' now reinvented, in part, as a sentimental American 1950s doo-wop pastiche. At the same time, it's possible a hint of personal nostalgia may have been at work here, too, David maybe recalling some of the soundtrack of his childhood?

While the saxophone accompaniment also offers up visuals of an early moving picture soundtrack, it's possible also to visualize an immaculately attired 1920s tea dance band fronted by a stiffly poised MC, readying to half sing, half speak his lyrics through a megaphone. This version of 'The Prettiest Star' practically lends itself to this type of light-hearted treatment, too (just as McCartney had done on his 1971 song, 'Uncle Albert/Admiral Halsey'). But attempting something similar here — even on an album as eclectic and experimental as *Aladdin Sane* — would more likely have resulted in a sound more akin to the New Vaudeville Band.

There is no doubt that this track, had it not been for Waugh's 1920s sentimentality, would have made an oblique bedfellow sitting among the other material on *Aladdin Sane*, its later association with Angie an uncomfortable reminder of times gone by for David, too. But history is history and, however uncomfortable it may have become for David later on, the song did start out dedicated to the then love in his life, and the woman who would give birth to his son, Duncan Jones. Within the context of the song's well-documented history then, and remembering the power couple that they presented at the time, we cannot deny fans of a certain age some nostalgic memory association.

This is not to say that on revisiting the song in 1973 David harboured the same sentiments he'd felt in 1970. Once again, *Aladdin Sane*'s label information offers up insights and other possible motivations. Gloucester Road, Kensington is given as 'The Prettiest Star's' place of origination — not a location that can readily be associated with Angie. Of course, we can only speculate now, but maybe Gloucester Road was David rededicating the song to his first true love, Hermione Farthingale? Their room in a shared house in Clareville Grove was sited just off Gloucester Road, and we know today that David always retained fond memories of her. In this regard, the sentiments of the original lyric fit just as well for Hermione as they do for Angie. So when David sang it for a second time, it's fair to consider that he may have had both women in mind. Even the pact he made with Angie, neatly summed up in a line about rising up all the way, fits with this hypothesis.

While the official press release of the time stated that *Aladdin Sane* "shows a close interrelationship of songs", the inclusion of this older composition slightly bucked that statement. Yet David and Ken Scott skilfully managed to create a sound that was sonically sympathetic with the rest of the album, something also successfully achieved with the album's only cover, 'Let's Spend The Night Together'.

While on the subject of the Rolling Stones, this track is one of just three or four on *Aladdin Sane* not influenced by that band; David was only now becoming personally acquainted with them, having kept a close eye ever since attending a live performance while still at school. Their influence, and particularly that of Mick Jagger, would play a major part in the shaping of Bowie in the early '70s.

Ultimately, *Aladdin Sane* — the album — proved a commercial and creative milestone in David's career and marked the arrival of thousands of new Bowie fans worldwide. Its dramatic appearance also affirmed a now undeniable fact, that with advance sales exceeding 100,000 units (it remained at No. 1 for five weeks) and with a massive promotional tour selling out in hours to support it, David Bowie had not only been fast-tracked to superstardom, he truly epitomized it.

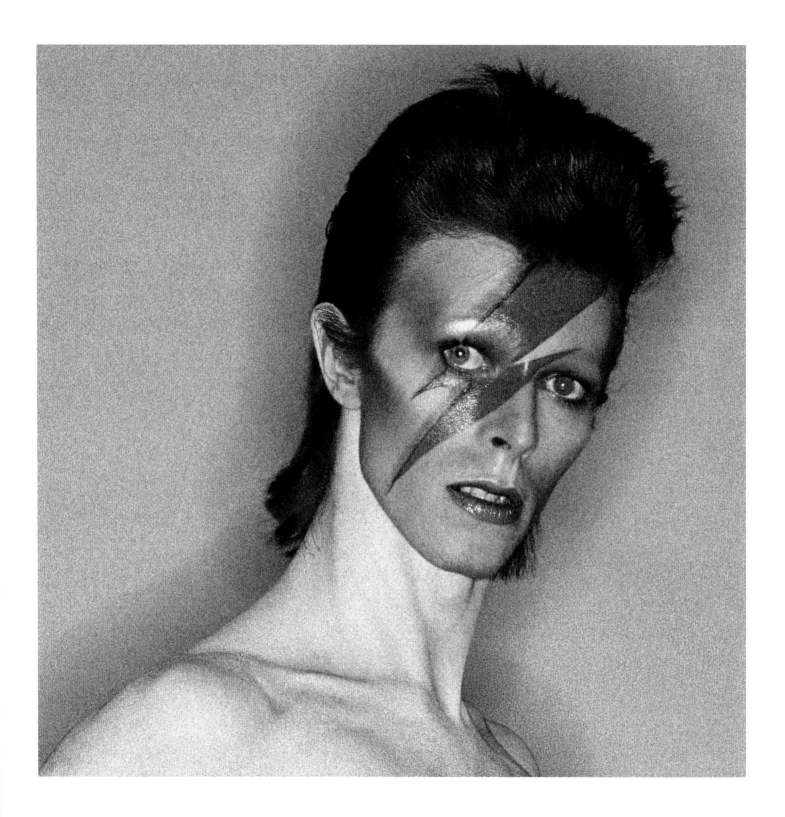

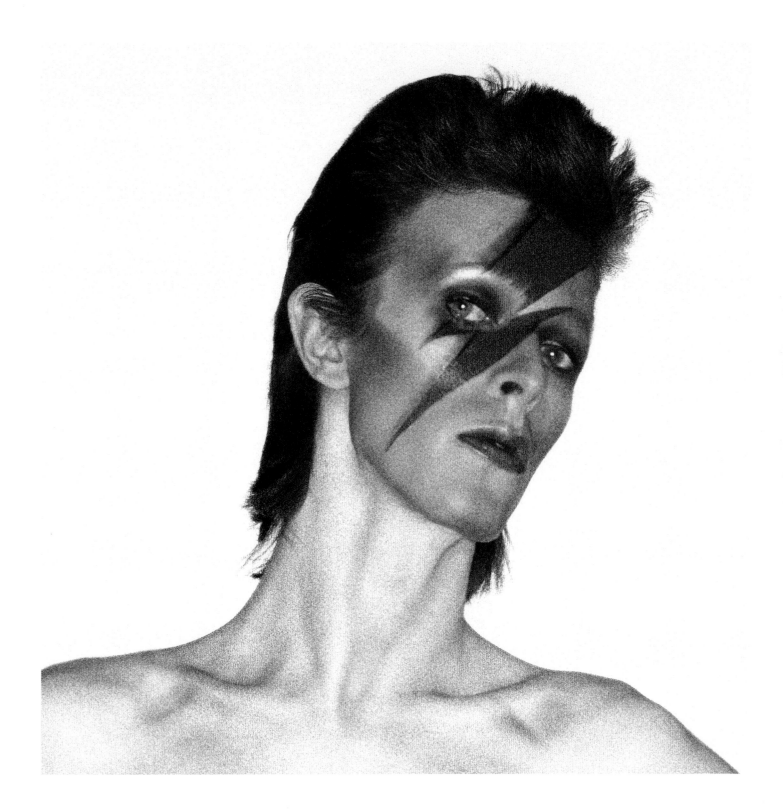

ABOVE — Headshots 52–53.

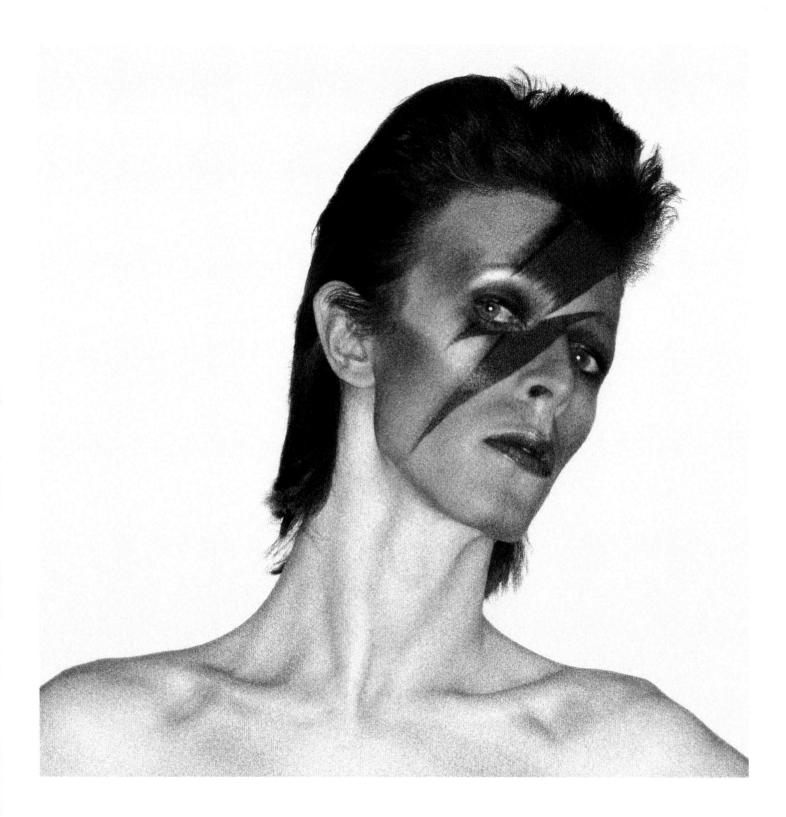

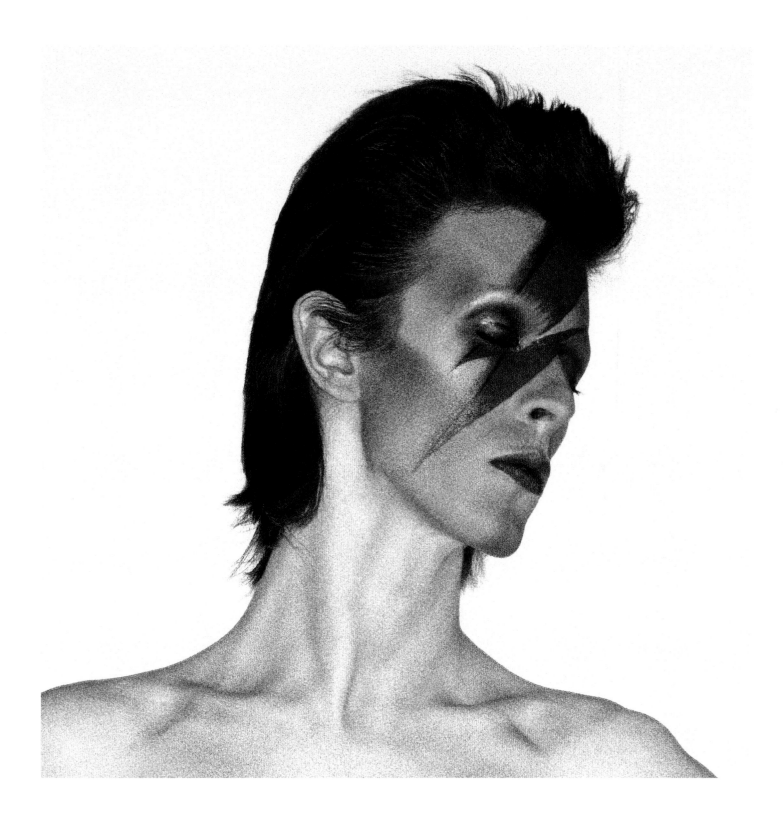

ABOVE — Headshots 54–55.

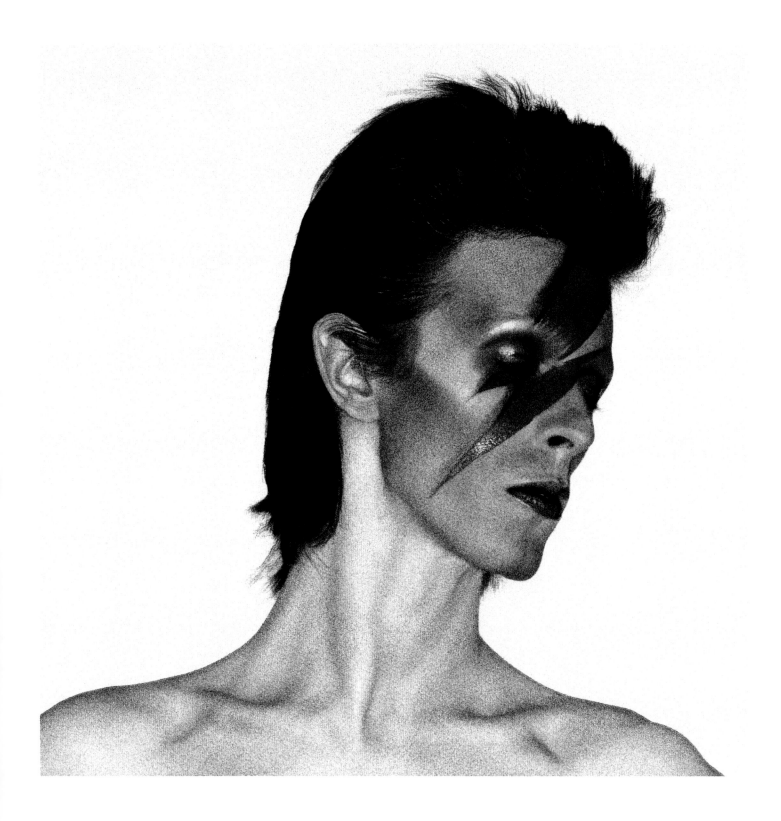

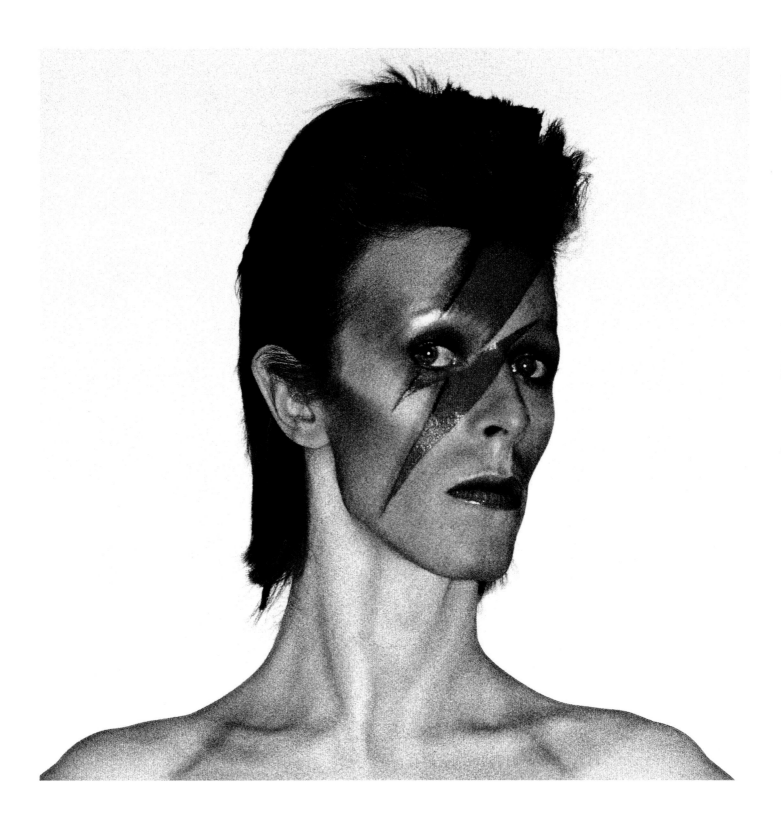

ABOVE — Headshots 56–57.

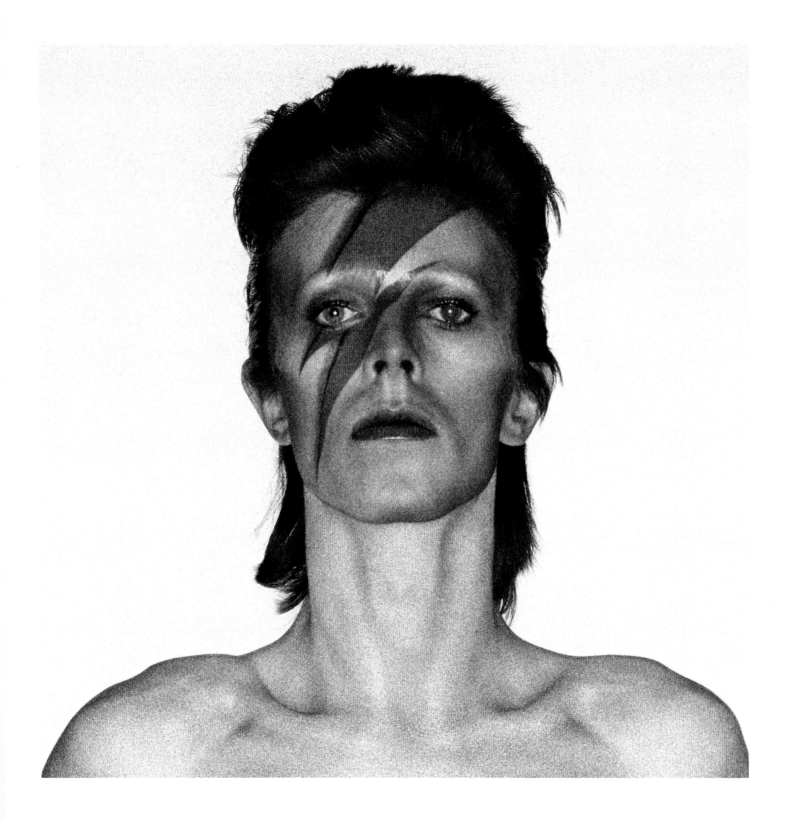

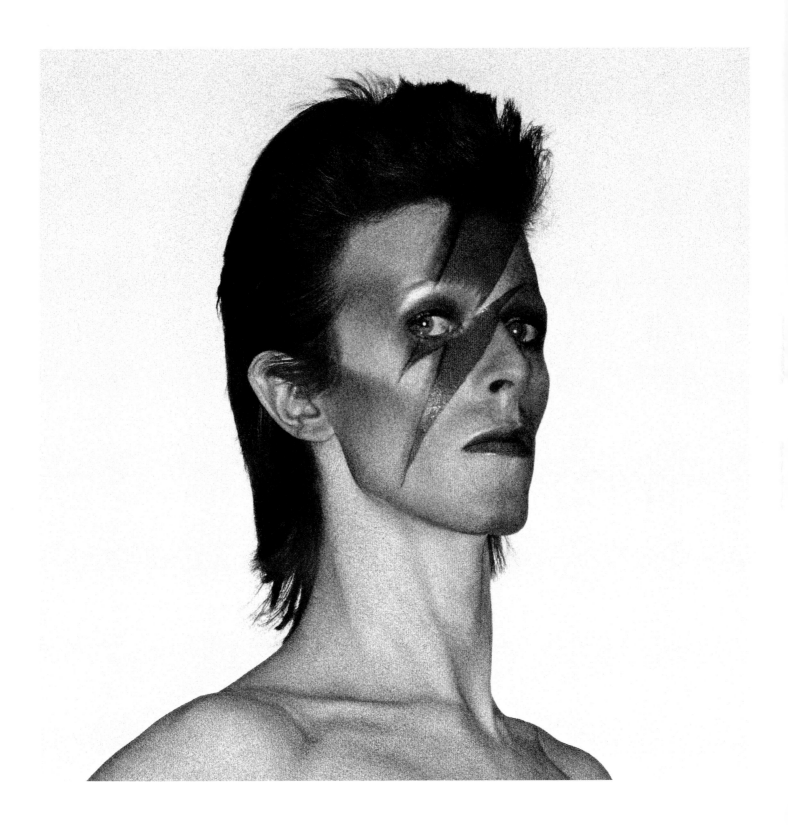

ABOVE — Headshots 58–59.

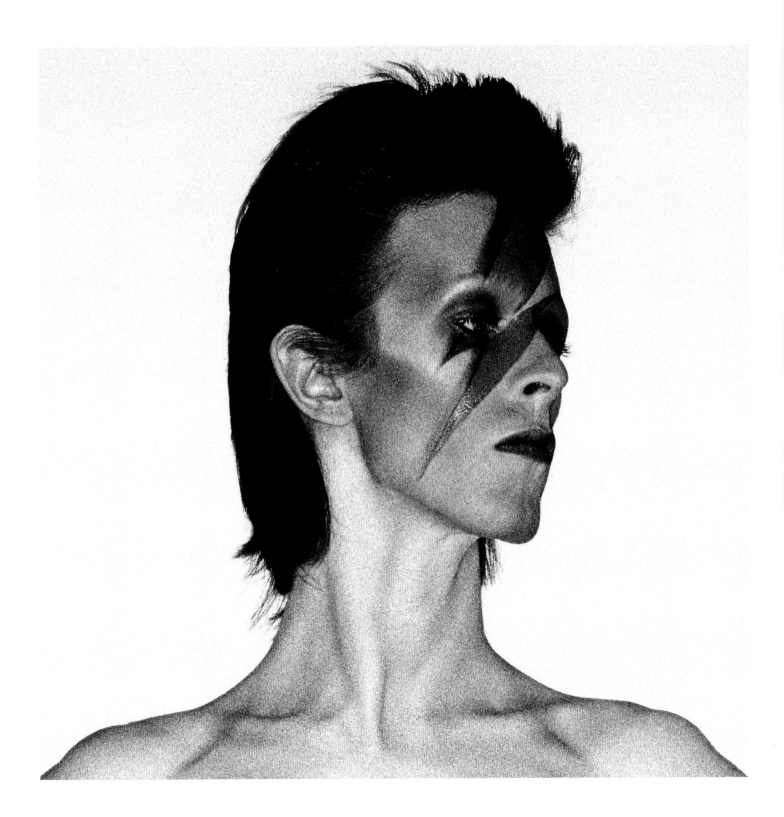

ABOVE — Headshot 60.

08.
LET'S SPEND THE NIGHT TOGETHER

CHARLES SHAAR MURRAY

BUT THEN THERE'S
THIS. THE
EXCEPTION THAT
PROVES THE RULE.
THAT MAKES
THE STONES VERSION
SOUND LIKE A
DEMO FOR BOWIE'S.

COVER versions can be many things, including "tribute" and "challenge". David Bowie's version of 'Let's Spend the Night Together' is both.

As Angie Bowie put it: "When you cut a new version of a song so firmly identified with the original artist, you're paying tribute, naturally, and that's good, you're flattering. But if you have the status David had, you're also staking your own claim to the song's glory and history. And in this case I have no doubt whatsoever that David was out to steal Stones' thunder — or more to the point, Stones' territory. He was tomcatting the turf, spraying young scent over the old cats', as he had done with Marianne Faithfull."

But then shadows and analogues of the Rolling Stones are all over *Aladdin Sane*. The album's kick-off track, 'Watch That Man', reflects the Stax-like, horn-driven, Memphis soul stew of 'Brown Sugar' and 'Bitch'; 'The Jean Genie' and 'Cracked Actor' hark back to the harmonica-honking, Chicago-via-Dartford blues-breaking of their earliest recordings (though, to your correspondent's possibly over-finicky ears, both tracks are more reminiscent of the Yardbirds). Plus: Jagger is namechecked in the horrific future of 'Drive-In Saturday' as the epitome of libidinous sensuality despite Bowie taunting Jagger in interviews: "For the West, Jagger is most certainly a mother figure and he's a mother hen to the whole thing. He's not a cockadoodledoo; he's much more like a brothel-keeper or a madame ... I also find him incredibly motherly and maternal clutched into his bosom of ethnic blues."

Now, we hold this truth to be self-evident: no one cuts the Rolling Stones on one of their own songs. In a sense, Bowie covered his bets admirably, selecting a song that was a familiar one-time hit but not one of the Stones' first division masterpieces. By which I mean: it wasn't 'Jumpin' Jack Flash' (which Johnny Winter had done to a sizzling turn) or 'Honky Tonk Women' (Auntie Tina (Turner) had sung the pants off *that* one), let alone showstoppers like 'Sympathy for the Devil' or 'Street Fighting Man' (neither of which I can imagine Bowie being comfortable singing. At least not the Bowie of 1973).

Nor was it their anthem, '(I Can't Get No) Satisfaction'. Otis Redding, who had never heard the Stones' original, had himself decided to cut the tune in a frenetic 1965 session with the Stax house band. He started out with a lyric sheet before him at the mic, but dropped it partway through the take and made up new lyrics on the spot. Mick Jagger later declared it the best Stones cover ever; Keef went further: "The way Otis Redding ended up doing it is probably closer to my original conception for the song ... Otis got it right. Our version was a demo for [his version]." Not least because the fuzz-guitar lick which provided the first of many hooks for 'Satisfaction' had originally been intended as a guide for horn parts which never got overdubbed because the band's label decided (possibly wisely) to rush the release as it was. The Otis cut was supercharged by the Memphis Horns, blazing and blaring like champs, just the way Keef had wanted on the Stones' record. You may not get to cut the Stones on one of their own songs — the rule stands — but at the very least, Otis pulls level; they breast the tape together.

But then there's *this*. The exception that proves the rule. That makes the Stones version sound like a demo for Bowie's. Face it: the Stones' track *plods*

(Jack Nitzsche's piano part is the primary culprit) and it sounds even ploddier if you play it *after* Bowie's version rather than *before*. The Stones' version is okay, but it sounds like it, too, was bashed out as a semi-demo and never got the finishing touches it needed.

Yep, Bowie cut the Stones on their own song.

Here, Mike Garson has the honour of firing the starting gun. After a snarling Ronson power chord overlaid with a ready-for-launch synth whoosh and burble, Garson pounds out hammering jazzy piano chords that sound like Jerry Lee Lewis momentarily possessed by the spirit of Cecil Taylor before the band kick the door down, Ronson chucking berries like Lord Keef his own self. The song's been revved up to what we'd later come to call "punk tempo" and Bowie sings it like Little Richard — at least, like a Little Richard who's a skinny white Brit and has never even been inside a Southern Baptist church. And Bowie sprinkles the track with the kind of synth noises that Brian Eno had deployed to such effect on the first Roxy Music album — he kept at least as close an eye and ear on the cub bands coming up in his rearview mirror as he did on those up ahead, whom he was determined to overtake. Here, the synth offers both fizzy ear candy and an instant signifier of futuristic sonic exoticism.

More than anywhere else on *Aladdin Sane*, the band sound like they're having Big Fun and are eager to flex the added muscle built during almost a year of heavy touring. "As a genuine nod to the Stones," Woody Woodmansey recalled, "we ... did our version of 'Let's Spend the Night Together'. As a result of our time in America the overall sound of the band had got heavier and Mick's guitar sound had naturally got dirtier than it was before." For his part, Garson reminisced, "This was pure jovial ... like, David was doing a Rolling Stones song — what can I do that's going to be so outrageous, just take it off the map, go left field with it and still keep that excitement? The intro had to be not that long, just a brief avant-garde moment and then into the piece. It was a one-take thing for me, and a total joy. Just a pleasure to play."

If Mick Ronson had had an ego equivalent to his musical talent and physical beauty, he would've been unbearable. If he'd had an ego even a quarter of that size, he'd have been a huge star. As it happened, he barely had an ego at all. He was instrumental (no overt pun intended) in hiring Garson in the first place: they'd clicked immediately, being (apart from anything else) the band's most sophisticated players. Neither of them had ever previously worked with anyone like the other, and almost every track is a testament to the way their seemingly disparate styles could fuse to the benefit of the ensemble sound. Never let it be said that Bowie hadn't learned how to be a consummate bandleader, at least in musical terms: keeping underpaid musicians on side was something he didn't learn until a little later.

The track positively fizzes. Its climax is a deceptive breakdown where the band ease up and Garson sprinkles notes like he's scattering birdseed ... over which Bowie recites, in a deliberately faux-dumb American teenage voice borrowed partly from Iggy Pop and partly from Frank Zappa, a call to DO IT!

Then there's an almighty *krunch* from the band, with a wicked Ronson pick slide and a cry to make LOVE!

A few more *krunches*. Then Bowie lets out a single falsetto whoop (some might say that he "screamed like a white lady") and the band return to stamp what's left of the song into the floor.

In 1966, 'Let's Spend the Night Together' was considered so risqué that when the Stones played on *The Ed Sullivan Show*, the host insisted that they change the words to "Let's spend some time together". Jagger compromised by singing "Let's spend some MMMM together" and smirking into the lens.

If Sullivan had ever heard how Bowie pimped the Stones' ride, he'd have swallowed his dentures.

In many ways, the track foreshadows *Pin Ups*, the album released later that same year after — *shock! horror!* — he pulled the plug on the Ziggy and Aladdin era. To record it, Bowie would reassemble his touring band (with veteran drummer Aynsley Dunbar replacing Woody, who'd Had Enough) to cut a selection of classics from Bowie's formative musical years: the Yardbirds and the Pretty Things, the Kinks and the Who, Them and Floyd and more. It was good fun, mostly likeable and listenable, with a fair few surprises, if not quite as many as some listeners would have liked. More to the point, it paid off debts of honour, both to the bands he celebrated and to the musicians who deserved one last hurrah. The musicians who had got him to where he needed to be before getting discarded in favour of those who could get him to where he needed to be next.

So ultimately … what do we got? A lithe young lion teasing the older bigger males of the rock pride? An exultant slamming burst of rip-roaring rock 'n' roll fun to give the proceedings that extra kick and fill a few more dance floors? Or — if we're going to pretend even for a few moments that the album does indeed contain a narrative, albeit one that been cut-the-fuck-up like a Christopher Nolan or Quentin Tarantino movie — then this track is exactly what the pitiable denizens of 'Drive-In Saturday' were craving all along.

DO IT! Let's make … LOVE!

THE ALBUM
ARTWORK

In 1972, Duffy formed Duffy Design Concepts, a vehicle allowing him to create a total visual concept, including photography, design and artwork. The *Aladdin Sane* commission was the perfect project, giving Duffy complete creative freedom — as seen in the following elements from the cover design.

ABOVE — Duffy's interpretation
of David's lightning bolt concept
was to become a central theme not
just of the album package, but also
Bowie's ongoing visual legacy.

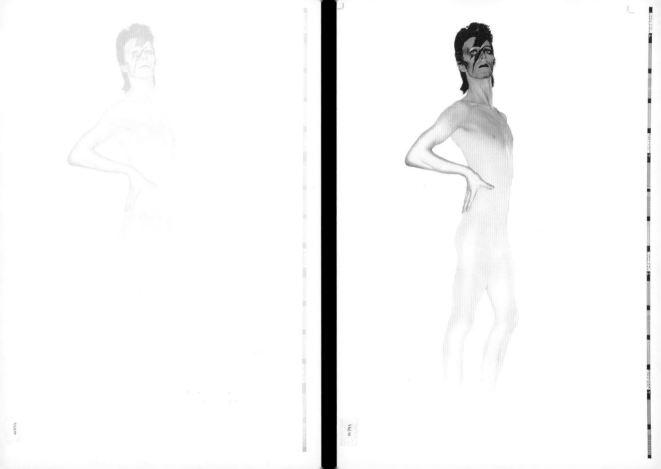

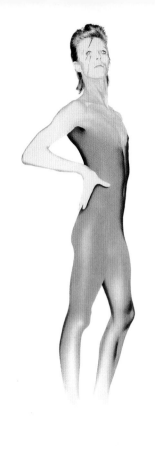
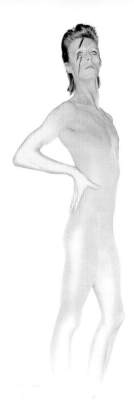

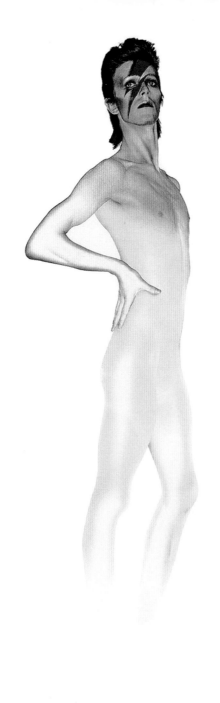

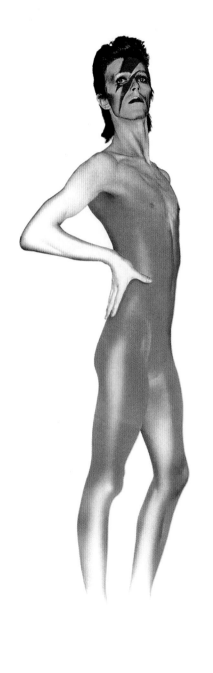

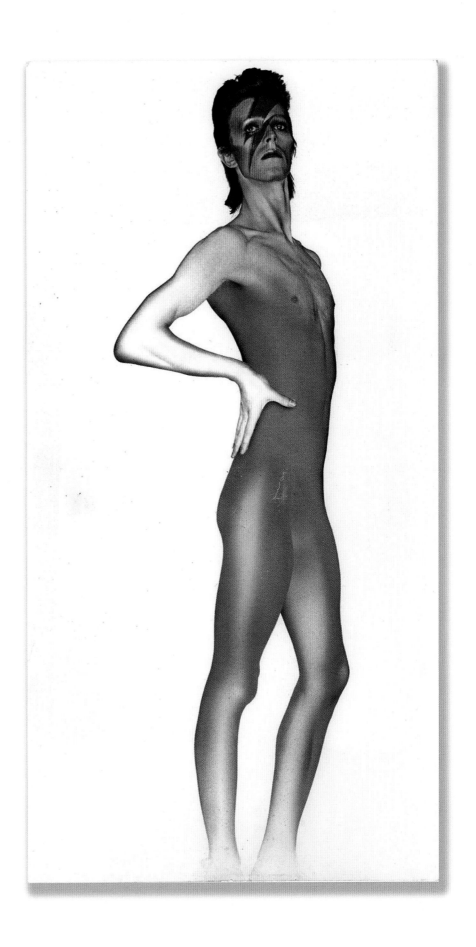

PREVIOUS PAGES — Colour
separations of the artwork that
adorned the gatefold interior
of the album. The artwork was
created in five layers: four layers
of colour with a silver layer on top.

RIGHT — The original full-length
dye transfer.

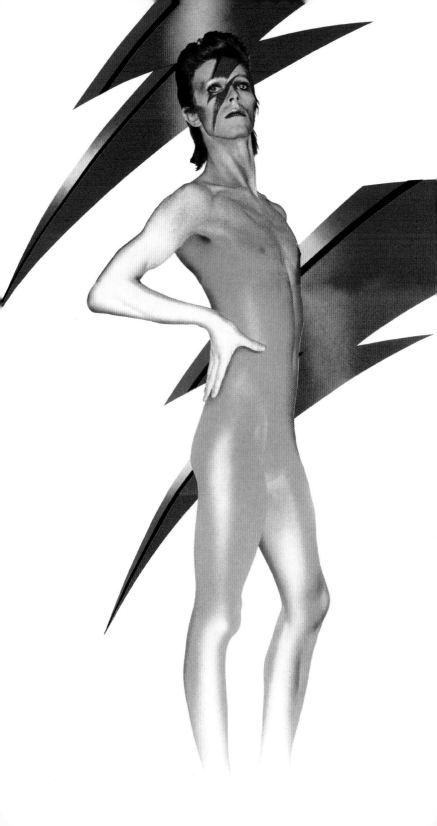

OPPOSITE — The final image.

RIGHT — As it appears in the album gatefold.

PIRELLI TO BOWIE: THE DYE TRANSFER PROCESS

IN 1972, Duffy shot his second Pirelli Calendar, a collaboration with British artist Allen Jones. Jones had produced a set of preliminary pencil sketches based on ideas inspired from 1950s' and 1960s' American fetish magazines, which Duffy then transformed into photographic images, aided by British airbrush artist Philip Castle. Computers and Photoshop were, of course, unavailable in 1972, and in many ways the final images in the 1973 Pirelli Calendar were ahead of their time. The 1973 publication still stands out as a peak moment in the calendar's illustrious history.

The session was shot on Kodak 120 Ektachrome film, and the *Aladdin Sane* images were then printed using an expensive and complicated process called "dye transfer". The process, undertaken by a London laboratory Lange & Wind, involved using three continuous-tone sheet film plates called matrices. These matrices were soaked in water-based cyan, magenta and yellow dyes. They were then rinsed clean of excess dye and squeegeed against a sheet of gelatine-coated paper, similar to regular photographic paper but without the silver compounds. The gelatin readily absorbed the dye from each matrix, resulting in a continuous-tone dye image on paper.

As soon as the dye transfer prints were ready, they were immediately whisked over to Philip Castle's studio for airbrushing under Duffy's supervision. On completion, Duffy personally took the prints to Photolitho Sturm in Basel, Switzerland, where the plates and separations were made for the album.

Sturm still operate today, though in 1994 Eastman Kodak stopped making all materials for this process. The dye transfer system was very complicated and expensive, but it did produce the ultimate colour saturation and surface material for achieving the airbrushed effect.

OPPOSITE — The original Aladdin Sane dye transfer, signed by Duffy.

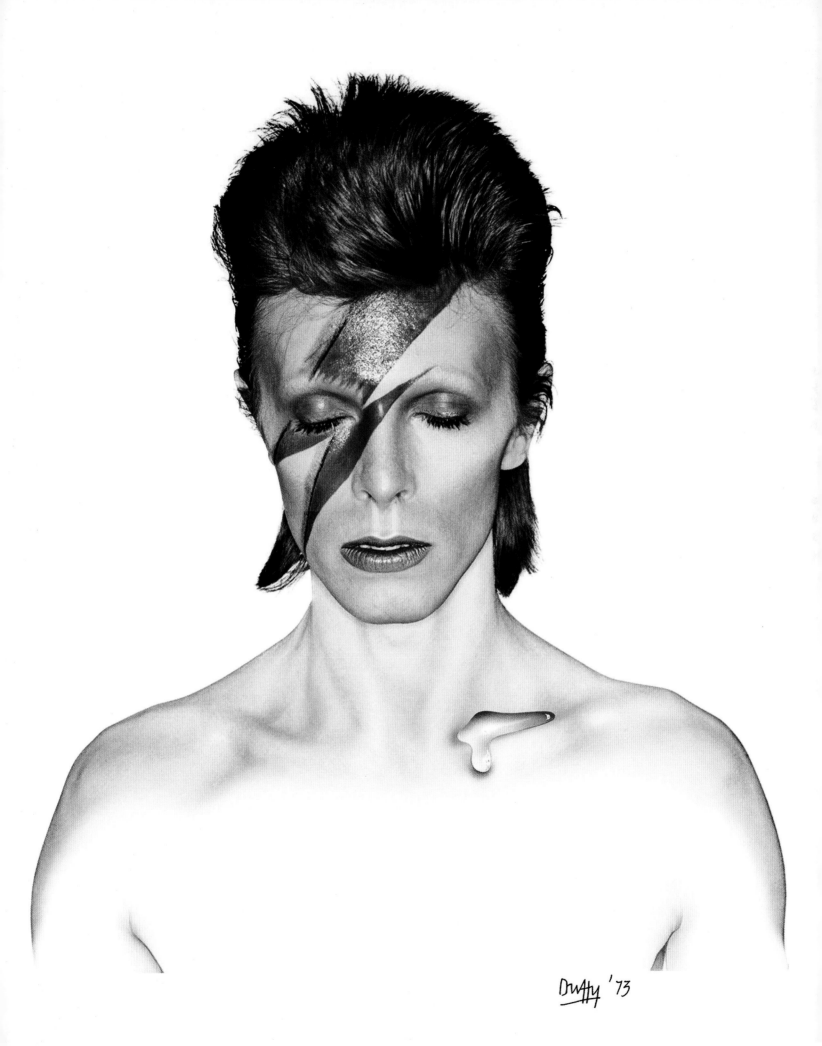

ABCDEFG
HIJKLMN
OPQRSTU
VWXYZ
ÆŒ
1234567890

ALADDIN SANE

OPPOSITE — The Cristal typeface
used on the album, sourced from
Conway typography.

ABOVE — A blue flame was added
to the album cover type as an
additional flourish.

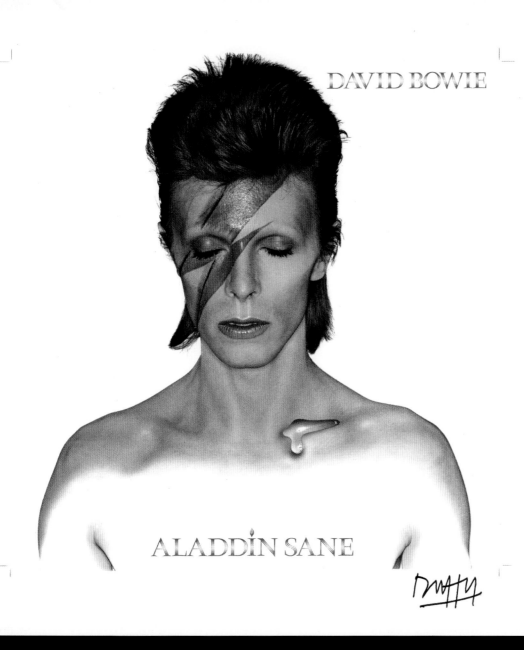

OPPOSITE — Line artwork for the
album's back cover created from
Agfacontour film.

ABOVE — An original, signed
principle artwork, with Pantone

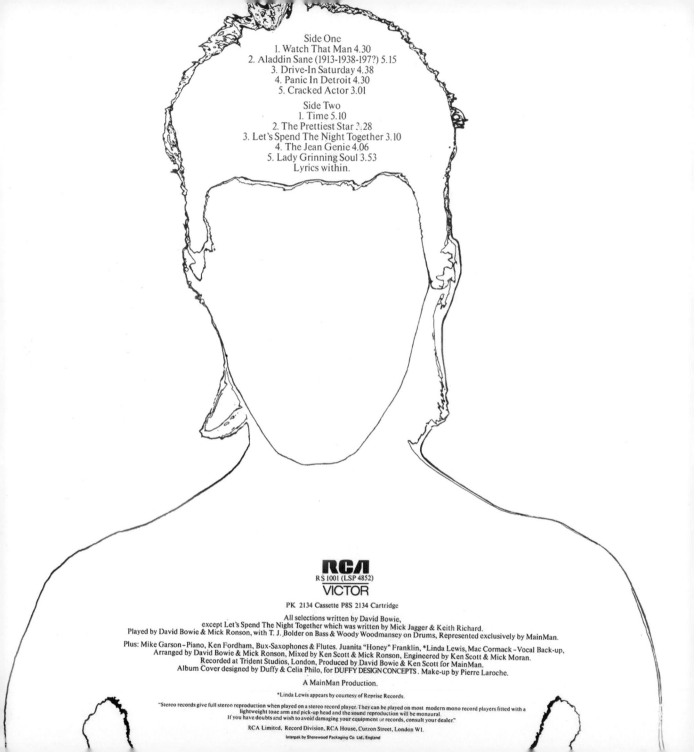

Side One
1. Watch That Man 4.30
2. Aladdin Sane (1913-1938-197?) 5.15
3. Drive-In Saturday 4.38
4. Panic In Detroit 4.30
5. Cracked Actor 3.01

Side Two
1. Time 5.10
2. The Prettiest Star 3.28
3. Let's Spend The Night Together 3.10
4. The Jean Genie 4.06
5. Lady Grinning Soul 3.53
Lyrics within.

RCA
R S 1001 (LSP 4852)
VICTOR

PK 2134 Cassette P8S 2134 Cartridge

All selections written by David Bowie,
except Let's Spend The Night Together which was written by Mick Jagger & Keith Richard.
Played by David Bowie & Mick Ronson, with T. J. Bolder on Bass & Woody Woodmansey on Drums, Represented exclusively by MainMan.

Plus: Mike Garson – Piano, Ken Fordham, Bux-Saxophones & Flutes. Juanita "Honey" Franklin, *Linda Lewis, Mac Cormack – Vocal Back-up,
Arranged by David Bowie & Mick Ronson, Mixed by Ken Scott & Mick Ronson, Engineered by Ken Scott & Mick Moran.
Recorded at Trident Studios, London, Produced by David Bowie & Ken Scott for MainMan.
Album Cover designed by Duffy & Celia Philo, for DUFFY DESIGN CONCEPTS. Make-up by Pierre Laroche.

A MainMan Production.

*Linda Lewis appears by courtesy of Reprise Records.

"Stereo records give full stereo reproduction when played on a stereo record player. They can be played on most modern mono record players fitted with a
lightweight tone arm and pick-up head and the sound reproduction will be monaural.
If you have doubts and wish to avoid damaging your equipment or records, consult your dealer."

RCA Limited, Record Division, RCA House, Curzon Street, London W1.
Interpak by Shorewood Packaging Co. Ltd., England

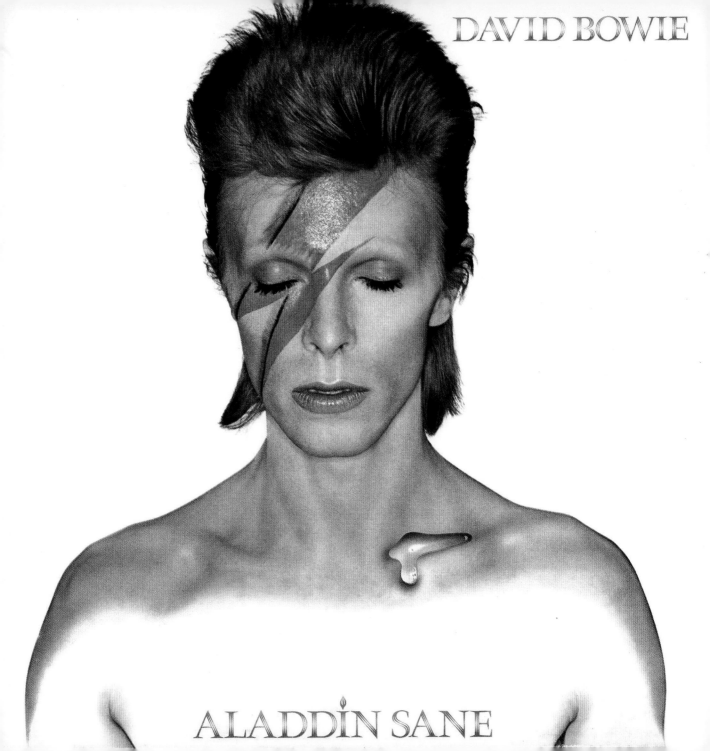

09.
THE
JEAN GENIE

NICHOLAS PEGG

The jean genie announces in four POUNDING, EXHILARATING minutes the arrival of what Bowie himself described as "ZIGGY IN AMERICA".

The hair on that famous sleeve image might be dyed a flaming red, but elsewhere on *Aladdin Sane*, David Bowie makes a virtue of showing off his roots. It's palpably the work of an Englishman abroad, criss-crossing the States and experiencing for the first time the reality behind the boyhood fantasies of Americana that had underpinned so much of his earlier work. These 10 songs are the sound of a British sensibility immersing itself in the American experience, drinking deep from the wellspring of jazz and blues that were the midwives to rock 'n' roll. Nowhere is this clearer than in the first fruit of the sessions: recorded in New York on 6 October 1972, added to the Spiders' live repertoire the very next day and released as a single just a few weeks later, 'The Jean Genie' announces in four pounding, exhilarating minutes the arrival of what Bowie himself described as "Ziggy in America".

Propelled by Woody Woodmansey's relentless drumbeat and an irresistibly catchy riff that just keeps on coming, 'The Jean Genie' is at once timeless and of its time. On the one hand, it's an instant glam classic with 1972 written all over it, and on the other it's a tour d'horizon of popular music history. That stomping guitar riff is hardly new: in 1965 a close relative had underpinned the Yardbirds' version of Bo Diddley's 'I'm a Man', but its origins lie decades earlier, in the delta blues of Muddy Waters, Howlin' Wolf and John Lee Hooker, artists who had entranced the teenage David Jones (one of his early bands was called The Hooker Brothers; another, The Manish Boys, was named after a Muddy Waters song).

The story goes that 'The Jean Genie' began life as an impromptu jam session on the tour bus as it sped between Cleveland and Memphis. Mick Ronson began picking out the riff on his new Les Paul, and the rest of the band started singing "Bus-bussin', bussin' along". When the tour reached New York a couple of weeks later, Bowie set to work on a more nuanced lyric, a studio was booked and the rest is history.

Raw and rootsy it might be, but there's nothing primitive about 'The Jean Genie'. It's a deceptively ornate piece of work, shimmering with the grace and confidence of a band at the height of its powers. That strutting riff is the armature over which Ronson lays down top dressings of spangly guitar, Bowie drapes his bluesy harmonica and shimmies those rattlesnake maracas, and Trevor Bolder weaves his nimble bass lines through Woodmansey's propulsive beat.

And then there are the words: as fractured, elusive and evocative as only a Bowie lyric can be. Among the countless intriguing tics that recur in Bowie's songwriting over the years, there's an ongoing tug-of-war between the antithetical impulses of self-abandon and self-restraint. In one famous song, he sings that he never lost control; in another, written many years later, he frets about having 'No Control'. The same tension underpins perhaps the most famous song of all, as Major Tom severs his connection with Ground Control and floats away into space. Just so, as if counterbalancing the previous album's exhortation to hang onto yourself, Bowie now offers up the equal and opposite force with an instruction to let yourself go.

Alongside that ecstatic surrender to the sensual, there's a playful, almost childlike appeal to the intellect: that subliminal echo of nursery rhyme that we find in so many Bowie lyrics, from 'The Laughing Gnome' to

'Ashes to Ashes', from 'Little Wonder' to 'Blackstar'. As if reciting some decadent playground skipping game, Bowie piles rhyme upon rhyme — "lasers", "blazers", "razors", "waiters", "beautician", "nutrition" — each new image a fresh piece of information, individually nonsensical, but together coalescing into an impressionistic portrait of the title character.

So who is the Jean Genie? Many have remarked on the punning reference to Jean Genet, the French author whose work had entered Bowie's orbit via his mentor and mime teacher Lindsay Kemp. Others have suggested that the song is a tribute to Iggy Pop, or even a self-portrait of Bowie himself. The answer, of course, is that it's all of these things, and none of them, and plenty more besides. Bowie being an elliptical writer, there has always been an understandable temptation to approach his lyrics as though they're cryptic crossword puzzles, with a "correct" solution to be cracked. But that's not how Bowie works. In fact, it's the *opposite* of how Bowie works. The ambiguity is key: we are actively invited to bring our own interpretations to the party. Like the Genie in the old pantomime tale from which *Aladdin Sane* derives its name (and there's another reference for the melting pot), the eponymous Jean Genie is a conjuring, shape-shifting enigma. He's whatever works for you. Bowie attested that the lyric was "a smorgasbord of imagined Americana", its central character a "white trash, kind of trailer-park kid thing — the closet intellectual."

Another springboard for the lyric was simply David's wish to entertain a new girlfriend, Cyrinda Foxe, a leading light of the Andy Warhol crowd in New York. "I wrote it for her amusement, in her apartment," David later recalled — and when it came to shooting the video for 'The Jean Genie' a few weeks later, by which time the tour had reached San Francisco, Foxe was flown in to play the appropriately Warholian role of a Marilyn Monroe figure, vamping and modelling for the camera as Bowie sizes her up in his film director's finger-frame. The video captures a snapshot of the Spiders at the height of what might be termed their second phase, the American adventure conferring upon them a newfound swagger and attitude. It's a development also on display in the barnstorming live performance of 'The Jean Genie' recorded back home in London for *Top of the Pops* a couple of months later: lost for decades, the clip was rediscovered in 2011, gifting us with a thrilling demonstration of how far Bowie and the Spiders had travelled since that celebrated performance of 'Starman' on the same show just six months before. Both clips are magical, but how different they are. In the first, we're witnessing the very moment, fragile and beautiful, when a new star emerges. In the second, that star has toured the States from coast to coast, partied with the New York Dolls, and made it back alive.

On home turf, 'The Jean Genie' became Bowie's biggest hit so far, peaking at No. 2 that January. It was denied the top spot by Little Jimmy Osmond — and then, irony of ironies, elbowed out of the way by Sweet's mega-hit 'Block Buster!', recorded at almost exactly the same time and coincidentally mining the very same Yardbirds riff. But 'The Jean Genie' was in it for the long haul: of the 10 songs on *Aladdin Sane*, it was destined to enjoy the most prolific afterlife in Bowie's concert repertoire. In fact, since we're crunching numbers, it comes second only to 'Fame' as the most

frequently performed number of his live career. Unusually for an artist who never made any secret of his low boredom threshold, David never seemed to tire of the song. "I think 'Jean Genie' is a gas — I still like that one," he once told a reporter, and on stage that enthusiasm was always palpable.

Over the years, 'The Jean Genie' was often the cue for something experimental, improvisational, a moment of musical extrapolation. It started almost straight away, as Bowie began inserting the Beatles' 'Love Me Do' into the earliest live versions, as witnessed in that firecracking *Top of the Pops* clip. The following year's Diamond Dogs show unveiled a radical reimagining, later revived for the Serious Moonlight tour: the verses now spare and minimal, stripped back to their bluesy roots, before picking up pace for the choruses. On the 1976 tour, 'The Jean Genie' became a gloriously elongated final encore: urgent of tempo, peppered with trick endings, shot through with a crazy paving of prog keyboards and squealing guitars, Bowie whooping and howling with wild shamanic abandon as if channelling Led Zeppelin in their pomp. And from the late 1980s onward, the cross-breeding of 'The Jean Genie' with an ever-expanding parade of rock and blues standards became part of the song's identity: there were excursions into the Rolling Stones' '(I Can't Get No) Satisfaction', Van Morrison's 'Gloria', Dylan songs, Hendrix songs, Elvis songs. Headlining the Phoenix Festival a full quarter of a century after 'The Jean Genie' was born, Bowie opened the number with the 1940s standard 'Driftin' Blues', taking the song right back to its roots once more.

In 1983, a decade after they had parted company, David Bowie and Mick Ronson were reunited at a Serious Moonlight concert in Toronto — and once again, 'The Jean Genie' was the appointed number. It was a fitting choice: few songs encapsulate so well the alchemy of that remarkable collaboration, and few enjoyed such staying power and occupied such a central position in Bowie's playbook. As popular music continues to forge ahead, 'The Jean Genie' will always be with us: a stone-cold classic that loves to be loved.

ALADDIN SANE

WORLDWIDE

The Aladdin Sane photograph formed the foundation of a global press campaign, appearing in a variety of promotional artefacts the world over.

I love you
David
xx

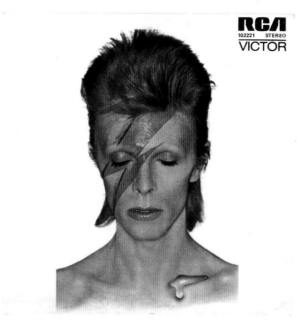

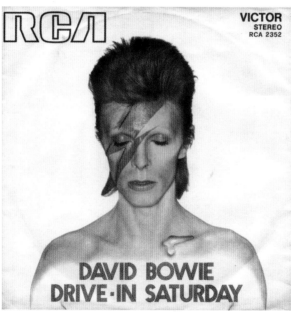

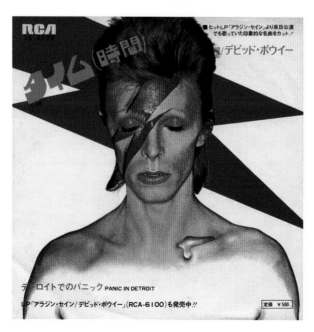

PREVIOUS PAGE — An insert included with the album doubled as an application to join David's fan club.

ABOVE, CLOCKWISE FROM TOP LEFT — Singles from Australia, Portugal, the USA, Brazil (complete with typo), Japan and Italy.

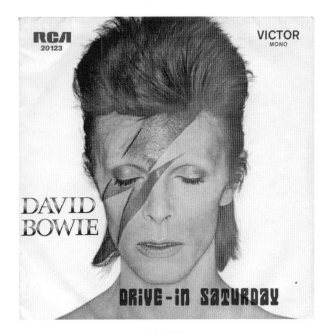

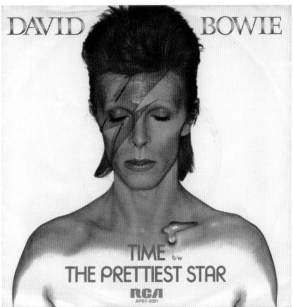

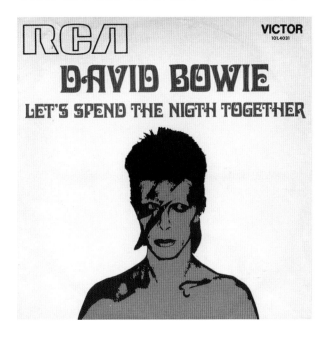

FOLLOWING PAGES — A selection of fan memorabilia, tour guides and press advertisements from around the globe.

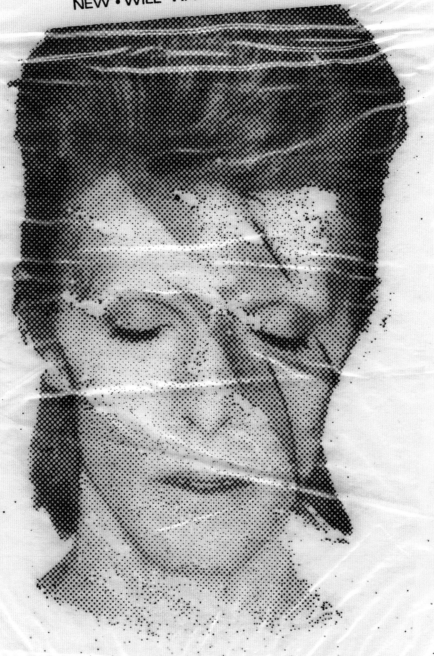

Let's spend the night together.

Spend the night with David Bowie on his new album "**Aladdin Sane.**"
Includes the hit single "**Let's Spend the Night Together.**"

RCA Records and Tapes

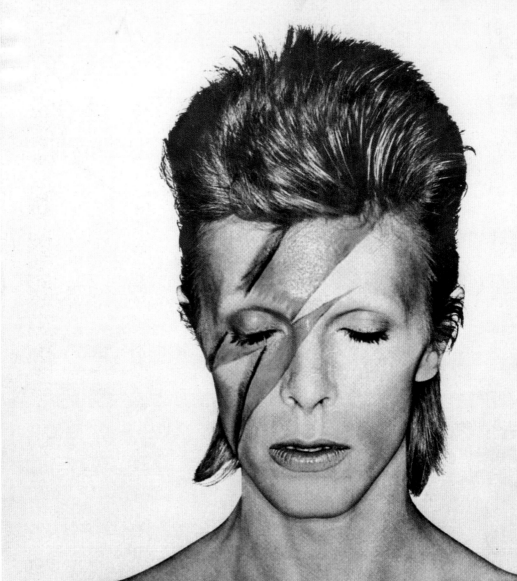

Nothing can stop a hit whose "Time" has come.

APBO-0001

David Bowie's new single "Time" from the album "Aladdin Sane."

ALADDIN SANE

BOWIE'S LATEST ALBUM

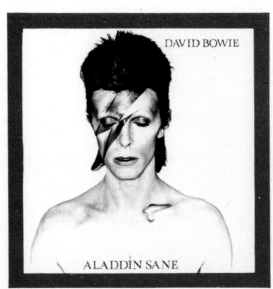

RS. 1001 (L.P.) PK 2134 (C) P8S 2134 (S8)

SIDE 1 : 1. WATCH THAT MAN (New York) ;
2. ALADDIN SANE (1913-1938-197 ?) (R.H.M.S.
"Ellinis") ; 3. DRIVE-IN SATURDAY (Seattle —
Phoenix) ; 4. PANIC IN DETROIT (Detroit) ;
5. CRACKED ACTOR (Los Angeles).

SIDE 2 : 1. TIME (New Orleans) ; 2. THE
PRETTIEST STAR (Gloucester Road) ; 3. LET'S
SPEND THE NIGHT TOGETHER (Jagger/
Richard) ; 4. THE JEAN GENIE (Detroit and New
York) ; 5. LADY GRINNING SOUL (London).

BOWIE
ALBUMS AND TOUR

RCA
Records and Tapes

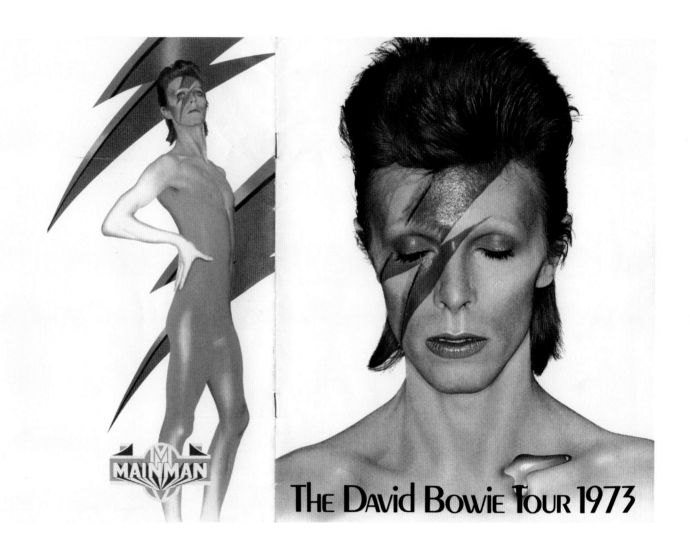

The David Bowie Tour 1973

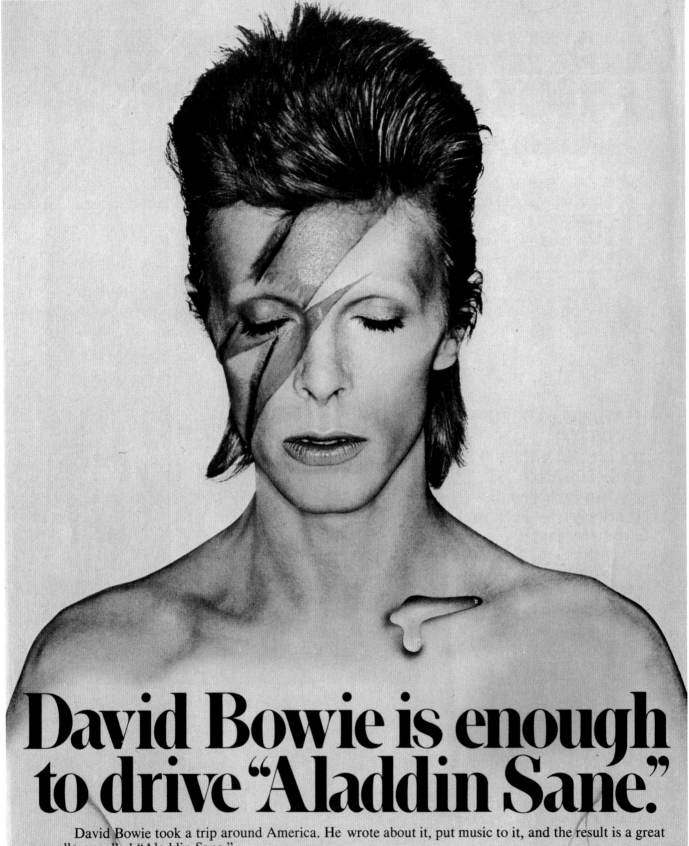

David Bowie is enough to drive "Aladdin Sane."

David Bowie took a trip around America. He wrote about it, put music to it, and the result is a great new album called "Aladdin Sane."

Includes "Time," "Watch That Man," "Let's Spend The Night Together," and seven other tales of David's cross-country adventures.

"Aladdin Sane." Volume five in the collected works of David Bowie.

RCA Records and Tapes

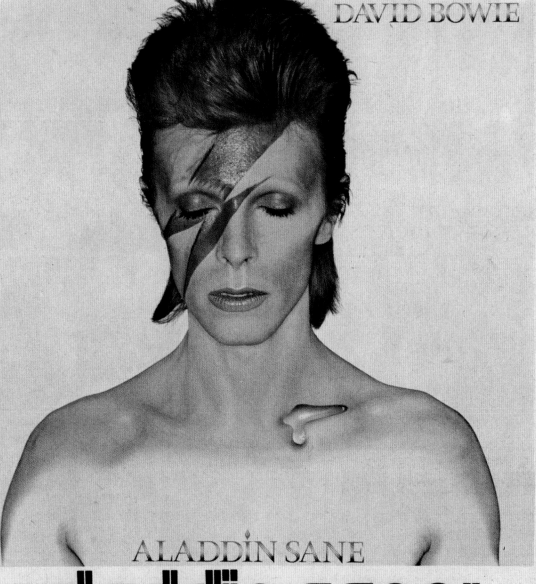

SIDE 1
Watch that man
Aladdin Sane (1913-1938-197?)
Drive- In Saturday
Panic in Detroit
Cracked Actor

SIDE 2
Time
The prettiest star
Let's spend the night together
The Jean genie
Lady grinning soul

Available April 19th

ALADDIN SANE

DAVID BOWIE

RS 1001
cassette PK 2134
cartridge P8S 2134

PRESENTS DAVID BOWIE · PROMOTER MEL BUSH

MAY

12 EARLS COURT	23 BRIGHTON, THE DOME
16 ABERDEEN, MUSIC HALL	24 LEWISHAM, THE ODEON
17 DUNDEE, CAIRD HALL	25 BOURNEMOUTH, WINTERGARDENS
18 GLASGOW, GREENS PLAYHOUSE	27 GUILDFORD, CIVIC HALL
19 EDINBURGH, EMPIRE THEATRE	28 WOLVERHAMPTON, CIVIC HALL
21 NORWICH, THEATRE ROYAL	29 HANLEY, VICTORIA HALL
22 ROMFORD, THE ODEON	31 BLACKBURN, ST. GEORGE'S HALL

AN RCA TOUR

JUNE DATES WILL BE PUBLISHED IN DUE COURSE

TELEVISION

Powerful 30 second commercials will be appearing time after time during the promotion of 'Aladdin Sane'.

PRESS ADVERTISING

Whole page, colour and black and white advertisements, promoting the album and tour, will be appearing in:

New Musical Express	London Evening Standard
Melody Maker	The Sun
Record Mirror	Daily Mirror
Sounds	Music Star
Disc	Pop Swop
	Mirabelle
	Fabulous 208

DISPLAYS

Hundreds of window displays will be installed nationally, featuring a four feet high cut-out figure of Bowie as a centrepiece. Specially prepared display packs containing sleeves, posters and a cut-out will be mailed direct to retailers. These can be ordered directly from your RCA salesman.

POSTER

A four colour poster of Bowie, illustrating the Aladdin Sane album will be supplied direct by your RCA salesman upon request.

LEAFLETS

A leaflet illustrating each Bowie album and listing his complete U.K. tour will also be supplied.

RCA Records and Tapes

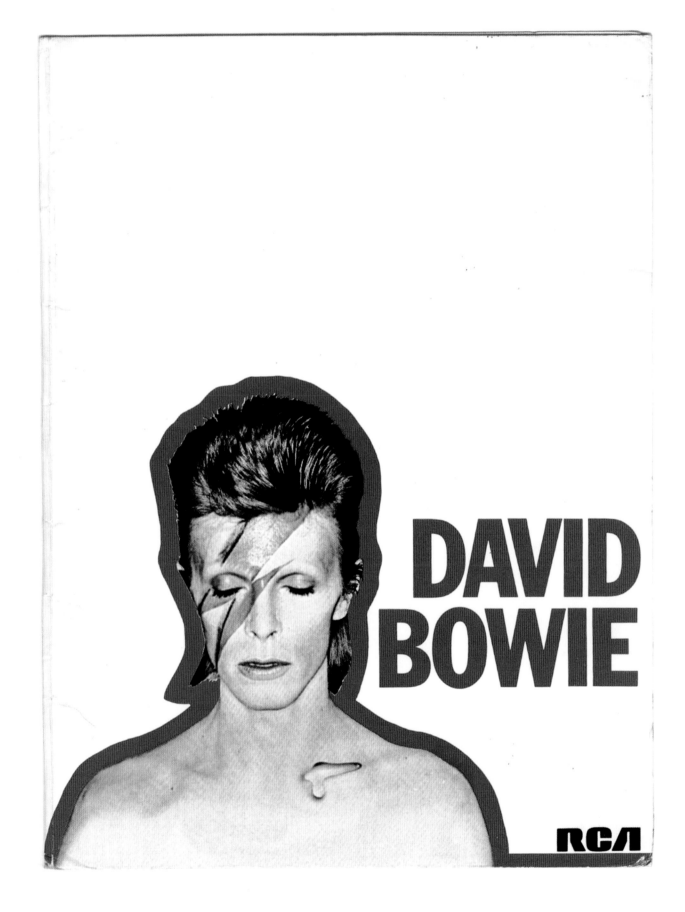

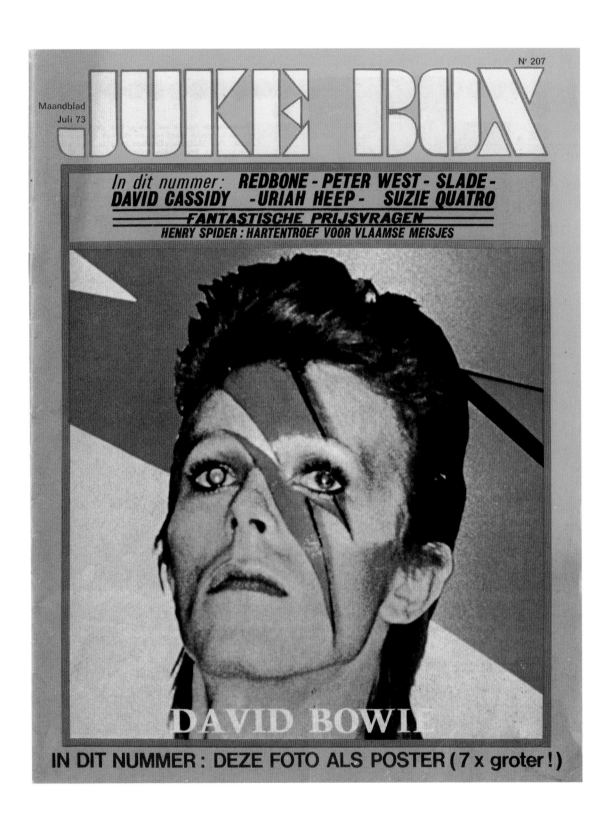

suosikki

N:o 8 ◆ 1973 ◆ 2:40 ◆ Skr 3:75 (inkl. moms.)

JARNO
SAARISEN
ELÄMÄ!

*DEEP
PURPLEN
KRIISI*

TOTUUS
SABBATHISTA
JA
SUOMESTA

BOWIEN SALAISUUDET –
osa 1 tässä numerossa!

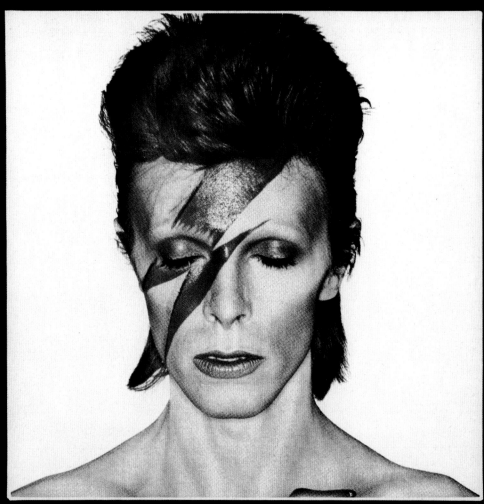

10.
LADY
GRINNING
SOUL

JÉRÔME SOLIGNY

YOU CAN'T EXPECT
ME TO REMEMBER
THE 1970S.
I LIVED THROUGH
THEM, THAT'S
GOOD ENOUGH.

DAVID BOWIE

PERSONALLY, I remember very well the day I spent in April 1991 with David Bowie, then the singer of Tin Machine, and the subjects he covered. I had met him for the first time that morning and it had been suggested to me, at the end of my first interview with him for *Rock & Folk* magazine, that I stay on in Paris. He was promoting the second (and last) studio album of the group he had formed with Reeves Gabrels and the Sales brothers — after a decade of artistic ups and downs, which had quite a few people gnashing their teeth. He must have enjoyed my company (or, at least, not been bothered by it — I never found out whose idea it was to ask me to spend a few more hours with him and his entourage that day) and, in between radio and television interviews (five or six in all), in dressing rooms or in his car, we spoke of things that were evidently very close to his heart, and had nothing to do with Tin Machine.

Quoted at the start of this piece is what he slipped into my ear after singing (to playback) 'You Belong In Rock N' Roll' in a television studio, and it's remained etched on my mind, and not only because it was funny. I already knew that memory could play tricks, could be selective — and that day David Bowie gave me proof. There were entire parts of his career which he appeared to have forgotten, but others of which he remembered even the slightest detail. In one of the two taxis which ferried us around that day, claiming a certain time (summer 1976) was very blurry in his mind (and I believed him), he declined to talk about the Château d'Hérouville. A few days later, he would even turn down an invitation to go there, if only to glance through the gates. In contrast, having grasped that I came from a port town, Le Havre, he spoke to me at length about SS *France* and went into a lot of detail about the ocean liners he travelled on before going back to flying in 1977. Likewise, he lingered on the life and work of Pierre Laroche, his make-up artist from the Ziggy Stardust years, who had recently died. Moving from one subject to another, he recalled the Duffy session for the *Aladdin Sane* cover and laughed at the idea that an almost insignificant detail (a little lightning bolt on a kitchen appliance) could have been the origin of his look for what was already, and would remain, the most iconic photograph ever taken of him.

He honestly didn't give the impression of editing his memories before opening his mouth. Rather, it was as if the things he thought of just fell from his brain without warning, landed in his throat and spun straight between his barely parted lips. All within a tenth of a second. Yes, David Bowie was a live wire, a very live wire.

It's quite likely that readers who like to get straight to the point may not see the connection between this preamble and 'Lady Grinning Soul'. Well, at the risk of disappointing them, I will allow myself to add that whenever he spoke to journalists from my country, Bowie would ask, as a sort of running gag, for any news about certain French language singers, especially Johnny Hallyday. I would personally reply with whatever I knew (not much, to tell the truth) and he would come out with his famous quip: "All the same, it's funny how the two most famous French singers are Belgian!" You could see how it amused him to refer to (Jacques) Brel and Johnny (Hallyday) in the same sentence. Partly out of politeness but largely because we loved him,

we laughed along with him. More seriously, on that day with Tin Machine, he asked me what had become of Françoise Hardy. Since I was in a better position to reply in this case, I told him what she was doing musically. I also spoke about the English arrangers she had worked with in the past (he knew them all), and mentioned Serge Gainsbourg, who had written for her. But although I was sure he would be passionately interested in that "holy monster", I found that David Bowie knew almost nothing about him. This surprised me, especially because in autumn 1969, Jane Birkin, then Gainsbourg's partner, had topped the British charts with him with a song written two years earlier for Brigitte Bardot. 'Je t'aime ... moi non plus' (covered by Jane and Serge) had been a huge hit in England the year that 'Space Oddity' first entered the charts.

It's true that David Bowie had not mastered the French language as much as he would do while living in Switzerland, but we can reasonably assume that he would have heard many times the very explicit lyrics of 'Je t'aime ... moi non plus', in which the line most repeated by Birkin and Gainsbourg is: 'I come and I go / Inside of you'. It's impossible to imagine even for a nanosecond that its meaning would have eluded an avid sleuth like Bowie or that he could have been unaware of what the couple were describing (and, in Jane's case, simulating) in the song. On *Aladdin Sane*, two verses of 'Lady Grinning Soul' each begin with the line: 'She'll come, she'll go'.

Of course, the lyrics of the song that ends the album are less crude than Serge Gainsbourg's. Here, in what is certainly the most sensual ballad in his entire discography — 'Letter to Hermione', directly tackling his earlier life, remains the most poetic — Bowie does not resort to simply describing the act of making love. He sublimates it by adding American cultural and contextual references (as throughout the rest of the album) and allusions that hint at drugs ("silver" for "silver spoon" and the Americard credit card, useful for making lines of coke). He even braves a reference to Marilyn Monroe (or her cologne): asked in 1952 what she wore to bed she replied, "Chanel No. 5."

There's a myth — seen in print more and more often, probably because it seems more attractive than reality — that it was the vocalist and backing singer Claudia Lennear who inspired Bowie's lyrics for 'Lady Grinning Soul'. Whatever she may say herself, it is impossible to prove (other women have also claimed to be the song's inspiration) — which does not necessarily make it false, either. So perhaps Lennear, who, according to Bill Wyman, is indeed the subject of the Rolling Stones' 'Brown Sugar', has spent her life asking herself whether being described as a "living end" was all that flattering: by not specifying when death would intervene, by sprinkling this affair with anxiety, Bowie really did open a can of worms.

Musically, 'Lady Grinning Soul' divided the press on the release of *Aladdin Sane* (deplorably, the adjective "lame" was even used by an eminent rock critic), though it is incontestably one of the wonders of David Bowie's entire oeuvre. He must have felt this, as he insisted on being there when it was mixed. And again (as I observed about 'Cracked Actor'), it is to an especially bold chord progression that the piece owes its elegance. The melody of the verse — which Bowie first releases to the air, singing the first

two notes without music — floats gently in equilibrium above a void and then evolves, heroically, over a handful of chords (very few tones separating them) and with alternating major and minor harmonies casting a spell, as if by magic. But Bowie becomes even bolder with the arrival of the chorus: he has us swallow the pill of an abrupt key change, by distracting our attention. He climbs very high in pitch, in a way he rarely did in the studio, and, supported by a chordal architecture even more daring than the previous one, he pours out, with panache, the rest of a melody that obeys only its own inner logic, and whose dramatic emphases hurtle the listener toward its ineluctable conclusion.

'Lady Grinning Soul' is a song that would have shone very brightly even if played simply, on a 12-string guitar, but it is Mike Garson, the American recruit, who walks through pulsating corridors under an open sky to propel the piece into an entirely different galaxy. Left to his own devices on half of the songs, the pianist is here all alone (for the second and last time on the album), opening this last track with a cascade of notes, bewildering to the average rock fan but which, in Garsonland, has always been the norm. Interviewed for this book, Mike said only that he had always considered this song the best on the album, and that it reflected his love for Chopin, Rachmaninoff and Liszt. About this famous intro, he modestly says he "just made the melody explode a bit" and that, if 'Lady Grinning Soul' sounds just as good today, "that's equally thanks to the talent of Ken Scott and the quality of the C. Bechstein grand piano", the secret weapon of Trident Studios. As for the instrumental part, which comes early, just after the first chorus, it is perhaps the other peak of the *Aladdin Sane* album, just as Mick Ronson's solo on 'Moonage Daydream' is certainly the peak of *The Rise And Fall of Ziggy Stardust and the Spiders from Mars*. In this section, Ronson (whose praises Garson has never ceased to sing) plays an acoustic, Spanish guitar solo for four bars with, in the background, the same grapeshot spray of piano notes as in the verses. (Mike does not play in the choruses, incidentally, where he is "replaced" by electric guitar arpeggios). For the four next bars, the last of the solo, the guitarist mirrors exactly the romantic soaring flourishes of Garson's right hand, sublimely and perfectly in unison, a spine-tingling moment, which always causes even more of a shiver.

Half a century after recording 'Lady Grinning Soul', Mike Garson describes this specific passage as a "magical interlude" and ends up letting slip, with a bit of a lump in his throat, that he misses both David Bowie and Mick Ronson. In the final section, dressed in an added layer of brass that seeks to comfort — in contrast to those implacable chords allowing only a sliver of hope (passing from G# minor to B) — Ronson lets rip some wails from his Les Paul. Listening again to the song today leaves the impression of Mike Garson launching that shower of crystal tears to the skies in order to let them know that he is still here, faithful to his post. As the guardian of the ebony and the ivory, Mike knows better than anyone that 'Lady Grinning Soul' was never sung by David in concert — and so it is for him, for Mick, for Trevor and for John (Hutchinson) that he plays. In this instance, memory is never selective.

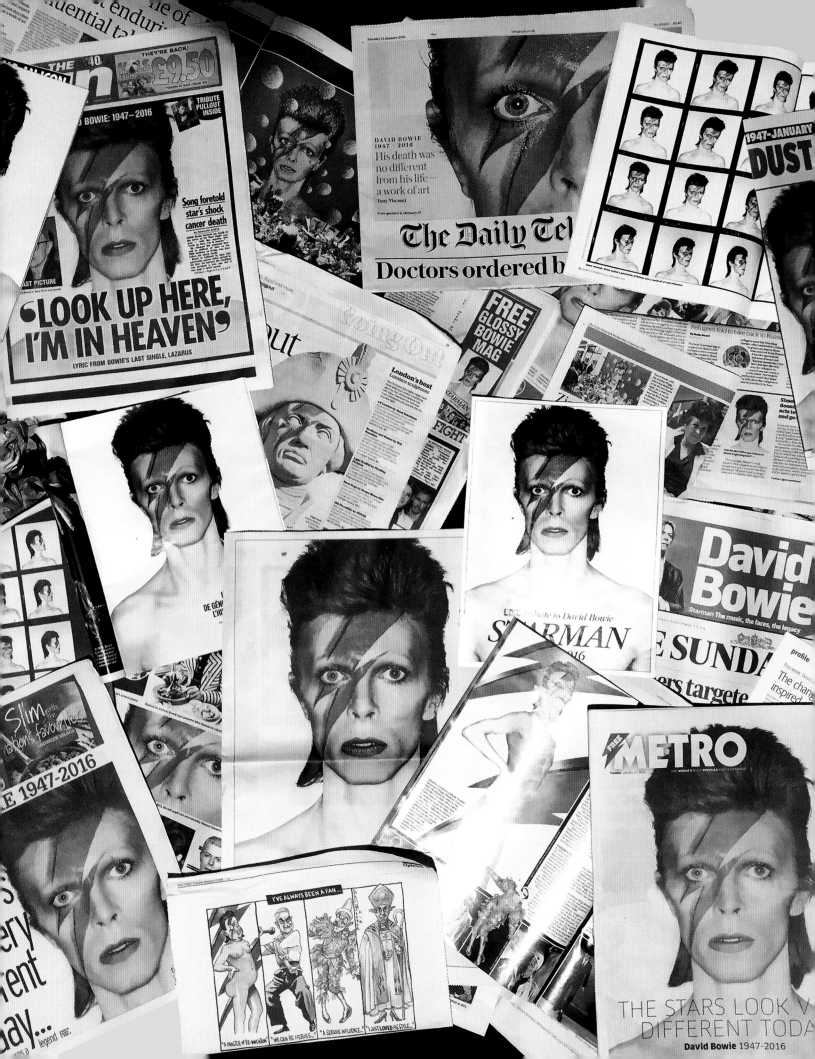

IMAGE TO ICON

GEOFFREY MARSH

ONE OF THE MOST EMBLEMATIC AND INFLUENTIAL ART IMAGES OF THE PAST HALF CENTURY, REPRODUCED OR PARODIED IN ADVERTISING, MEDIA AND ENTERTAINMENT WORLDWIDE.

CAMILLE PAGLIA (2013)

LISA Armstrong, the *Daily Telegraph's* Head of Fashion, recalls the immediate impact of Bowie's album: "*Aladdin Sane* was everywhere in 1973, so ubiquitous he even infiltrated my school — Dorchester Grammar, a rural establishment hitherto impervious to fashion and so it seemed to me, anything colourful. Like a West Country Kabuki tribe, the girls in the fifth and sixth forms marched arm-in-arm (forbidden) down the corridors with their spiky orange haircuts (not forbidden, but only because the rules have yet to catch up), alabaster faces and tweezered-to-the-brink-of-extinction eyebrows, in tribute to their hero, and terrifying my fellow first years and me."

But how does such an image retain its power and impact over decades of new album releases and new music? And how does it shift from image to icon?

David's *Aladdin Sane* image has four key virtues for longevity:

First, simplicity — it's easy to create. Even an inebriated schoolboy can scrawl it on their face with their sister's stolen make-up, with some hope of creating a cool effect;

Second, drama — with just two colours you can make an instant impact. The flash exploits the eyes and nose to turn something two-dimensional into so much more, cutting down across the brain and splitting the face;

Third, recognition — apply it and you will be instantly recognizable pretty much anywhere in the world. At once, you are in a club of outsider rebels with a dash of sophistication; and

Fourth, inclusivity — it works for any sex.

There are also things it avoids. It's neither overtly feminine or male, an important consideration for sexually uncertain teenagers, with the alien obscuring the androgyny. It is also apolitical. Unlike the Rolling Stones lips logo, perhaps its only rival in the T-shirt popularity stakes, there is not a touch of humour or irony. Both were created in London, five miles and three years apart, a reminder of the capital's enormous creative design power. However, John Pasche's lips was designed deliberately as a logo, while the lightning bolt was part of a bigger concept. Therefore, although Bowie never appeared on stage with the flash, his fans preserved this identity through endless copies for concerts, parties and celebrations.

The success of the lightning bolt also owed much to the time of its creation. The rise of glam rock in the early 1970s brought male make-up centre stage and provided a permissive environment for facial experimentation. In a world without social media and where tattoos were uncommon, it also provided an instant ideogram, akin to the yellow and black "smiley" face, trademarked in 1972. Its influences across the music scene ranged from AC/DC's AC DC logo to Freddie Mercury. The former appeared, in red, in 1975 on their album *High Voltage* (Australian release only) and went through small changes until the current design was finalized in

PREVIOUS PAGE — David's Aladdin Sane portrait graced the covers of newspapers the world over when news broke of his passing.

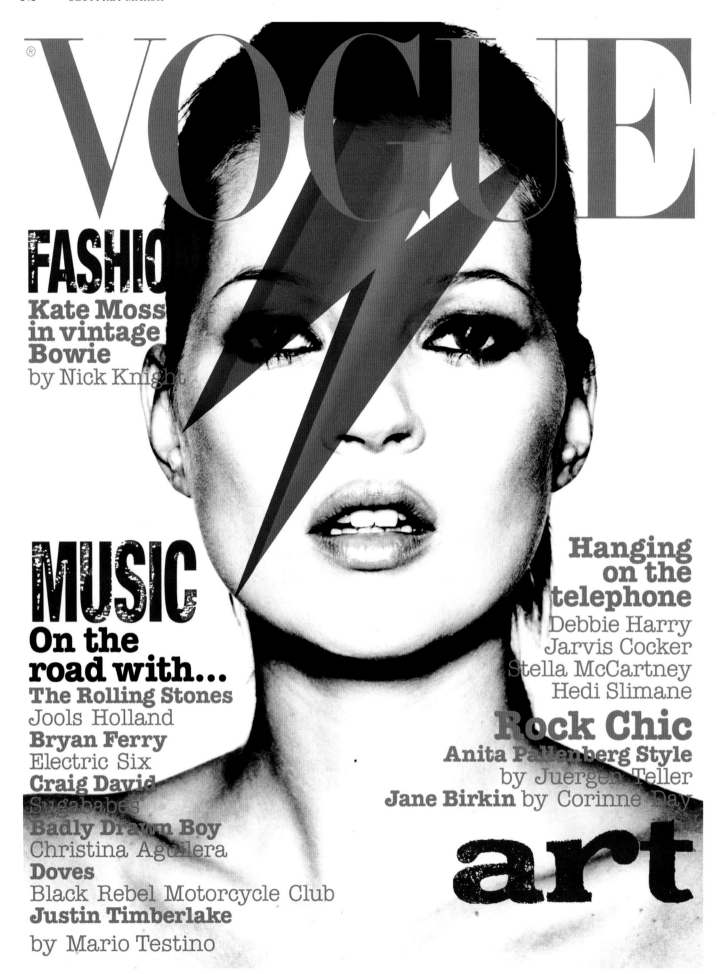

VOGUE

FASHION
Kate Moss
in vintage
Bowie
by Nick Knight

MUSIC
On the
road with...
The Rolling Stones
Jools Holland
Bryan Ferry
Electric Six
Craig David
Sugababes
Badly Drawn Boy
Christina Aguilera
Doves
Black Rebel Motorcycle Club
Justin Timberlake
by Mario Testino

Hanging
on the
telephone
Debbie Harry
Jarvis Cocker
Stella McCartney
Hedi Slimane
Rock Chic
Anita Pallenberg Style
by Juergen Teller
Jane Birkin by Corinne Day

art

1977 by Bob Defrin with the help of typographer Gerard Huerta. A few years later, Freddie Mercury, during Queen's The Works tour of 1984–85, wore a flamboyant stage outfit comprising a black lightning bolt design on a white lycra vest and white leggings with black lycra appliqué lightning bolt stripes.

During the 1980s and 1990s, Bowie had moved on, but the lightning bolt remained burnt into the collective subconscious of his fans. It even survived his retirement from performance in 2003. However, as *Aladdin Sane* approached its 40th anniversary, the lightning bolt received an unexpected boost from an unlikely direction. On 3 June 2012, residents in Bristol awoke to find that a wall at 22 Upper Maudlin Street had been decorated with the image of a young Queen Elizabeth II with the lightning bolt across her face. Although Banksy had previously had his work on the wall and some claimed it was a new piece by him, it is attributed to Incwel. Sandwiched between the Queen's actual Diamond Jubilee and the opening of the 2012 London Olympics in July, the work attracted much media attention and provided a new burst in popularity. The following year, the Victoria and Albert Museum used the flash as the logo in its entrance hall for their David Bowie Is exhibition, which became one of its most successful shows ever, touring the world until 2017.

David's death in 2016 seems to have had no impact on the enduring popularity of the Aladdin Sane image. Indeed, as fans gathered in Brixton and around the world to mourn his passing, the symbol was everywhere. And the story continues. As I write this in summer 2022, the National Portrait Gallery in London is closed for renovation but on the exterior hoardings, Aladdin Sane (the eyes wide open version) is next to an imperious Queen Elizabeth I in a street gallery. The fact that Bowie is looking east toward Charing Cross Station, the terminus he commuted to from Sundridge Park aged 16 for his first job, only adds to this fascinating juxtaposition of Great Britons.

Let's finish back with Chris Duffy, talking about his father and Bowie, "Eventually we all have got to pass on, but I would guess that David's legacy will be the *Aladdin Sane* picture. It has become a cultural icon. Several years ago, I started calling it the *Mona Lisa* of Pop. I think it is quite befitting. There isn't really an image that is as ubiquitous. It's been used on fridge magnets, caps, calendars, T shirts, lighters, beer mats, and it is quite extraordinary, you know? You can go somewhere like a market in Goa and you'll find people selling rip-off Aladdin Sane t-shirts."

Will people eventually tire of it? Possibly, but only if a new icon arises more closely representing society's values. At present, in the tangled skein of global popular culture, it is difficult to imagine from where such a challenger might emerge.

OPPOSITE — British *Vogue* magazine's homage to Aladdin Sane, featuring Kate Moss photographed by Nick Knight.

OVERLEAF — Attributed to an elusive graffiti artist known as Incwel, this portrait of Queen Elizabeth II decorated a Bristol street.

FOLLOWING PAGES — The Victoria and Albert Museum's David Bowie Is exhibition toured around the world.

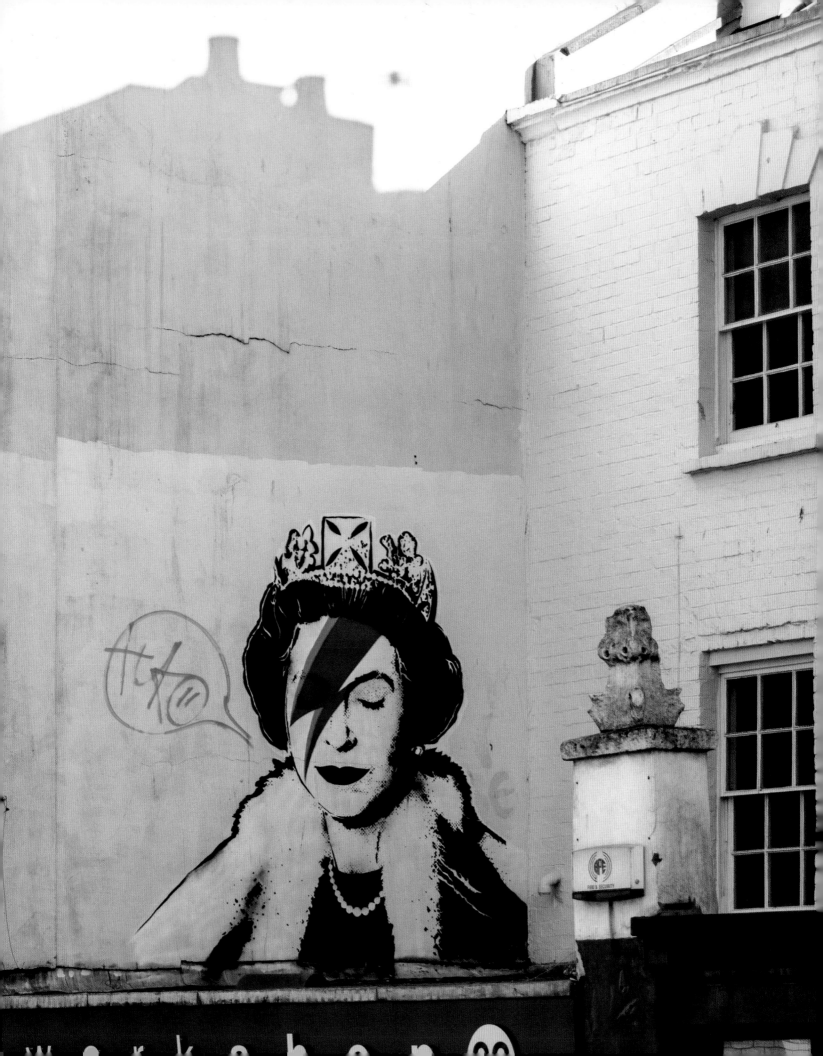

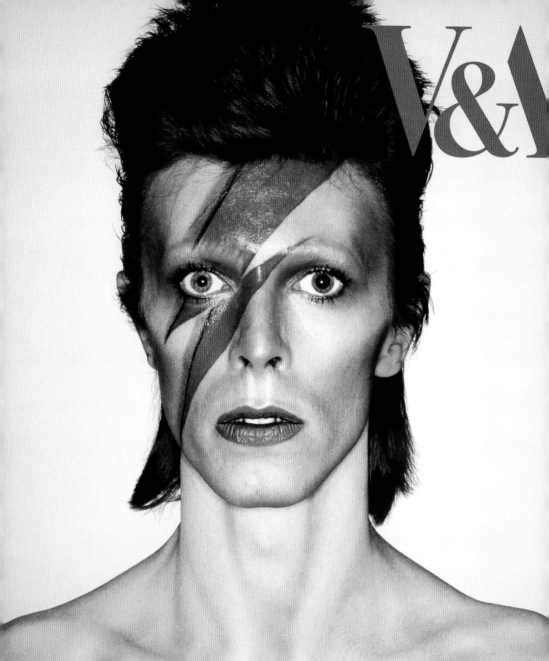

V&A

David Bowie is here

A MAJOR EXHIBITION AT THE VICTORIA AND ALBERT MUSEUM

23 MARCH – 11 AUGUST 2013

IN PARTNERSHIP WITH

GUCCI

BOOK NOW ONLINE OR 020 7907 7073* V&A MEMBERS GO FREE

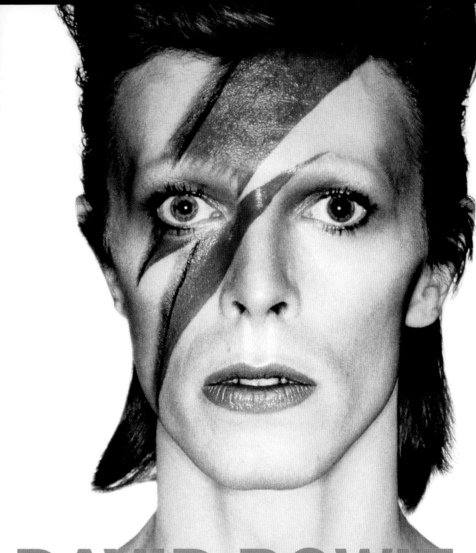

DAVID BOWIE is
coming to Tokyo
2017 1/8 SUN → 4/9 SUN

Warehouse TERRADA G1bldg. TENNOZ

www.davidbowieis.jp

Exhibition organised by
the Victoria and Albert
Museum, London

Photo: Duffy © Duffy Archive & The David Bowie Archive ™

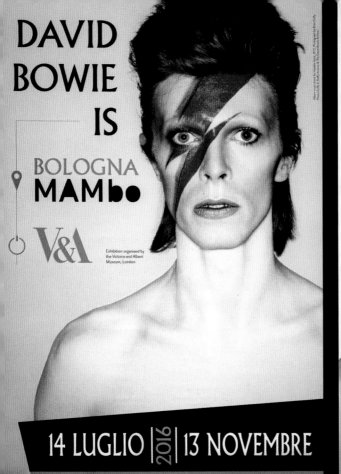

DAVID
BOWIE
IS

BOLOGNA
MAMbo

V&A

Exhibition organised by
the Victoria and Albert
Museum, London

14 LUGLIO | 2016 | 13 NOVEMBRE

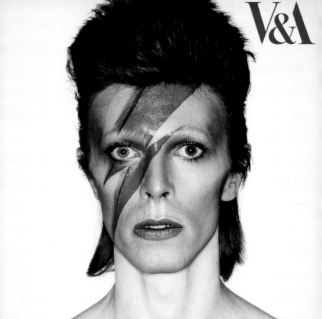

V&A

DAVID BOWIE *is*

MUSEU DEL DISSENY DE BARCELONA
FROM MAY 25TH TO SEPTEMBER 25TH 2017

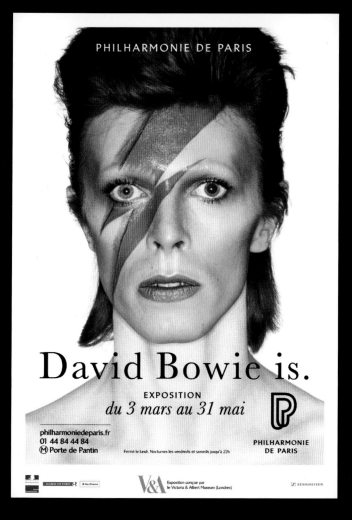

PHILHARMONIE DE PARIS

David Bowie is.

EXPOSITION
du 3 mars au 31 mai

philharmoniedeparis.fr
01 44 84 44 84
Ⓜ Porte de Pantin

Fermé le lundi. Nocturnes les vendredis et samedis jusqu'à 22h.

PHILHARMONIE
DE PARIS

Exposition conçue par
le Victoria & Albert Museum (Londres)

SENNHEISER

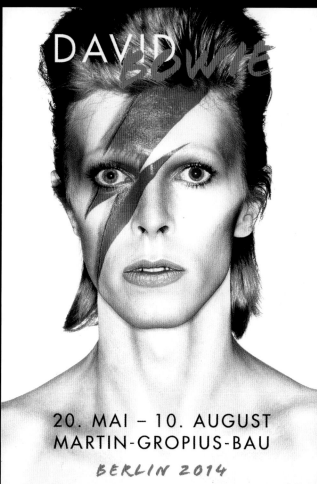

DAVID BOWIE

20. MAI – 10. AUGUST
MARTIN-GROPIUS-BAU

BERLIN 2014

ten

BRIXTON£

David Bowie (1947–), musician

DETAIL FROM NUCLEAR DAWN,
COLDHARBOUR LANE

©BRIXTON POUND 2015
THEBRIXTONPOUND.ORG
BRIXTONPOUND.COM
DESIGN BY DANNY RUSSELL, CHARLIE WATERHOUSE

BP10 0000275
BP10 0000275

BP10 0000275

(–2016)

OPPOSITE — The Brixton Pound
is a form of currency intended
to support the local economy of
Brixton, the area of London in
which David was born. Their ten
pound note features his portrait.

ABOVE — In 2017, the Royal Mail
introduced a series of stamps
commemorating David's work,
including the Aladdin Sane portrait.

OVERLEAF — Aladdin Sane is
launched into space to celebrate the
launch of the Royal Mail's stamps.
Attached to helium balloons,
the stunt offered a poignant
opportunity to see David's portrait
take its place among the stars.

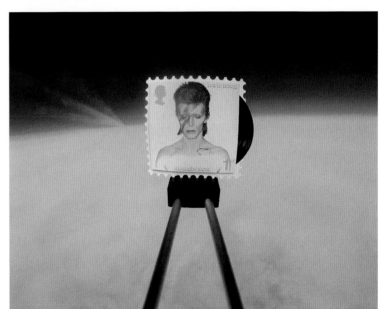

Many thanks to Bill Zysblat, Tom Cyrana, Aisha Cohen at RZO and Mark Adams at davidbowie.com. Thank you to Joe Cottington at Welbeck Publishing for his belief in this book and his meticulous management and attention to detail, Jonathan Barnbrook and Seán Purdy at Barnbrook studios for their creative flexibility in bringing my vision to life. Thanks to Kevin Cann, Paul Morley, Charles Shaar Murray, Nicholas Pegg and Jérôme Soligny for delivering unique perspectives and interpretations on a subject that has and will continue to intrigue Bowie fans worldwide. A huge thanks to Geoff Marsh who has been a constant supporter of the Duffy Archive, his ability to think left field always illuminating whatever zeitgeist he immerses himself in.

I would also like to thank my team at the Duffy Archive for their endless support and finally, a special thanks to Sandie Goodman, whose commitment to the project has been indispensable; I am eternally grateful for her dedication and enthusiasm for all things Duffy.

www.duffyarchive.com
www.aladdinsane50.com

Published in 2023 by Welbeck

An Imprint of Welbeck Non-Fiction Limited,
part of Welbeck Publishing Group.
Based in London and Sydney.

www.welbeckpublishing.com

A CIP catalogue record for this book is available from the British Library

ISBN 978 1 80279 554 7

Associate Publisher: Joe Cottington
Design: Seán Purdy at Barnbrook
Production: Rachel Burgess

Printed in China

10 9 8 7 6 5 4 3 2 1

FSC MIX — Paper from responsible sources — FSC® C020056

Additional images: p46 Warner Bros. Pictures / Album; p202 St Bride Library; p242 Nick Knight, British Vogue © Condé Nast; p244–245 Carolyn Eaton / Alamy Stock Photo; p246 Victoria and Albert Museum; the V&A logo is TM and © Victoria and Albert Museum; p247 Warehouse TERRADA; p248 MAMbo — Museo d'Arte Moderna di Bologna (left), Museu del Disseny de Barcelona (right); p249 (left) Philharmonie de Paris (left), Gropius Bau (right); p250 The Brixton Pound / This Ain't Rock 'n' Roll; p251 Royal Mail; p252–253 Royal Mail / Sent Into Space.

Quotes as outlined in text except: Lord David Puttnam (18, 31), Tony Defries (40), Duffy (40) and Celia Philo (41–45) first appeared in Duffy Bowie: Five Sessions by Chris Duffy and Kevin Cann (ACC Art Books, 2019). Camille Paglia (50, 51, 240), David Bowie Is by Victoria Broakes and Geoffrey Marsh (V&A, 2013), reproduced with the author's kind permission. David Bowie (107) onstage, Cleveland, Ohio, 1972, (107–108) NME, 27 January 1973, (187) Rolling Stone, 28 February 1974; Angela Bowie (187), Backstage Passes (Orion, 1993). Keith Richards (187), Guitar World, 2005. "Woody" Woodmansey (124, 188), Spider From Mars (Sidgwick & Jackson, 2016). Matthew Fisher (170, 172), David Bowie: Any Day Now by Kevin Cann (Adelita, 2010). Mike Garson (188), Bowie's Piano Man: The Life of Mike Garson by Clifford Slapper (Backbeat Books, 2018).

CONTRIBUTORS

CHRIS DUFFY wrote the introduction to this book, and the essay on the dye-transfer process, as well as overseeing the project. He is a photographer, CEO of Duffy Archive and son of Brian Duffy. Chris has photographed music icons including David Bowie, Adam Ant, Steve Strange and Spandau Ballet. He continues to promote Duffy's work on a world stage, and is a well-regarded speaker and regular contributor to Bowie events and conventions.

GEOFFREY MARSH wrote the essays 'Duffy: The Great Escaper', 'The Aladdin Sane Shoot' and 'Image to Icon'. He was co-curator of the Victoria and Albert Museum David Bowie Is exhibition and co-author of the accompanying book. Geoffrey was the director of the Theatre and Performing Arts department of the V&A Museum from 2003 to 2021.

PAUL MORLEY wrote the essays on 'Watch That Man' and 'Time'. Paul is a writer, broadcaster and cultural critic. He has written numerous books about music, including the *Sunday Times* bestseller *The Age of Bowie*, and was an Artistic Advisor for the David Bowie Is exhibition at the V&A.

KEVIN CANN wrote the essays on 'Aladdin Sane' and 'The Prettiest Star'. Kevin is a David Bowie specialist and has worked as a writer, designer and music promoter for the last 40 years. His books include a definitive account of Bowie's early years, *Any Day Now*, as well as *Duffy/Bowie: Five Sessions*, co-authored with Chris Duffy.

CHARLES SHAAR MURRAY wrote the essays on 'Drive-In Saturday' and 'Let's Spend the Night Together'. Charles is an author, journalist and broadcaster who wrote for the *NME* throughout the 1970s, including a review of *Aladdin Sane* on its release. He is an award-winning author of books including *Crosstown Traffic*, *Boogie Man* and *David Bowie: An Illustrated Record* (with Roy Carr).

NICHOLAS PEGG wrote the essays on 'Panic in Detroit' and 'The Jean Genie'. He is a leading voice on David Bowie, and author of *The Complete David Bowie*. Nicholas has acted as consultant on numerous Bowie projects, including the V&A David Bowie Is exhibition, the BBC's *Five Years* documentaries and the 2022 film *Moonage Daydream*.

JÉRÔME SOLIGNY wrote the essays on 'Cracked Actor' and 'Lady Grinning Soul'. Jérôme is a musician, author and journalist based in Le Havre, France. He spoke with Bowie many times over a 25-year friendship and interviewed him very often for *Rock&Folk* magazine. He is the author of *Rainbowman*, a two-volume analysis of Bowie's music.

MARK ADAMS is a David Bowie expert, archivist and manager of the official David Bowie website and social media. He acted as consultant on this book, providing archive material and assistance.

BARNBROOK is one of Britain's most well-known and highly regarded independent creative studios, and designed this book. Creative Director Jonathan Barnbrook worked with David Bowie regularly, designing the covers of his last four albums.

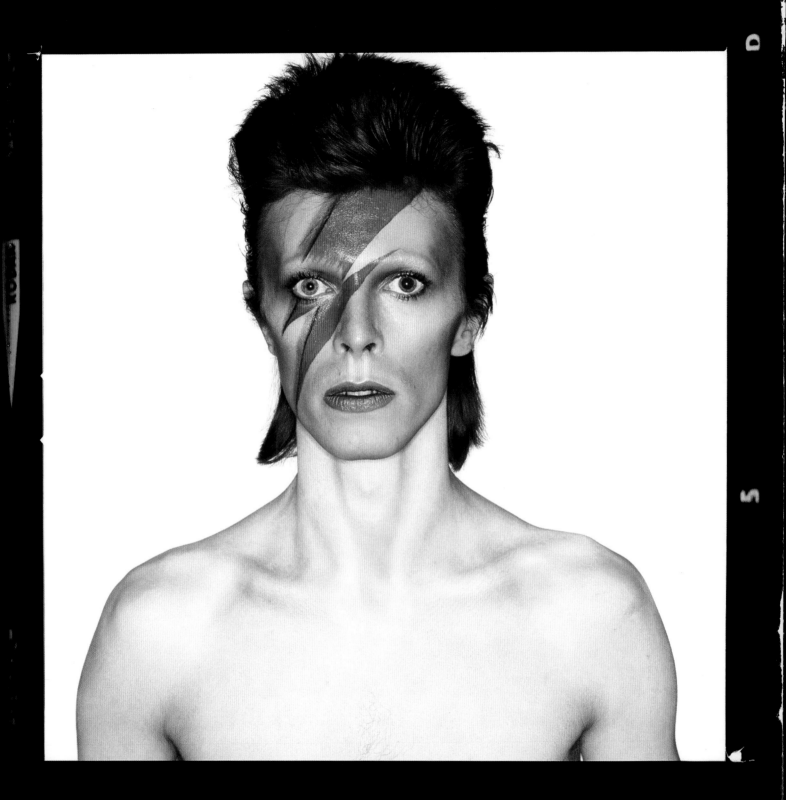